The Craft of Drawing

A Handbook of Materials and Techniques

The Craft of Drawing

A Handbook of Materials and Techniques

Dan Wood

Southern Illinois University, Carbondale

Harcourt Brace Jovanovich, Publishers

San Diego New York Chicago Austin Washington, D.C.

London Sydney Tokyo Toronto

Cover illustration by Russel Redmond.

ISBN: 0-15-515540-7
Library of Congress Catalog Card Number: 87-82784
Printed in the United States of America

Photo Credits

5: Dard Hunter Paper Museum at The Institute of Paper Chemistry. 6: © Elaine Root, courtesy Martha Chalelaine. 7: Dard Hunter Paper Museum at The Institute of Paper Chemistry. 9 top: Public domain. 9 bottom: Courtesy S. D. Warren, Division of Scott Paper Company. 10: The Institute of Paper Chemistry. 11: Photo Researchers. 12: The Institute of Paper Chemistry. 13: Courtesy Strathmore Paper Company. 20: The Institute of Paper Chemistry. 23: Courtesy Weber Costello. 56: Courtesy Eberhard Faber. 142: Courtesy Genigraphics. 143 top: Courtesy Apple Computer. 143 bottom: Courtesy Genigraphics. 144: Courtesy Genigraphics. 148: Photo Researchers. 150: Photo Researchers. 163: Courtesy Richard J. Kryczka. 165: Courtesy Richard J. Kryczka. 167: Courtesy Stephen Allen Cox, Commercial Graphics-Design, Southern Illinois University at Carbondale. 177: Photo Researchers.

Preface

During the last several decades there has been an unprecedented interest in the field of drawing. This new attitude is apparent in the increasing number of drawing exhibitions that are held annually throughout the world and in the growing number of people who collect drawings. Historically, drawing has been viewed as something done in preparation for a more "important" artwork, such as a painting or sculpture. As such, drawing was considered a subservient, although fundamental, art form.

Today, drawing is seen as an independent art form equal in stature to painting, printmaking, and sculpture. Although many contemporary artists still make preparatory drawings, increasingly they are creating drawings that exist as independent works of art unassociated with other art forms. The line separating drawing from other art forms has become indistinct as today's artists freely incorporate drawing with a variety of media such as acrylic, collage, or xerography.

Teaching drawing is a difficult, although rewarding, profession. Many instructors who have taught drawing for any length of time have developed their own philosophy and methods and seldom rely completely on the ready-made solutions found in a single textbook. In fact, many experienced drawing teachers prefer not to use a textbook at all; rather, they select their information from a variety of sources. It is for just such a teacher that *The Craft of Drawing* has been designed.

This book does not espouse a particular philosophy or method of teaching, nor does it contain exercises. Instead, the book is devoted to a discussion of the materials and

techniques used in drawing. In other areas of art, such as painting, sculpture, printmaking, and ceramics, students learn about materials and techniques from the beginning of their academic training. It is impossible to make a painting without knowing how to stretch and prime a canvas, or to throw on a potter's wheel without knowing a proper throwing technique. Likewise, there is a craft to drawing that entails much more than simply selecting a proper paper and a suitable drawing medium.

Often, students are expected to learn about materials through experimentation, or trial and error. This can be a costly and time-consuming venture. It would be preferable to teach this information as early as possible, since the materials and techniques artists use directly influence the type and quality of the artworks they make. Unfortunately, some students do not learn the importance of such information until graduate school or later. Even some professional artists do not completely grasp the significance of this information, as evidenced by the rapid deterioration of certain contemporary artworks.

There is a school of thought that believes it is more important to teach a philosophical approach to drawing, or to teach perception and creativity, than it is to teach about materials and techniques. Adherents of this school contend that if an artist becomes too technically proficient something is lost in the creative process or the "free spirit" of the artist is tempered. The position taken in *The Craft of Drawing* is that when artists truly understand the possibilities and limitations of their materials and technical processes this information becomes a servant of, rather than a detriment to, concept and creativity. In sum, then, *The Craft of Drawing* has been designed to be a practical handbook for students of drawing during their academic training as well as later in their careers.

The Craft of Drawing is divided into five parts — The Drawing Surface, Drawing Materials and Techniques (Dry and Fluid), Drawing Aids, Innovative Drawing Processes, and Preservation and Presentation of Drawings. Although the book can be used in any sequence, the current organization leads the student from choice of paper through choice and use of particular media to preservation of drawings, the latter part of which includes a thorough discussion of portfolio development. Interspersed throughout are inserts of drawings by masters accompanied by discussions of the materials and techniques used in the works. Every attempt has been made to make the information presented here as current and accurate as possible, not only in traditional areas, but in such areas as using computers in the drawing process.

Most artists spend a lifetime developing a personal style and evolving the craft of their artwork. They view their careers as serious professions and take pride in the knowledge and experience they have acquired over the years. As the British artist Whistler said, an artwork when completed, whether executed in minutes or months, actually represents the experience of a lifetime. The artwork becomes the unique personification of the artist's life at a given moment.

Few artists create their artworks out of vanity or self-gratification; rather, they create out of a need to share their unique vision with the world. I hope *The Craft of Drawing* will be a useful tool for students in their artistic training and development.

Acknowledgments

I would like to thank the following people for assisting me with the preparation of this book: research assistants Spyros Karayiannis, Melanie Chartier, Richard Kryzcka, and Rick A. Pere; my colleagues at Southern Illinois University, Carbondale: Lawrence A. Bernstein, Patricia Beene Covington, Herbert L. Fink, Michael J. Youngblood, and John Yack, and editorial assistant Susan Wilson. I also acknowledge the contributions made to this book by my reviewers: Ralph Baker (University of Oregon), Frederick A. Horowitz (Washtenaw Community College), and John A. O'Connor (University of Florida). I also thank the staff at Harcourt Brace Jovanovich: editors Albert I. Richards and Julia Berrisford, manuscript editor Margie Rogers, production editor Lisa Doss, and production manager Lynne Bush. Special thanks go to art editor Susan Holtz and designer Cheryl Solheid for the excellent design and layout of the book.

Dan Wood

Contents

PART ONE

The Drawing Surface

1
Paper

A BRIEF HISTORY

Over the centuries, drawings have been created on a variety of surfaces. The first drawings were probably made when a prehistoric man or woman scratched marks in the dirt with a sharp stick. Ancient artists chipped out images with a stone on rock walls or scratched them into bone or antler. Later, the Egyptians chiseled their hieroglyphics into stone and also painted and drew on plaster-covered walls. The Greeks and Romans incised symbols into wax tablets with metal styluses. Artists of other civilizations painted on tree bark, animal skins, pottery, and fabrics (Fig. 1–1). Although most of these drawing surfaces were adequate, they all had practical limitations.

The first truly practical writing/drawing surface was papyrus, which was used in Egypt as early as 2400 B.C. (Fig. 1–2). Papyrus was prepared from the fibers of the papyrus water reed, a plant that grew in the Nile River delta. It was made by sandwiching crisscrossing layers of the plants' stalks together and hammering them until they were formed into a sheet of meshed fibers. Papyrus was somewhat similar to paper in character. In fact, the word *paper* is derived from *papyrus*.

Papyrus was used for more than forty centuries until it was eventually replaced by parchment, which was (and still is) made from the skins of young animals such as deer, cows, sheep, and goats. It is prepared by first removing the hair and flesh from the skin; then the skin is split, stretched over a frame, scraped, and allowed to dry. Finally, the skin is soaked in hot water and smoothed on both sides with a pumice stone. After drying, it is removed from the frame and is ready to use.

3

Paper similar to that used today was invented about A.D. 105 by a Chinese papermaker, Ts'ai Lun. He discovered that certain materials could be broken down into their individual fibers, processed, and reassembled into a flat sheet. He began his process by making a watery pulp from pieces of rag, mulberry bark, and old fishing nets. Then he dipped a rectangular screen into the pulp. When he removed the screen and held it in a horizontal position, the water drained through it and a flat sheet of fibrous pulp remained. Finally, the sheet was lifted from the frame, dried, bleached in the sun, and pressed.

The Chinese were able to keep their papermaking secret for nearly 700 years until invading Arab armies captured several Chinese papermakers and took them back to the Middle East. Paper was introduced to Europe when the Moors invaded Spain in the twelfth century. From there, the craft slowly spread throughout Europe, and from Europe to America, where the first paper mill was established in Philadelphia in 1690.

FIGURE 1-1
American Indian tribes used animal skins as a writing surface. Below is a Kiowa calendar for the period August 1889 to July 1892. Smithsonian Institution, Washington, D.C.

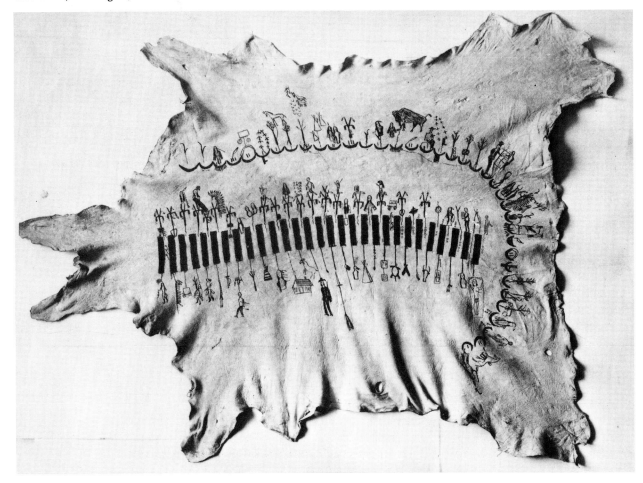

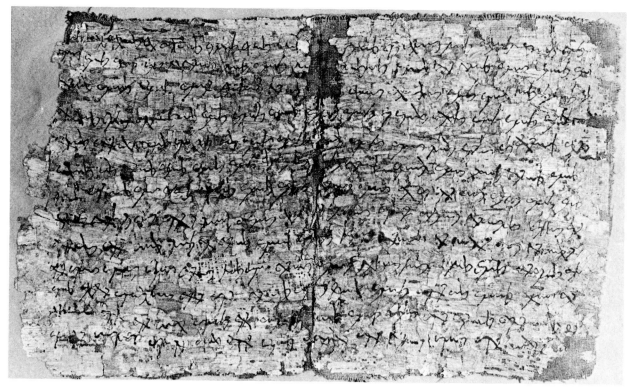

FIGURE 1–2
Papyrus used as a drawing surface.

HOW PAPER IS MADE

In essence, the papermaking process has changed little since it was discovered by the Chinese. Now, as then, paper is made by flowing a mixture of pulp and water onto a screen. When the screen is shaken lightly, the water drains away and a flat sheet of intertwining fibers remains.

Today, paper is made in one of three ways: it can be produced by hand, it can be formed on a mold, or it can be manufactured by a Fourdrinier machine.

Handmade Paper

From the time it was invented until the early 1800s, all paper was made by hand. Handmade papers are formed as individual sheets on a hand mold. The mold consists of two parts: a wooden frame that is covered with a mesh screen and an open wooden frame called a *deckle*.

The papermaking process begins when fibers, and sometimes other ingredients, are mixed into a pulp. After the pulp is prepared, the deckle frame is positioned on top of the screened frame and the entire mold is dipped into the mixture. The mold is then removed and placed in a horizontal position with the pulp resting on top of the screen (Fig. 1–3). The deckle frame curbs the pulp and determines the size of the sheet. (Sometimes a deckle frame is not used and the

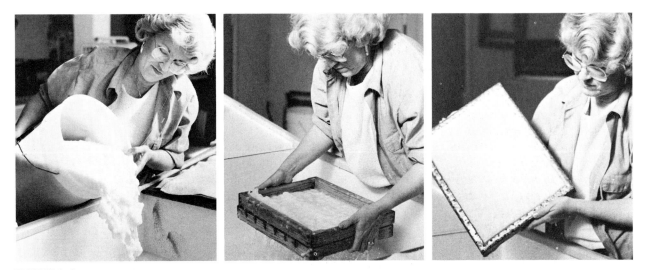

FIGURE 1-3
Three stages of papermaking: Cloth fibers are mixed into a pulp (left); pulp rests on top of a screened frame (center); and pulp spills over edges of frame creating deckled edges of paper.

pulp is allowed to spill over the edges of the frame to create a thin, fuzzy edge called a deckle (Fig. 1-4). The beauty of the four deckled edges is considered an aesthetic part of the handmade process.) The screen is lightly shaken to remove any excess water and to align the fibers. After the water has drained from the pulp, the deckle frame is removed and the screened frame is placed upside down on a flat causing the paper pulp to adhere to the felt. This process is called "couching." Sheets and felts are stacked and then placed under pressure to remove any excess water and to interlock the paper's fibers. Finally, the sheets are separated from the felts and are left to dry in the open air.

Handmade papers sometimes have a design called a *watermark* imprinted within each sheet (Fig. 1-5). The watermark is formed by sewing a thin wire

FIGURE 1-4
Deckled edges of paper.

bearing the maker's name or trademark into the mold. The wire causes the pulp to settle in a slightly thinner layer on the design, thus making the watermark slightly transparent. Although it is not always immediately visible, the watermark can most clearly be seen when the finished sheet is held up to a light.

Handmade papers have several advantages over other papers. Because they are made slowly, their fibers have more time to interlock during formation, thus producing a stronger, more durable paper. Also, since the mold is lightly shaken in several different directions during formation, the fibers disperse evenly to form a uniform paper with no distinct direction to its grain. This characteristic enables the paper to stretch equally in all directions when dampened and prevents buckling—a great advantage, for instance, when the paper is used with a liquid medium like watercolor or ink wash. In addition to their technical advantages, handmade papers usually are more attractive and interesting than other papers. In fact, many papermakers consider their product a work of art rather than a craft. Handmade papers are often thought of as an integral part of the finished artwork rather than as simply a surface to be covered with a drawing medium (Fig. 1–6).

FIGURE 1-5
Magnified view of a watermark on paper.

FIGURE 1-6
Patricia B. Covington, *Awl*
Clan Dancer, 1987. **Cast cotton,**
30″ × 32″. Collection of the artist.

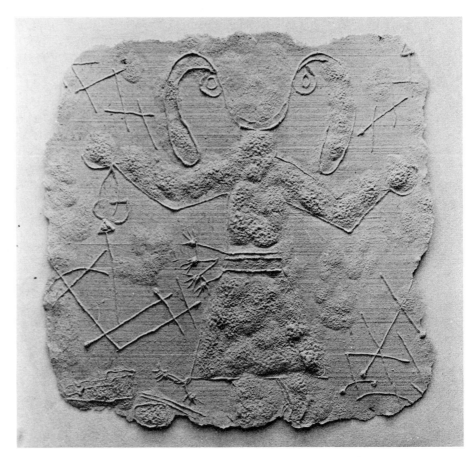

Moldmade Paper

Moldmade papers are made in the same general process used to produce hand-made papers. However, they are made on a small machine, and the sheets are formed by a rotating cylindrical mold instead of a hand mold (Fig. 1-7). As the mold rotates, pulp is gathered from a container beneath the cylinder and is then deposited as a long, flat sheet onto a felt conveyor belt. Some machines can produce only rolls of paper. Others have a thin wire sewn across the cylinder which perforates the paper so it can be separated into individual sheets.

A sheet of moldmade paper is identified by the two natural deckles that are formed by the outside edges of the cylindrical mold. In addition, some sheets have two "artificial" deckles that are formed when the individual sheets are separated from the wet paper roll. Most moldmade papers also have a watermark that is formed by a thin wire sewn into the mold.

Because they are produced slowly, moldmade papers have a consistent fiber formation that makes them quite strong. Although they have a slight grain direction, it is not pronounced.

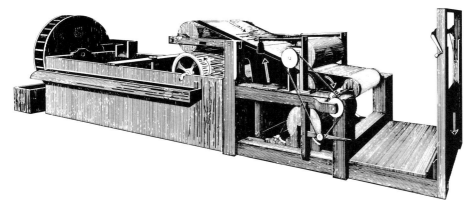

FIGURE 1-7
Diagram of a Gilpin paper machine. With this process, deckle-edged paper is produced.

Essentially, moldmade papers are used for the same purposes as handmade papers. Like handmade papers, they resist buckling and therefore are especially suitable for wash, watercolor, and printmaking techniques.

Machine-Made Paper

Today, almost all paper used for ordinary purposes is produced on a Fourdrinier machine. The process for making paper by machine can be generally described as follows. First, a liquid, fibrous pulp is prepared. Next, the watery pulp is spread onto a fine-screened, wire conveyor belt. As the conveyor rapidly rotates, the water is drained through the screen, and a continuous, flat sheet of interlocking fibers remains. The sheet then moves through a series of felts and heavy rollers that remove any remaining water. Then it passes through a series of heavy iron rollers that smooth its surface. Finally, the sheet is wound into a large roll and is ready to be processed further or cut into individual pieces (Fig. 1-8).

FIGURE 1-8
The enormous Fourdrinier machine is the primary way paper is manufactured today (right). At left, pulp is shown being spread on a wire conveyor belt of the Fourdrinier.

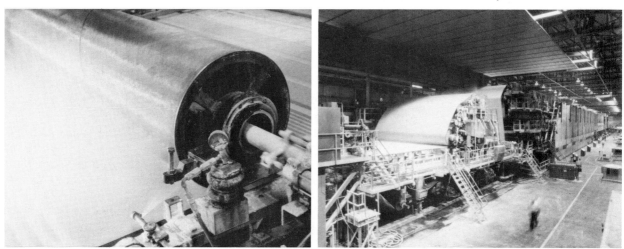

The main advantage of machine-made paper is that it can be produced quickly. Therefore, it is less expensive to manufacture than handmade or mold-made paper. Because it is mechanically produced, each individual sheet is consistent in its formation and appearance. Machine-made paper has a pronounced grain that is caused by the parallel alignment of the fibers as they are carried forward by the wire conveyor belt. The direction of the grain causes the paper to tear easily when it is torn along, or with, the grain. However, the sheet does not tear well when torn against the grain. In addition, the direction of the grain also causes the paper to buckle and stretch unevenly when it is dampened and used for wash or watercolor techniques.

Machine-made paper is adequate for most routine artwork, such as layouts, preliminary drawings, and sketching. Depending upon its fiber content and quality, it can also be used for more professional purposes.

TYPES OF PAPER

When seen under a microscope, paper appears as a mesh of long fibers that have been formed into a solid, flat sheet (Fig. 1–9). The fibers that are used to make paper can be obtained from a variety of raw materials, but most are derived from plants and trees (such as flax, hemp, cotton, and wood). The type of fibers that are used will determine the characteristics and quality of the resulting paper. For practical and economic reasons, artists' papers are most commonly made from cotton or wood fibers.

Cotton/Rag Paper

Rags have been used to make paper since it was invented by the Chinese. They continued to be the main source of fibers for papermaking until about 1860, when

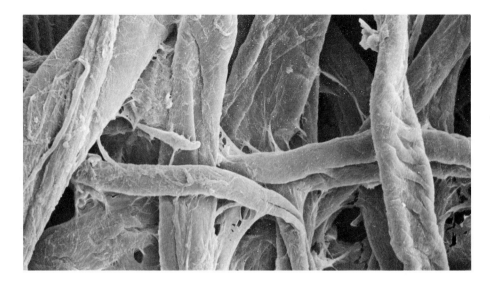

FIGURE 1–9
Paper viewed through an electron microscope.

various methods of wood pulping were introduced. Wood has since replaced rags as the main source of fiber for papermaking.

In papermaking, the terms *rag* and *cotton* are used almost synonymously to describe paper that is made solely from cotton fibers. These fibers are obtained from small, discarded pieces of new cotton fabric (rags) gathered from textile mills and garment factories, or from raw cotton.

Because cotton fibers are practically pure cellulose and generally inert, they are used to produce a high-quality paper that is essentially free of impurities and therefore more resistant to deterioration than most other papers. Pure cotton papers are among the finest artists' papers made. They are relatively permanent, strong, and durable, and have excellent working characteristics. (Examples of papers made from pure cotton fibers include: professional quality drawing, charcoal, watercolor, and printmaking papers.)

In addition to being made from 100 percent cotton fiber, papers are also often made from a combination of various percentages of cotton and wood fibers. These "rag content" papers usually contain 20- 50- or 75 percent cotton fibers. As the percentage of cotton fiber is reduced so is the quality and permanence of the paper.

Wood Fiber Paper

Wood fibers are usually prepared for use in paper manufacturing in one of two ways, either mechanically or chemically (Fig. 1–10). In the first process, wood logs or chips are ground into a pulp. The resulting pulp contains not only the wood fibers but also lignin (the material that originally held the fibers together). Lignin is highly acidic and contains many impurities that cause paper to rapidly discolor and deteriorate. Groundwood papers are inexpensive to produce and

FIGURE 1–10
Wood fibers viewed through an electron microscope.

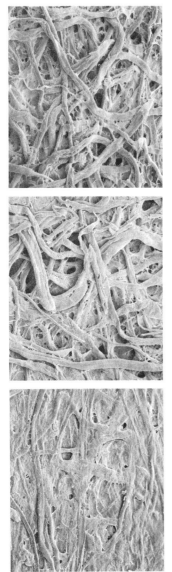

FIGURE 1-11
Views through an electron microscope of three different finishes to a paper surface: rough (top); medium (center); and smooth (bottom).

therefore are quite practical for limited purposes. (Examples of papers made from groundwood fibers include newsprint, construction paper, and common cardboard.)

In the second process, wood chips are treated chemically to separate and remove the lignin from the cellulose fibers. Removing the lignin results in a purer fiber pulp and subsequently a better quality paper. Although these papers do not deteriorate as rapidly as groundwood pulp papers, some chemicals used in the papermaking process can cause the paper to gradually discolor and deteriorate. While they are suitable for many purposes, these papers are usually inferior in quality to cotton content or pure cotton papers. (Examples of papers made from chemically processed wood fibers include most drawing tablets, common illustration and mat board, layout paper, and nonprofessional watercolor paper.)

GLOSSARY OF PAPER TERMS

The following glossary includes terms that are commonly used by paper manufacturers, retailers, and artists when discussing paper. Know and use these terms when selecting and purchasing paper for artistic uses.

Acid-free papers refers to papers that are essentially free of acids. Acids can cause paper to deteriorate (that is, it becomes discolored, brittle, and loses its strength). Acid-free papers are one of the most permanent of all artists' papers.

Deckle the thin fuzzy edge that is created on a sheet of paper during the formation process. A sheet of handmade paper characteristically has four deckles while a sheet of moldmade paper has two.

Finish refers to the nature of the surface. The finish is applied to the paper after it has been formed. Although there are numerous finishes, they can generally be grouped into three categories: smooth, rough, and medium (Fig. 1–11).

 rough This type of finish is the opposite of a smooth finish. It is characterized by an uneven surface texture that is covered with projections, points, ridges, or bumps. (This surface is well suited for abrasive media such as charcoal, pastel, and conté crayon.)

 medium This type of finish is also called cold press. It refers to papers that are grouped between the smooth and rough categories. These papers have a slight but not pronounced texture. (This surface can be used with a variety of artists' media such as charcoal, graphite, conté crayon, ink, and wash.)

 smooth This type of finish is also called hot press, plate, or high finish. Theoretically, the surface is similar to a piece of smooth glass. In comparison to other finishes, a plate finish is rather nonporous and nonabsorbent. (This surface is very receptive to artists' media such as pen and ink, technical pens, and nylon-pointed markers.)

Formation refers to the type of fibers that are used to make the paper and to the way they are aligned or arranged within the body of the sheet.

Grain refers to the direction in which the paper's fibers are aligned during the formation process. Handmade papers have no distinct grain direction, while moldmade papers have a slight grain direction. Machine-made papers usually have a distinct grain direction that runs parallel to one side of the sheet.

Ply refers to the thickness of a single sheet of paper. Single sheets of paper can be glued or bonded together to produce a thicker sheet or board. For example, a paper can be made in 2-, 3-, 4-, or 5-ply thicknesses.

Sizing refers to ingredients that are added to the paper to make it more water-resistant. Common sizings include rosin and wax. Papers with large amounts of sizing are often called "hard papers."

Surface refers to the exterior faces of the paper rather than its body. An artist works directly on the top or bottom face, or surface, of the paper.

Tooth refers to a rough or medium-rough textured surface on the face of the paper. It can result from the arrangement of the fibers during formation. However, more frequently it is a type of finish applied after formation. The tooth occurs as peaks and valleys that actually wear away or "bite" the medium as it is drawn across the paper.

Watermark a design with the maker's name or trademark imprinted within the sheet of paper. It is formed by a fine wire sewed into the mold, which causes the pulp to settle in a slightly thinner layer on the design during the formation process. In some instances, the watermark is simply an embossed logo or manufacturer's trademark stamped into a corner of the finished sheet (Fig. 1–12).

FIGURE 1–12
Watermarks on finished sheets of paper.

Wire side and felt side These terms apply primarily to machine-made papers. The wire side (or "wrong" side) is the side of the sheet that was in contact with the wire screen during the manufacturing process. The felt side is the side of the sheet that was above, or not in contact with, the screen. Generally, artists create their artworks on the felt side (or "right side") of the sheet. On some papers the two sides are distinctly different. On others the two sides are similar, and the artwork can be created on either side. If an artist needs to know which side is which, many papers have a watermark imprinted into the sheet which can be correctly read from the felt side.

COMMONLY USED ARTISTS' PAPERS

A complete list of the types of paper produced today is beyond the scope of this book. However, the following list includes those papers that artists most commonly use (Fig. 1–13). For more specific information concerning the types and uses of paper, consult *The Dictionary of Paper*, an excellent reference book, published under the auspices of the American Paper and Pulp Association.

Newsprint paper on which newspapers are commonly printed. Because it is so inexpensive, artists often use it for rough sketches and layouts. Newsprint is made from wood fiber pulp and is available in individual sheets or pads in either a smooth or rough texture. It turns yellow and deteriorates rapidly because it is highly acidic.

FIGURE 1–13
Common types of paper used by artists.

Drawing paper is a generic term for any paper used for general drawing purposes. There are many types of drawing papers, and they vary considerably in such characteristics as formation, surface texture, and finish. Drawing papers are usually made either from wood or cotton fiber pulp or from a combination of the two.

Rag paper made from pure cotton fibers, usually obtained from reprocessed cotton cuttings. Rag paper is available in a variety of surface textures, finishes, colors, and weights. It can be purchased in individual sheets, pads, or rolls. Generally, these papers are made with acid-free ingredients and are relatively permanent. They also are one of the most expensive of all artists' papers.

Charcoal paper made to be used with charcoal sticks or charcoal pencils. It has a rough surface texture, or tooth, that is designed to abrade and hold the charcoal particles onto the paper. Charcoal paper is available in assorted textures and colors.

Pastel paper most appropriate for pastels or crayons. Its characteristics are basically the same as charcoal paper, and in fact the two terms are often used interchangeably. Like charcoal paper, pastel paper is made in an assortment of textures and colors.

Watercolor paper used with watercolor or ink washes. It is made in a variety of thicknesses, or plys, and is characterized by a rough medium-rough surface texture. The best watercolor paper is handmade from cotton fibers and has a consistent fiber formation with no distinct grain.

Construction paper a low-grade, inexpensive paper that is manufactured from wood fiber pulp. It is available in an assortment of colors and is usually used with crayons, pastels, and common tempera paint. Its high acid content causes fading and rapid deterioration and it is therefore not recommended for professional use.

Parchment paper a heavy, hard paper made with a surface texture and color that resembles real vellum (skin of a young cow, sheep, or goat prepared especially for writing). Frequently, it is used to create an "antique" or professional appearance in manuscripts such as diplomas or documents.

Board single sheets of paper glued or bonded together. A board's thickness is measured in plys, with each ply representing a single sheet of paper. For example, a board can be made in 4-, 5-, 6-, 7-, or 8-ply thickness. Like paper, boards are made in an assortment of types that vary considerably in their quality and characteristics:

 Bristol board actually a heavyweight paper rather than a board. It is available in 2, 3, 4, or 5 plys. It is a commonly used drawing surface for pen and ink and graphite pencil. Bristol board can be erased repeatedly without damaging its surface.

 Illustration board usually made by gluing a high-quality drawing paper on one or both sides of a central core made of wood fiber pulp. However, it can

also be made from plys of pure cotton fiber. As its name implies, illustration board is used for drawing and illustration purposes with most standard drawing media.

Poster board a stiff board that is generally made in a 6- or 8-ply thickness. The front side is usually white or any one of an assortment of colors, while the backing is made from wood fiber pulp. Poster board can be used with most standard drawing media.

Watercolor board made by mounting a sheet of watercolor paper onto a cardboard backing. Commercial artists often use it because the backing provides a firm, flat working surface that does not buckle and that is easy to handle.

Foam core board made by gluing wood fiber papers on the front and back sides of an inert, plastic-foam central core. It is an extremely lightweight board that is both rigid and durable. Frequently, a special type of acid-free foam core board is used as a mounting or backing surface for displaying artworks.

Mat board used to mount and mat artwork for display purposes. Standard mat board is available in assorted colors and textures. It is made by gluing a paper facing over a cardboard core. Also, more ornamental varieties are available with decorative facings made from materials such as cork, fabrics, or metalic foil. Usually, standard mat board is made from wood fiber pulp which is highly acidic. Therefore, it should not be used to display artwork whose permanence is important.

Museum board used to mount and mat artwork for display purposes. It is used when conservation of the artwork is important. Museum board is pH-neutral and does not contain chemicals that will damage the artwork or cause deterioration. It is available in a wide range ot tones and pastel colors.

PART TWO

Drawing Materials and Techniques: Dry Media

2
Charcoal

Charcoal is one of the oldest and most basic of all drawing materials. It is a popular drawing medium that, in essence, has changed little since it was first discovered — probably when someone in prehistoric times picked up a charred stick from a spent campfire and used it to make a mark.

STICK CHARCOAL

Stick charcoal (Fig. 2–1) is made by placing thin branches of wood in a vacuum-sealed chamber, a kiln, and heating them until they are reduced to carbon. The type of wood that is used determines both the quality of the medium and its hardness. In general, the longer the sticks are heated, the softer the charcoal

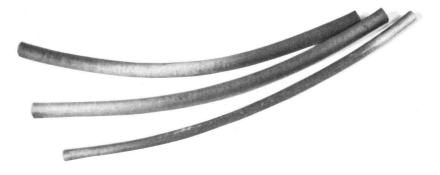

FIGURE 2–1
Stick charcoal.

FIGURE 2-2
Willow charcoal.

becomes. Stick charcoal is manufactured in various thicknesses and in a range of hardness: soft, medium, and hard.

The best stick charcoal is made from the thin branches of the English willow tree. In appearance, willow charcoal sticks are slightly crooked with small, scarred nubs located where branches once projected from their sides. Also, they contain a central core that is considerably darker than the rest of the stick (Fig. 2–2). Willow charcoal is a naturally pure carbon that is free from resins and impurities. It produces a warm gray mark. Willow charcoal is classified according to the thickness or diameter of the stick (thin, medium, and thick) rather than by hardness, since all willow charcoal has nearly the same consistency and hardness.

Some manufacturers also make stick charcoal from thin dowels of wood such as pine and maple. While these sticks are adequate for many drawing purposes, they are not of the same high quality as willow charcoal.

Many manufacturers, artists, and authors incorrectly use the name ''vine charcoal'' when referring to stick or willow charcoal. Actually, as the term implies, vine charcoal describes charcoal that is made from grape or berry vines. This misnomer may have begun when berry vines were sometimes used to make charcoal when willow branches were not available.

Because it is virtually pure carbon, stick charcoal is rather friable (brittle). It tends to break and splinter easily. In fact, when seen under a microscope, charcoal particles actually appear as sharply splintered bits of carbon rather than as rounded granules. Because it is so friable, stick charcoal does not adhere well to smooth, hard, drawing surfaces. For best results, it should be used on softer

FIGURE 2–3
Electron micrograph of a
charcoal mark on charcoal paper.

papers with a slightly rough texture or on specially prepared charcoal papers with a raised "tooth" that is designed to abrade and hold the charcoal particles onto their surfaces (Fig. 2–3).

Artists frequently use stick charcoal for quick sketches and layouts, although they can also use it for more developed drawings. The medium is particularly suitable for sketching because it is so easy to manipulate and erase. The stick can be held so its tip is used to draw thin lines. Or, it can be flipped on its side and used to draw broad, dark areas of value. Darker areas of value also can be formed with the tip of the charcoal by building layers of lines with a hatching or crosshatching technique. For finer, more detailed work, the charcoal's tip can be sharpened with a sandpaper block.

Stick charcoal can be blended easily with your fingers, paper stomps, cotton swabs, or a folded paper towel. The medium offers an additional advantage in that large areas of charcoal can be wiped away quickly and easily with a small chamois or erased with a kneaded eraser. Because it is so erasable, the medium can be reworked repeatedly. In fact, when working with stick charcoal, many artists use the eraser as a drawing tool. They lay down the darker areas of charcoal first and then use a kneaded eraser to "pull out" highlights and lighter areas of the drawing.

Stick charcoal has several disadvantages. It is rather dirty and messy to use. You can smear or "wipe out" entire areas with an accidental brush of your hand. Also, the medium produces a slightly lighter range of values when compared to compressed charcoal or conté crayon.

Stick charcoal will smear and fall from the paper's surface unless it is sprayed with a fixative. A fixative is a solution that is used to bind and seal the

Käthe Kollwitz

Käthe Kollwitz (1867–1945) was born in Konigsberg, East Prussia. She exhibited exceptional artistic ability as a youth and later studied art in Berlin and Munich. Throughout her life she was involved in social issues, many of which later became the subject of her artwork. Kollwitz is best known for her work in the area of printmaking, although she also worked in sculpture. Most of her drawings were made as preliminary studies for prints or sculpture, and a significant number of these studies were executed in stick charcoal.

Kollwitz drew many self-portraits during her career. One in particular, completed about 1935, presents a curious contradiction.

Although titled *Self Portrait — Pencil in Hand* (Fig. 2–4), the work is executed in stick charcoal, Kollwitz's favorite drawing medium.

The portrait presents yet another contradiction in its execution: the artist has used two radically different drawing approaches in the same work. Kollwitz used the charcoal stick in a traditional, almost academic approach to draw the dominant features of her self-portrait. In essence, the portrait is a line drawing that has been fortified with modeling effects. Kollwitz established an interaction between the two most important aspects of the drawing—the face and the hand—by depicting both with a

similar drawing technique in which she used the sharpened tip of the stick to create the dark lines and values that articulate and emphasize her facial features. Similarly, she used the charcoal stick in the same approach, but with a lighter touch, to depict and emphasize her suspended hand holding the drawing medium.

In complete opposition to Kollwitz's traditional drawing approach is the bold, assertive line that she scrawled across the page with the broad side of the charcoal stick. The mark is not unlike those that would be used by the abstract expressionists 20 years later. It emanates from the artist's hovering hand and functions both as a descriptive and abstract visual element that directs our attention to the very essence of this self-portrait. The portrait is a drawing about the very act of drawing.

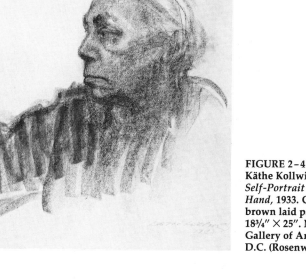

FIGURE 2–4
Käthe Kollwitz,
Self-Portrait — Pencil in Hand, 1933. Charcoal on brown laid paper, 18¾″ × 25″. National Gallery of Art, Washington, D.C. (Rosenwald Collection).

carbon particles to the paper. Fixatives are available in workable or permanent varieties. Workable fixatives are semipermanent. Even after a drawing has been sprayed with a semipermanent fixative it can be erased and reworked. Drawings sprayed with permanent fixatives cannot be erased and are subsequently difficult to rework. When making more developed charcoal drawings, artists sometimes work in stages, building one layer over another. Frequently, they use a workable spray fixative to isolate the first layer before the next layer is drawn over it. Drawings should be sprayed with several light coats of fixative rather than with one thick coat. This method prevents the carbon particles from spreading and forming distortions such as puddles and streaks. Generally, when charcoal drawings are sprayed with a fixative they will darken slightly. Many fixatives contain acidic chemicals that will eventually cause paper to deteriorate. They should be used sparingly and with caution. Also, fixatives often contain toxic chemicals and therefore should be used in a well-ventilated area.

COMPRESSED CHARCOAL

Compressed charcoal (Fig. 2–5) is made by mixing powdered charcoal with a clay binder and then compressing the mixture into small cylindrical or rectangular sticks (Fig. 2–6). Sometimes a small amount of graphite is added to the mixture as a lubricant. The more carbon the mixture contains the softer the stick and the

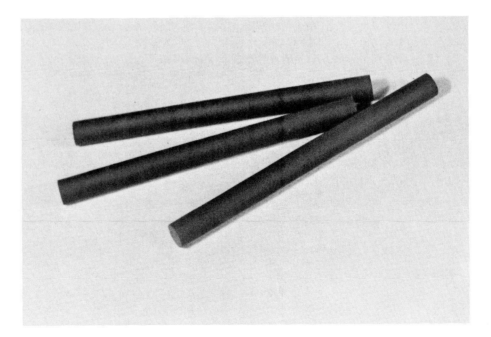

FIGURE 2–5
Compressed charcoal.

darker its mark. Compressed charcoal sticks are manufactured in the following range of hardness: 00 (the softest and darkest), 0, 1, 2, 3, 4, and 5 (the hardest and lightest).

Compressed charcoal sticks are slightly different than stick charcoal. They are less brittle and therefore more durable. Also, they make a denser, darker mark and thus produce a wider, darker range of values. Although compressed charcoal is easier to blend, it is more difficult to erase than stick charcoal. Compressed charcoal sticks can be manipulated and used with most of the same techniques that are used to draw with stick charcoal.

The procedures for using spray fixatives with stick charcoal discussed on pages 20 and 22 also apply to compressed charcoal.

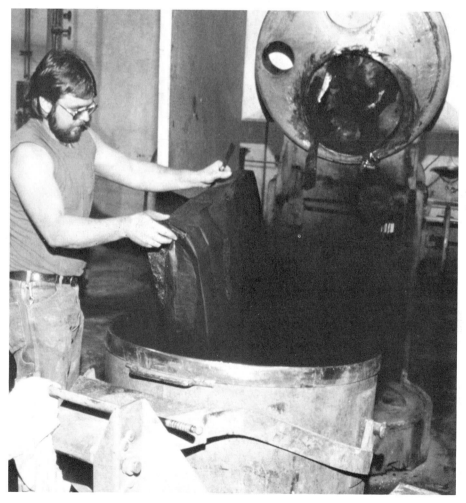

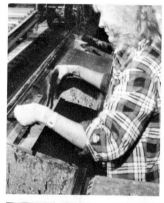

FIGURE 2-6
Procedures for making compressed charcoal include: mixing ingredients (left); extruding rectangular strips of charcoal (upper right); and placing sticks on trays for drying (lower right).

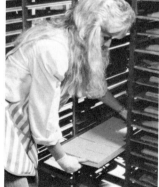

Spyros Karayiannis

Spyros Karayiannis (b. 1954) was born in Greece but immigrated to the United States when he was 14 years old. He frequently incorporates innovative combinations of collage, transfers, photography, and xerography in his drawings and paintings.

The human condition is a dominant theme in much of Karayiannis's artwork. As an artist, he is interested in the nonverbal interactions that can occur between individuals. His works are contemplative and introspective, often dealing with themes of personal alienation and isolation.

Karayiannis derives his subject matter from his own black-and-white still photographs which themselves are often influenced by the aesthetics of European filmmakers of the 1960s. Like a movie director, the artist poses his models and asks them to act out situations. At this time, he directs the interaction between the participants, encouraging them to focus on a limited range of emotions while he closely observes their spatial distancing, physical gestures, and facial expressions. Karayiannis does not film his characters while they are acting. Rather, he shoots the photos in sequential, but individual frames. The photographs are taken from different viewpoints. As a result of their sequencing, the artist sometimes uses them to develop a series of artwork, rather than just one piece.

Karayiannis drew *Reconciliation* (Fig. 2–7) in compressed charcoal using a photographic image as the basis for its subject matter. Like much of the artist's work, it depicts a "frozen" moment. Two figures, about to engage in an act of reconciliation, stand in an expanse of space. The space is nonreferential, intentionally left empty to focus the viewer's attention on the interaction about to occur between the figures. A sense of timelessness pervades the drawing. There are no natural or cultural references with which the viewer can identify. The space is truly a void, but one that is consciously structured by the artist.

Karayiannis executed his drawing on smooth surfaced, acid-free tracing paper. This is a thin, yet durable paper that accepts most drawing media, as well as repeated erasures. He first applied drafting tape along the paper's edge to establish the drawing's borders and to adhere it to a supporting surface. He also used a piece of drafting tape to establish the horizon line that separates the ground plane from the upper area of the drawing. Later, he blurred the sharpness of this line by rubbing it with his fingertips.

Karayiannis considers the way he constructed the spatial atmosphere of *Reconciliation* to be an important aspect of his drawing technique. He formed this area by applying the charcoal stick with sweeping, arced movements until a medium-dark value was established. Then, employing the same motions, he used a medium-soft stick eraser to blend, blur, and accent the charcoal lines. He later darkened the upper areas of the drawing by applying the medium with similar motions but with more pressure. During the working process, interesting textural effects were created as the dark charcoal lines were ingrained into the paper's surface and as the eraser abraded the paper's tooth. In addition, certain accidental effects that occurred as the artist drew were allowed to remain as part of the aesthetics of the working process.

Once he established the spatial atmosphere of the drawing, Karayiannis prepared mock cutouts of the figures and temporarily adhered them to the drawing's surface to determine their value relationships before laying down the ground plane.

The artist created the ground plane by lightly applying the charcoal with the side of the stick so no visible marks were apparent. He then carefully blended the medium with his fingertips and, once again, used the stick eraser like a paper stomp to blend and lighten the medium.

Finally, Karayiannis lightly drew the figures on the ground plane with graphite pencil guidelines, using his photograph as a reference. Then, before completing the figures with a compressed charcoal stick, he predetermined the value relationships, first establishing the white areas and then carefully drawing from light to dark. Since the figures are only several inches high, the more detailed areas were drawn with the tip of a small paper

stomp which was "dabbed" in pulverized charcoal prepared from the stick. Where necessary, intricate details were picked and "carved" from the drawing with a fine pointed kneaded eraser.

Karayiannis does not spray his finished drawings with a fixative, but, instead, frames them under glass with protective mats to keep the media from touching the glass.

FIGURE 2-7
Spyros Karayiannis,
Reconciliation, **1984.**
Charcoal on paper,
19″ × 25″. Collection of
Precision Assembly Corp.,
St. Louis.

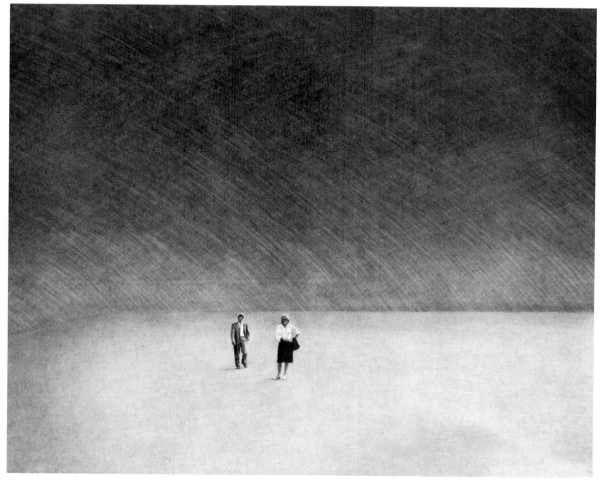

CHARCOAL PENCILS

Charcoal pencils (Fig. 2–8) are made by covering thin rods of compressed charcoal with paper or wood encasements that are peeled or cut away as the charcoal wears down. They are manufactured in a range of hardness: extra soft (6B), soft (4B), medium (2B), and hard (HB). The softer grades should be sharpened with care, as their points break easily.

The main advantages of charcoal pencils are that they are clean and convenient to use. However, they are not as flexible or as versatile as stick and

FIGURE 2–8
Carbon and charcoal pencils.

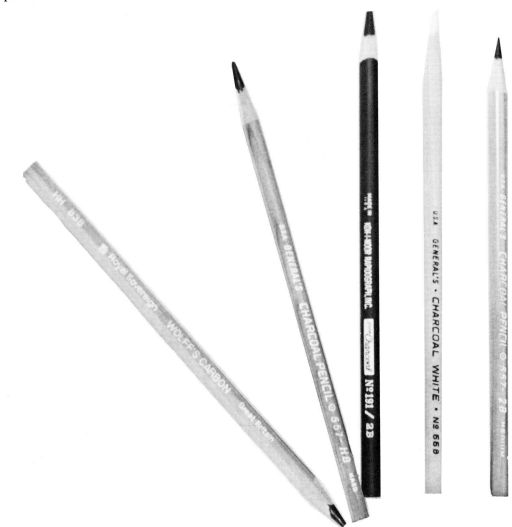

Jasper Johns

Jasper Johns's *Study for Skin I* (Fig. 2–9) is one of a series of four artworks executed in charcoal. This group of drawings was made in preparation for a proposed sculpture that was never completed.

In preparation for the sculpture, Johns (b. 1930) had planned to cast a head in a solid material and then cover the cast with a thin rubber skin. He would then have cut the skin from the cast and spread it flat to resemble a topographical Mercator (navigators') map. Later, Johns planned to cast this flat "map of skin" in bronze. Johns created these four studies to help him better understand how the skin would appear when it was cut from the cast and positioned on a flat surface.

The artist created his artwork by rubbing oil on his hands and face and pressing them to the surface of the paper to make a literal imprint. He then rubbed over these impressions with the broad side of a charcoal stick to form a pale, ghostlike image.

Critics have frequently noted that artists express the uniqueness of their personalities by the marks they make. Often these marks become as identifiable as personal signatures. Johns would have us take this idea one step further: his drawing is literally an imprinted "autograph." The impressions of his hands and face are as individual and fresh as the footprints of a newborn child on a birth certificate. Yet, they are as universal and

timeless as the handprints left on cave walls by prehistoric artists over 15,000 years ago.

Ironically, in contrast to the personal quality of his images, Johns has framed the artwork in a cold, mechanical format reminiscent of an engineering blueprint. When seen in conjunction with the statistics in the boxes in the lower right-hand corner of the drawing, this format underscores the preparatory nature of these sculptural studies.

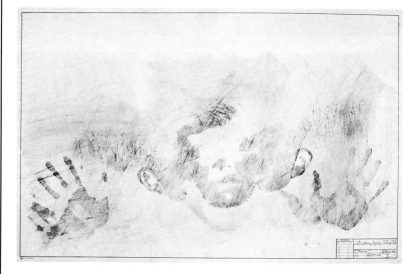

**FIGURE 2–9
Jasper Johns,
Study for Skin I, 1962.
Charcoal on paper,
22″ × 34″. Collection of the
artist.**

compressed charcoal, since generally only their tips are used when drawing. Artists use charcoal pencils primarily when making smaller linear drawings or when developing detailed areas within a larger drawing.

CARBON PENCILS

Carbon pencils (Fig. 2–8) are a variant of charcoal pencils. In essence, they are made like charcoal pencils, but their "leads" contain slightly different ingredients. Carbon black (made from charred animal bones) is added to the carbon, clay, and graphite mixture. The carbon black enables the carbon pencil to make a slightly darker mark than the standard charcoal pencil. Carbon pencils also are made in a wider range of hardness than charcoal pencils: the range is BBB (softest and darkest), BB, B, HB, H, and HH (hardest and lightest). Carbon pencils bridge the gap between charcoal pencils and graphite pencils.

POWDERED CHARCOAL

Powdered charcoal is manufactured by grinding charred wood into a fine powder. The powder's darkness is determined by the type of wood that is charred. It can also be made by pulverising compressed charcoal sticks into a powder.

Artists use powdered charcoal in various ways. For example, they can apply it to a drawing with their fingers or a paper stomp to blend. Or they can cover an entire page with powdered charcoal to establish a rather dark working surface. Then proceeding from dark to light, they can use a kneaded eraser to establish the light areas of the drawing and compressed charcoal to further reinforce the dark areas of the drawing.

The types of charcoal just discussed can be used together in a single drawing. However, each has unique visual characteristics such as density, darkness, or reflectivity. Therefore, when using them together you should be sure that they are visually compatible. For example, you may develop a large drawing using a compressed charcoal stick and later add details using a charcoal pencil only to find that the two media do not "look right" together.

Artists also use charcoal in combination with other drawing media, such as pastel, conté crayon, or pencil because it erases so easily. They also use it to make tentative studies and layouts that they then develop with a more permanent medium, such as ink or conté crayon. In addition, artists sometimes use charcoal directly on canvas to make preliminary studies for paintings. Although charcoal is a traditional medium, certain contemporary artists have found unique and innovative ways to use it.

3
Chalk, Pastel, and Crayon

There is often confusion in the way the terms *chalk, pastel,* and *crayon* are used by artists. This confusion began centuries ago. For example, the French used the word *crayon (craion)* to describe the structure or shape of a drawing instrument rather than its composition or ingredients. Thus, the word *crayon* was used to describe drawing instruments as diverse as chalk, pastel, graphite pencil, and metal stylus.

Today, it is still difficult to accurately define these terms. In fact, Webster's Dictionary defines a crayon as a "small stick of chalk, charcoal, or colored wax used for drawing, coloring, or writing." The problem is complicated even further by the recent introduction of new materials that are similar to, and sometimes mistaken for, chalk, pastel, or crayon. In addition, artists' materials currently are made with such various combinations of natural and synthetic ingredients that exact classification is often difficult.

Although chalk, pastel, and crayon are somewhat similar in nature, they are individually distinct. To avoid confusion, we will describe and discuss each material separately.

These materials can be conveniently grouped and generally described as follows: *Natural chalks* were thin drawing/coloring sticks that were made from natural earth substances. These substances were mined and shaped into drawing tools that were used directly for drawing. Today, quality natural chalks are not commercially available. Therefore, they are seldom used by contemporary artists. *Pastels* are thin drawing/coloring sticks that are formed by hand or by mechanical

processes. They generally are made by mixing dry powdered pigments, inert materials, and a water-soluble gum binder. *Crayons* are thin drawing/coloring sticks that are also formed by hand or by mechanical processes. They are made by mixing dry powdered pigments, inert materials, and an oily or waxy binder.

NATURAL CHALK

Since prehistoric times, artists have used natural earth substances to create drawings and paintings (Fig. 3–1 and Plate 1). Early artists dug chunks of colored earth from the ground and fashioned them into crude drawing tools or pulverized and mixed them with animal fat or natural gums to form primitive paints. Over the centuries, as they experimented with various natural substances, artists eventually learned which materials worked best and where they could be found.

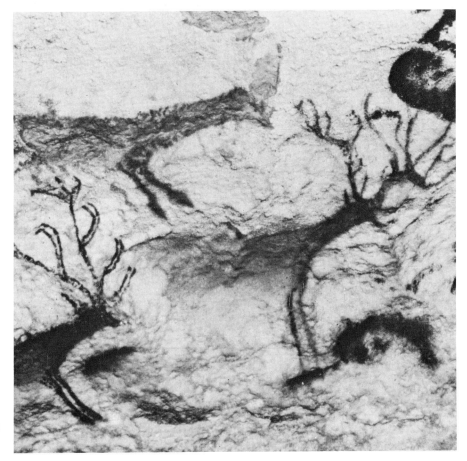

FIGURE 3–1
Hall of Bulls, c. 15,000–13,000 B.C. Caves of Lascaux, Dordogne, France.

During the Renaissance, a number of artists began to use thin sticks of soft, colored rock as drawing tools. The raw materials used to make these "drawing stones" were derived from special deposits of richly pigmented earth. These deposits were of such outstanding natural color and quality that slabs of the materials could be taken from the mines and simply cut and shaped into sticks that were used directly for drawing.

The color (or value) of the sticks was determined by the type of minerals located in the deposits. The most common "colors" were black (derived from a shale composed of carbon and clay), red (derived from a red iron ore called hematite), and white (derived from calcite chalk or talc). Occasionally, deposits of gray, yellow, and brown were also available.

As a group, these materials came to be known as "natural chalks" (Fig. 3–2). However, this term is somewhat of a misnomer since only the white sticks were actually made from chalk.

The characteristics of natural chalks varied according to the deposits from which they were mined. The best chalks were made from substances, free from impurities, that produced a mark of consistent color and quality. Also, the chalks had to be durable enough so that they would not crumble, yet soft enough to leave a dense, dark mark on the paper. In general, red and black natural chalks were slightly harder and more brittle than their contemporary counterparts while white natural chalks were similar to today's white pastels.

Since natural chalks were rather firm, artists used them on the same papers that they used for charcoal or ink drawings. These papers had a slight, but not pronounced, tooth. It was not until the eighteenth century that specially prepared papers with a textured surface were introduced for use with the softer fabricated chalks. Occasionally, artists tinted their papers in soft colors, such as blue, pink, tan, or gray, to make them more visually compatible with the chalks.

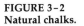

FIGURE 3–2
Natural chalks.

Michelangelo Buonarroti

Michelangelo Buonarroti (1475–1564) is considered one of the greatest artists of all time. His most famous masterpieces were in the media of painting, sculpture, and architecture. However, he was also a master draftsman.

During the Renaissance, drawing was considered the foundation for all other artforms. Michelangelo created hundreds of drawings during his lifetime. He intended some of these drawings to be autonomous artworks, devoid of association with his paintings or sculpture. In fact, he even presented several of these artworks as gifts to close friends. Michelangelo also created many drawings that were done as preparatory studies for painting or sculpture. His drawing *Studies for the Libyan Sibyl* (Fig. 3–3 and Plate 2) is such an example.

This study, like many of Michelangelo's drawings, is executed in red chalk (sanguine). The artist's facility with this medium is demonstrated in the forceful lines he used to quickly and assuredly delineate the figure, as well as in the soft chiaroscuro (a modeling technique in which light and dark values are systematically applied to create an illusion of volume) modeling effects that reinforce his basic line drawing and reveal its muscle structure. Here,

Michelangelo delicately blends the chalk in an almost sensuous fashion to create the rippling play of dark and light across his model.

Interestingly, Michelangelo drew his study from a nude male model. However, when he transferred the figure to its final position in a niche of the Sistine Chapel ceiling, it was transformed and reappeared as a clothed female figure.

FIGURE 3–3
Michelangelo Buonarroti,
Studies for the Libyan Sibyl.
Natural red chalk, 18⅜″ × 8⅜″.
The Metropolitan Museum of
Art, New York (Purchase, 1924,
Joseph Pulitzer Bequest).

Artists used natural chalks for various purposes. Frequently, they used natural black chalks to make light layouts for drawings that subsequently were developed in another medium, such as ink or charcoal. In addition, they used both black and red chalks to make elaborately modeled preparatory drawings that served as studies for more developed artwork, such as frescoes or oil paintings. Sometimes, artists combined black, red, and white chalk in a single drawing. For example, when drawing a portrait, they established the main features in black chalk. Then they drew the hair and beard by intermixing thin strokes of black and red chalk. Finally, they formed the lighter accents and highlights with white chalk. Occasionally, artists developed their portraits even further by using additional colors of chalk and delicate modeling techniques on tinted papers.

Natural chalks were used for about 400 years. Their popularity began to decline in the late eighteenth century as their quality deteriorated. They were eventually replaced by handmade or manufactured pastels.

PASTELS

Pastels were introduced early in the sixteenth century and gradually replaced natural chalks as a favorite drawing medium (Fig. 3–4). They became especially popular during the nineteenth century and are still used by many contemporary artists.

FIGURE 3–4
Pastel sticks.

Antoine Watteau

The French artist Antoine Watteau (1684–1721) lived a short life; he died of consumption at the age of 37. Nonetheless, in an artistic career that lasted just over a decade, he achieved immortality as both a draftsman and a painter.

Like so many artists of his time, Watteau often made drawings that served as preparatory studies for his paintings. In fact, he sometimes incorporated the same study into more than one painting. In addition, Watteau executed a considerable number of independent drawings that he assembled in notebooks for future reference as potential subject matter for paintings.

Although there are exceptions, Watteau created most of his drawings from life rather than from his imagination. Characteristically, Watteau executed many of his drawings as isolated studies of individual images, or of several independent, sometimes nonrelated, images placed on a page without reference to their position in space. In some of Watteau's drawings, the images appear to float in an ill-defined space.

Watteau's favorite drawing medium was red chalk, usually of a crimson hue, but occasionally of a more reddish-brown color. He executed many of his most important drawings using a drawing technique in which he combined red, black, and white chalk in a single drawing. This method became known as the "trois craion" (three crayon) technique. In this technique, Watteau usually created his initial drawing in red and black chalk and then added white to achieve brilliant highlights, although in certain instances the white was laid down before the red and black areas of the drawing were established.

Watteau frequently drew on cream-colored chamois paper. He occasionally used his moistened fingertips to blend red and white chalk together to create the sensual flesh tones of his drawings. In addition, he often applied his chalks in individual strokes and hatchlines without intermixing or blending. It is this technique that creates the fresh, shimmering color effects that are so characteristic of Watteau's drawings (Fig. 3–5 and Plate 3).

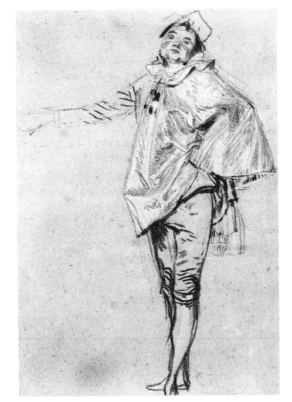

FIGURE 3–5
Jean Antoine Watteau, *Man Standing.* **Black, red and white chalk on gray-brown paper, 10¹¹/₁₆″ × 7⁷/₁₆″. Museum Boymans-van Beuningen, Rotterdam.**

Early pastels were made by mixing powdered pigments with a water-soluble binder, such as milk, beer, honey, or glue. Sometimes, ingredients such as clay or chalk were also added to extend the mixture. Initially, artists experimented with different formulas to determine the best combinations and proportions of ingredients. When they had determined the right formula, they mixed the ingredients into a paste that was rolled into small cylindrical sticks and set aside to dry.

As artists began to make their own pastels, rather than relying on raw materials, they discovered that pastels had a number of advantages over natural chalks. First, by regulating the type and amount of ingredients in the mixture, artists could control the quality and hardness of the medium. Also, since so many combinations of different pigments were possible, artists could produce an extensive range of previously unavailable colors. In addition, by adding light or dark extenders to the basic formula, they could produce a nearly infinite range of tints and shades of a single color.

Pastels are manufactured today with the same basic procedures that were used to manufacture early pastels. Basically, they are made from the following ingredients: pigments, chalk, a gum or clay binder (the binder controls the pastel's hardness), and a preservative. These ingredients are mixed into a dough that is compressed into thin sticks, cut, and dried in a kiln.

Commercial pastels can vary considerably in their color and quality depending upon the type and amount of ingredients used in the manufacturer's formula. The better brands are made with large quantities of high-quality, permanent pigments. Also, the colors are identified by and labeled with the names of standard artists' pigments (for example, the standard names cerulean blue or cobalt blue instead of ocean blue or Dutch blue). Artists' pastels can be purchased as individual sticks or in sets. They are also available in pencil form.

The word *pastel* came into use during the eighteenth century when pastels became popular as a portrait medium. Because they were used with white chalk to produce the delicate, pale tones that were fashionable at that time, they became known as "pastel colors." Actually, the name is somewhat of a misnomer since the medium can produce brilliant as well as soft colors.

Since they are made with high-quality permanent pigments, pastels are one of the simplest and purest artists' media for working directly in color. In fact, many artists use them as a primary medium closely associated with painting; and it is not uncommon to hear artists speak of "painting in pastels."

Pastels generally are used on special papers that have a textured surface designed to abrade and hold their particles onto the page. Often these papers are tinted in soft colors to enhance the visual quality of the pastels. Pastels also can be used on painting surfaces such as primed canvas or muslin. In addition, the medium can be used in conjunction with a variety of artists' media such as watercolor, ink, conté crayon, charcoal, and oil paint.

When working with pastels, artists use a variety of approaches. These range from a linear approach often used with the harder pastels to a more diffused,

Edgar Degas

The French artist Edgar Degas (1834–1917) received his initial artistic training in the classical tradition. The influence of this training is apparent in his early artwork, in both the formal composition and the emphasis upon line as a dominant descriptive element.

Although Degas's classical training formed the foundation for his early success as an artist, it was soon replaced by an interest in portraiture. This subsequently gave way to a concern for more contemporary, often mundane subject matter expressed through candid views, movement, and color.

During the formative years of his career, Degas was strongly influenced by photography. This new innovation enabled him to more directly study motion, and he made numerous studies of moving horses and human figures from stop-action photographs. He was also fascinated with the "accidental" effects caused by photographic cropping, which strongly influenced the composition of his later artworks. Degas's interest in candid composition received additional reinforcement from Japanese woodblock prints which were popular in Europe later in the nineteenth century.

In 1881, when he was 47, Degas began to use pastel. It became his preferred medium, and he continued to draw with it until years later when his eyesight failed. By working in pastel, Degas was able to combine the elements of both drawing and painting. Thus, he was able to link his classical background with its strong emphasis on line to his new-found interest in movement, candid views, and color. Degas once referred to himself as "a colorist in line." In addition, by using pastel instead of oil paint, he could work more rapidly and thus capture the spontaneity and movement of his subjects that so intrigued him.

Degas developed his facility for drawing in pastels only after years of patient practice. He experimented with various working techniques such as softening his pastels by holding them over steam or pulverizing them into a powder which he applied with a damp brush. In addition, he developed a complicated procedure in which he painted his initial composition in gouache (a water-based paint) over which he later applied pastels. During the final years of his career, as his eyesight dimmed, his drawings became less linear and more painterly. He applied pastels in broad strokes of pure color, building layer upon layer until the textured surface of his drawings glowed with sparkling embers of broken color (Fig. 3–6 and Plate 4).

FIGURE 3–6
Edgar Degas,
The Dancers, c. 1899. Pastel
on paper, 24½″ × 25½″. The
Toledo Museum of Art,
Toledo, Ohio (Gift of
Edward Drummond Libbey).

painterly approach usually associated with the softer pastels. Pastels can be applied in a thin, almost transparent manner; or, they can have an impasto quality (thick, heavy application). They can be applied as the Impressionists did, in individual flicks and dots of brilliantly shimmering color. They can be crushed or crumbled and aggressively worked into the paper with your fingers or a large paper stomp. Finally, they can be pulverized into fine powders that are applied to the paper and delicately modeled or blended with your fingers or a small paper stomp.

Most artists prefer to use the edges and points of pastel sticks formed by natural breakage and wear rather than mechanically shaping or sharpening the sticks. However, if a special effect is needed, the stick can be shaped with a

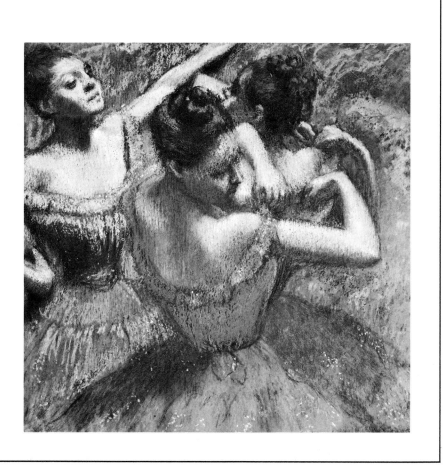

sandpaper block. Because of their high pigment content, pastels are very difficult to erase.

Even though pastel drawings tend to smudge and smear, they are usually not sprayed with a fixative. Fixatives often cause color distortions such as "bleeding" and changes of intensity and value. However, some artists do use workable spray fixatives selectively during the working process to build layers of color. In this method, the area is isolated with a template and sprayed with a fixative. Once sealed, the artist can apply the next layer of color. (Fixatives can be removed by carefully dissolving them with alcohol applied with a soft brush.) When completed, pastel drawings should be handled as little as possible and, ideally, framed and displayed under glass.

Commercial Chalks

Sometimes the words *pastel* and *chalk* are used interchangeably. However, pastels should not be confused with commercial chalks. Commercial chalks, such as those used on classroom chalkboards, are made from the following ingredients: pigments, white chalk, a clay binder, and water. These ingredients are mixed into a dough and compressed into sticks that are cut and then dried in a kiln. Although chalk and pastels are made with similar ingredients and manufacturing processes, there are some very basic differences between the materials. Generally, chalks are made with small amounts of poor quality pigments. Therefore, it is impossible to obtain brilliant colors with them. Also, chalks are brittle, very dry, and quite dusty. They do not adhere well to most drawing surfaces. Chalks are intended primarily for commercial use rather than use by professional artists.

CRAYON

There are many different types of crayons. Crayons are drawing/coloring sticks that are made by combining pigments, and occasionally other materials, with an oily, waxy, or greasy binder. Specifically, the presence of the viscous binder distinguishes a crayon from the other drawing media. A sample of the most common types of crayon available to contemporary artists includes: wax crayon (such as those used in elementary school), lithographic crayon (a type of crayon used in the lithographic printmaking process), and oil pastel.

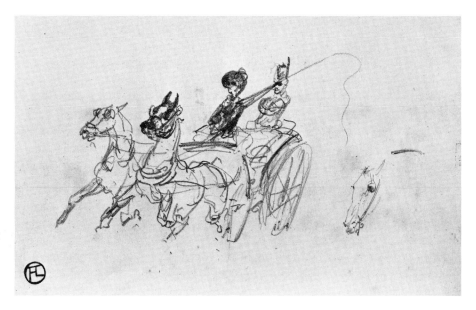

FIGURE 3–7
Henri Toulouse-Lautrec,
Toulouse-Lautrec Sketchbook: La Comtesse Noir, **1880. Graphite on ivory wove paper, 16 cm × 25.6 cm. The Art Institute of Chicago, Chicago (Robert Alexander Waller Collection).**

Crayons were known as early as the Renaissance. During the seventeenth and eighteenth centuries, artists made a crayonlike medium by soaking sticks of pastel or charcoal in oil or soap. But it was not until the late eighteenth century when crayons were developed and used for lithography that they also became a popular drawing medium. Henri de Toulouse-Lautrec often used crayons not only for lithographic printmaking but also to draw many of his independent sketches and drawings (Fig. 3–7).

Wax Crayon

Wax crayons, like those used by children, are a familiar drawing/coloring medium. These crayons are made by mixing small amounts of low-quality pigments (usually in the form of dyes) with excessive amounts of a paraffin binder. Their colors are nonpermanent and tend to fade in time. The cheap pigments make it impossible to produce brilliant color effects. While the paraffin binder makes the crayons clean and easy to use, it also makes them brittle and inflexible. Wax crayons are not intended for professional use, although, occasionally, artists do us them for rudimentary sketching.

Lithographic Crayon

Lithographic crayons (Fig. 3–8), also called litho crayons, were originally developed for lithography. Specifically, artists used them to draw the master image on

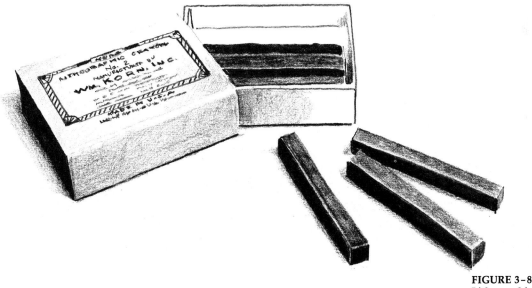

FIGURE 3–8
Lithographic crayons.

Mary Cassatt

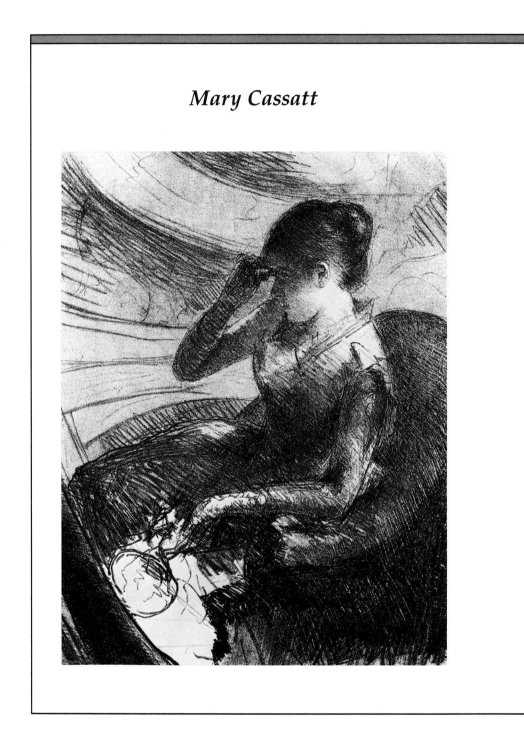

Mary Cassatt (1845–1926) received her initial training in the United States before studying art and developing her professional career in Europe. From a wealthy Philadelphia family, she chose to become an artist during an era when it was nearly unheard of for a woman to pursue such a career. However, due to her perseverance and exceptional abilities, she became very successful and later supported herself through the sale of her artwork.

Although she traveled between the United States and Europe much of her life, she eventually became an expatriot and settled permanently in Paris. There she met and befriended Edgar Degas, who had a lasting influence on her artwork, and she appeared as the subject of several of his artworks. It was her mentor Degas who persuaded her to abandon the Paris Salon, where she had

FIGURE 3–9
Mary Cassatt,
Woman Seated in a Loge, c.
1881. Lithograph,
reproduction, 11⁷/₁₆″ × 8³/₄″.
The Maryland Institute,
College of Art (The George
A. Lucas Collection), on
indefinite loan to the
Baltimore Museum of Art,
Baltimore.

exhibited her artwork for five years, and exhibit with the Impressionists.

The majority of Mary Cassatt's artwork consists of drawings, paintings, and prints. Like Degas, she was especially fond of pastel. Her subject matter often portrayed the intimate, personal moments of women's lives. She depicted women of leisure, quietly relaxing in their gardens, socializing over afternoon tea, or watching a performance in a loge at the opera. She also created a significant number of works that portrayed women sharing tender moments with their young children. Many of Cassatt's models were family members or close friends who shared the same social status and interests as herself. Perhaps the most intriguing feature of Mary Cassatt's artwork was her ability to capture, without sentimentality, subtle personal interchanges conveyed by a momentary glance or fleeting gesture.

Woman Seated in a Loge (Fig. 3–9) was drawn by Mary Cassatt in lithographic crayon around 1880. Like much of Cassatt's work, this drawing captures her subject offguard. Ironically, the artist watches the subject, who in turn intently watches the performers on the stage below. Compositionally, Cassatt portrays her subject as though viewed through opera glasses by a distant observer from

across the balcony. Indeed, Cassatt would later use this composition as the basis for an oil painting in which exactly such a situation is depicted.

There is a dichotomy between the subject Cassatt has shown and her means of execution. Her model is a passive spectator seated quietly in an opera loge. Yet, she is enveloped and contained in a vortex of powerful, sweeping curves that echo one another and energize the composition. The influence of Degas can be seen in the forceful lines that delineate and describe the figure as well as in the shorter broken lines that energize the paper and create the flickering, luminous effect of this drawing.

the lithographic stone. Although this still remains their main function, artists often use them to make independent sketches and drawings as well.

Litho crayons are made by combining wax, tallow, soap, shellac, and lamp-black (finely powdered black soot) into a mixture. This mixture is then formed into thin, round sticks that are wrapped with paper that can be peeled away as the stick wears down. In addition to the standard pencil model, litho crayons are also manufactured in thin, rectangular sticks. They are available in seven gradations ranging from 00, the softest, to 5, the hardest (European-made crayons reverse the order of this numbering system).

The ratio of shellac to the other ingredients in the mixture determines the hardness or softness of the crayon. The fluid, greasy nature of the mid-range litho crayons (No. 3 or No. 4) makes them an excellent medium for drawing quick gesture studies and bold linear drawings. In addition, both the crayon and the stick can be used to form broader, expanded areas of mass. For special purposes, the tip of the crayon can be sharpened with a razor blade. Also, solvents such as distilled water or rectified turpentine can be used to dissolve the crayon to produce fluid effects. Litho crayons are almost impossible to erase from paper.

Oil Pastel

Oil pastels are produced for use by professional artists. They are called by a variety of trade names and, like pastels, can vary considerably in their quality and character depending upon their ingredients. The better brands are made by mixing pigments and various inert ingredients with a wax binder. In essence, oil pastels are formed with the same basic manufacturing processes that are used to produce pastels.

Because of their waxy binder, oil pastels have a natural cohesion and can be used on a variety of papers and other drawing surfaces. However, drawing/

FIGURE 3-10
Oil pastels.

painting media that contain an oily or waxy binder will eventually cause deterioration if applied directly to unprimed paper, wood, or fabric. Therefore, if permanence is a consideration, the drawing surface should be coated with a primer. When compared with pastels, oil pastels are slightly waxy and less dry and brittle. Some oil pastels that are made with only a small amount of wax binder closely resemble pastels (Fig. 3–10).

Most of the same working techniques recommended for pastels can be applied to oil pastels. Since they are slightly waxy, oil pastels can be blended and modeled easily. Opaque or fluid effects can be achieved by mixing a small amount of solvent, such as rectified turpentine or linseed oil, with the medium. For example, the stick can be dipped or soaked in the solvent before drawing, or the solvent can be applied directly to the drawing with a stiff brush or a paper stomp. Oil pastels are difficult to erase although heavier deposits can be removed by carefully scraping them away with a razor blade.

Artists sometimes use oil pastels and water-based drawing media together in a single drawing. When combined in this fashion, the water-based media do not mix with the crayon. Rather, they are repelled by the waxy binder and form subtle "resist" areas.

Oil pastel drawings do not need to be sprayed with a fixative since their waxy binders contain sufficient cohesion to hold the pigment particles to the drawing surface. They should be framed under glass when completed, but should not touch the glass since contact with the glass can cause damage to the artwork from both heat and condensation.

Conté Crayon

The conté crayon (Fig. 3–11) was developed in the late eighteenth century by the French artist/chemist Nicolas Jacques Conté. Conté crayons are made by mixing

FIGURE 3–11
Conté crayons.

Michael Gould

Michael Gould (b. 1956) is an American artist who paints in oil and draws in oil pastels and paint sticks. Paint sticks are thick sticks that contain professional quality, artist's oil paint in a compact, solid form. They are shaped much like children's "jumbo" crayons. The tip of the paint sticks dry and form a hardened skin when they are not in use. This skin must be broken each time the sticks are used to expose the medium.

Gould's drawings are painterly in their approach, and he frequently uses them as a basis for developing his oil paintings. Natural landscapes are the primary subject matter of Gould's artwork, although he often depicts landscapes with traces of urbanization.

Light is the compositional force behind Gould's artwork. The artists believes light is imbued with a spiritual and emotional quality, and it is this elusive aspect of light that inspires him.

Gould is interested in the qualities of both natural and artificial light. When drawing during daylight hours, he prefers to work at dawn or dusk. Gould is intrigued by the rapid lighting changes that occur during these intervals, and he maintains that capturing the effects of these fleeting moments is more challenging than working under static lighting conditions. It is during these moments that Gould's energies and emotions are the most focused. This in turn causes him to work at what he describes as a "higher pitch." For similar reasons, Gould also enjoys working on location at night when there is such a dramatic conflict between light and dark.

Gould professes a strong identification with his subject matter. His emotional responses are influenced by the transient nature of the natural landscape with its rapid and unexpected change. Gould's responses are affected by the time of day, lighting conditions, and the changing seasons. There is a direct interplay between the mood of the landscape and the emotions of the artist. As one changes, so does the other, and this interdependence directly influences the outcome of the artwork.

Color is an important aspect of Gould's artwork. He does not use color in a naturalistic manner; rather he uses it to express his emotional response to the landscape in order to evoke a similar response from the viewer.

Willow and Loosestrife (Fig. 3–12 and Plate 5) is a small drawing executed in cool colors using oil pastels and paint sticks. It was drawn on location, at daybreak, in a botanical garden near Ann Arbor, Michigan. The drawing depicts a willow tree overhanging a small lagoon bordered with colorful loosestrife flowers. The artist was especially attracted to this scene because of the freshness of the early morning light and the way it illuminated the overhanging branches of the willow tree.

Gould executed the drawing on four-ply ragboard which is particularly receptive to oil pastels and paint sticks because of its absorbancy, tooth, and surface whiteness. Before he began to draw, Gould adhered the ragboard to a supporting surface with four loops of tape attached to the back side of the board.

Gould began his drawing by first establishing a thin, colored border around the picture plane. He selected the color of the border to correspond to his emotional response to the landscape. Once the border was established, he began to develop the positive and negative relationships of the drawing by blocking in solid areas of color. From the start, Gould worked back and forth, alternating oil pastels and paint sticks. He finds the flexible nature of both media especially suitable to making changes throughout the working process.

The artist worked from general areas to more specific details by building layers of mass until he achieved his intended effect. He worked from both light to dark and from dark to light and simultaneously developed the foreground, middle ground, and background of the composition.

"Touch of hand" is important to Gould. He applied the medium, using both its tip and its side. As he

worked, the consistency of his medium was continually changing because the medium dries and hardens, from its initial soft state, as it is applied to the drawing surface. (Generally the medium begins to dry about 30 minutes after application and is completely dry within a day.)

Gould uses oil pastel and paint sticks because they are well suited to his style of working—they allow him to achieve a wide range of rich color effects in a short period of time. Gould forms the transparencies of his drawing by using light pressure to apply thin layers of different colors. In addition, certain colored paint sticks inherently produce colors of a transparent nature. Interesting blending effects can be achieved by mixing layers or solid masses of color with a blending stick (a solid, transparent paint stick that mixes with either oil pastel or paint sticks). Gould forms impastos and rich textural effects by building solid layers of color and by sometimes twisting and grinding the media to deposit collected residue from the stick onto the drawing surface.

The border for *Willow and Loosestrife* that was initially established as the first step in the drawing process is ''worked'' and developed as the drawing progresses. It provided a transition between perceptual space and pictorial space which the viewer must cross over. The degree of color contrast between the border and the image helps to establish the mood of the artwork.

When completed, the drawing was mounted with a floating mount and framed so that it is not in contact with the glass of the picture frame.

FIGURE 3–12
Michael Gould,
Willow and Loosestrife. **Oil**
pastel. Collection of the artist.

pigments with a gum binder. This mixture is formed into a paste that is then compressed into small rectangular sticks and allowed to dry.

Conté crayons are available in black and white and in three degrees of hardness: HB (hard), B (medium), and 2B (soft). They also are available in gray and in a limited range of earth tones: sanguine, a reddish orange; bistre, a dark brown; and sepia, a dark reddish brown.

A variant of the conté crayon is made in a pencil form with the conté core encased in wood. We should note that *Conté* also is used as a trade name for other artist's materials such as pastels and colored pencils.

The conté crayon is a versatile medium that can be used to execute rapid, large-scale drawings, or smaller, more precise drawings. Conté crayon is somewhat less abrasive than charcoal or pastel and produces a rich, dense mark that adheres well to both smooth and rough paper.

Matthew Daub

Matthew Daub (b. 1951) is a contemporary American artist who paints in watercolor and draws in conté crayon. He often uses a simple three-by-five color snapshot as a general reference when composing his artwork. Although Daub creates his drawings as autonomous pieces, he frequently uses them as the basis for his paintings. Sometimes, however, he reverses this procedure and uses his paintings as the basis for drawings.

Many of Daub's drawings deal with urban themes. He shoots his own photographs and often takes mental notes while absorbing the mood of the location.

Christmas Day: Peoria (Fig. 3–13 and Plate 6) is a drawing based on a photograph taken by the artist on Christmas day. The streets and surroundings near this normally busy industrial complex were deserted, and a stillness permeated the scene. Yet, paradoxically, the entire setting was activated by clouds of steam billowing from the factory complex. It is precisely this dichotomy that intrigued the artist and set the mood for a drawing that is devoid of life yet full of energy.

Christmas Day: Peoria was drawn with bistre conté crayon on a smooth-surfaced, cotton illustration board. For his drawing surfaces,

FIGURE 3–13
Matthew Daub,
Christmas Day: Peoria, **1985.**
Bistre conté crayon, 8″ × 16″.
Collection of William Louis Dreyfus.

Frequently, before beginning to draw, artists snap the conté stick into several pieces. Breaking the crayon naturally shapes its tip into sharp, crisp edges and angular points that can be used to produce a variety of lines. Further, the flat sides of these pieces also can be used to draw expanded masses of dark value.

Artists often use the conté crayon to develop subtly modeled drawings. Because it is so finely textured, conté crayon can be blended easily into smooth gradations of value with your fingers or a paper stomp. Highlights and lighter areas of value can be formed by using a soft, kneaded eraser to expose the white of the paper. Even more densely concentrated areas of dark value can be formed by dipping the tip of the conté crayon in a small amount of solvent, such as turpentine, just before drawing. Or, the solvent can be applied directly to the drawing with a dampened cotton swab or paper stomp.

Daub looks for a surface that has just enough tooth to hold the medium but not enough to force its texture upon him.

Before beginning his drawing, Daub used a ruler to establish the crisply defined borders of his artwork. He then applied drafting tape along the edges of the border and adhered the board to a supporting surface.

Daub began his drawing by "blocking in" the entire composition with light values. Initially, he applied the medium using light pressure so the conté crayon was not forced into the grain of the paper. After he had established the basic shapes and value relationships of the initial composition, he proceeded to develop the drawing by building graduated layers from light to dark and by building from generalized to more specific areas.

As the conté crayon was used, it wore to a sharp, chiseled tip. Daub exploited this natural edge to "cut" sharp lines across his drawing and to establish the crisp edges of his images. When drawing areas that require more control, he used conté pencils sharpened with a standard pencil sharpener.

In addition to the conté crayon and conté pencil, Daub also used other tools while drawing. He considers these tools as important as the medium itself. The smooth, satiny surface of his drawing was created by using a soft paper towel to gently work the medium into the grain of the paper. The extremely dark areas often required three or four applications of the conté crayon and subsequent rubbings with a paper towel to build up the desired density. When delicate blending was necessary, the artist modeled detailed areas with a small paper stomp.

The lighter areas of a conté crayon drawing must be planned in advance and controlled from the drawing's inception, since it is a difficult medium to erase. Very light areas are simply masked or left white from the beginning. However, artists often use a range of erasers to establish the lighter, intermediate values of the drawing. In this work Daub used a soft, kneaded eraser to lift lighter deposits of the medium from the page. For more vigorous erasures he used a Pink Pearl eraser. To erase detailed areas or to "cut" lines into the drawing he used a common typewriter eraser in stick form.

When Daub finished his drawing, he sprayed it with a workable fixative. He framed the artwork under glass with a protective mat to prevent the drawing from touching the surface of the glass.

Georges Seurat

The French artist Georges Seurat (1859–1891) is noted for developing a painting technique formally known as divisionism, but popularly called pointillism. Seurat used this technique to create subtle color passages by placing small dots of pure pigment adjacent to each other directly on the canvas rather than mixing the pigment before applying it to the canvas. In theory, the small dots of color would be optically mixed by the viewer's eye rather than by the artist's brush.

Before he began his career as a painter, Seurat had completed a body of work of over 500 drawings, many of which were executed in conté crayon. Seurat's drawings are not as well known as his paintings, although many critics feel they are of equal significance.

Even though Seurat often used his conté drawings as studies for paintings, they were not studies in the typical sense. Rather, most were autonomous, developed drawings meant to exist on their own merit. One such example is *L'Echo* (The Call) (Fig. 3–14), which was used as a study for one of Seurat's first major paintings, *Une baignade, Asnières*.

L'Echo is a small drawing executed in black conté crayon on rough-textured paper. The image depicts a boy with his hands cupped to his lips as he calls out into the distance.

This artwork, like so many of Seurat's drawings, is contradictory. On the one hand, it is formally structured and nearly rigid in its

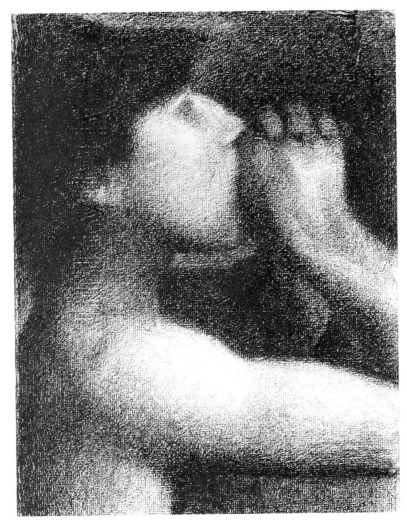

FIGURE 3–14
Georges-Pierre Seurat,
L'Echo, **1883–84. Conté crayon, 30.7 cm × 23.7 cm. Yale University Art Gallery, New Haven (Bequest of Edith M. Wetmore).**

FIGURE 3–15
Detail of Figure 3–14.

presentation. Yet, in seeming opposition, the drawing was executed in such a way that it exudes a mysterious energy.

The drawing's formality results from the calculated placement of the image. A profile is inherently more rigid and less engaging than a frontal or more candid pose. Thus, a certain distance is established between the subject and the viewer. In addition, Seurat tightly cropped his drawing to focus attention on the central gesture from which the work derives its name. The drawing's structure is further maintained by a number of reoccuring horizontal and vertical lines and shapes that repeat the rectangular shape of the page.

In contrast with Seurat's formal approach to composition is his drawing technique. Traditionally, academic artists had used a single line to trace the contours of an image, or they had embellished their line drawings with delicate modeling effects to create an illusion of volume. Although Seurat had been trained in the academic approach, he later broke with this tradition and established his own unique drawing style.

Many authors have mistakenly drawn comparisons between Seurat's pointillist painting technique and his conté crayon drawing technique. The analogy, as commonly stated, indicates that

Seurat applied his conté crayon to rough-surfaced paper in a pointillist technique, using small dots to achieve the sparkling, luminous quality of his drawings.

This observation is incorrect as an analysis of Seurat's conté crayon drawings will show. (Actually, Seurat had completed nearly all of the drawings he would make during his career before he began experimenting with his pointillist painting technique in 1885.)

Instead of using a single line to create the contours of an image, Seurat built his image by applying individual lines until they formed a mass of intertwining layers (Fig. 3–15). By nature, the conté crayon is a rather soft and waxy medium. When the stick is drawn across a rough-toothed paper, it fractures

into short, staccato lines with a soft blurred edge.

Seurat utilized the raised tooth and lowered recesses of his paper to form subtle dark and light values. When he applied the conté crayon with less pressure, the granules adhered only to the tooth of the paper, leaving the white recesses visible as small flecks of light. Even Seurat's darkest darks emit flickering bits of light. This shimmering light is formed by and emanates from within the recesses of the drawing. It is an internal light that seems to "breathe from," rather than rest upon, the surface of the paper. The light and dark values of Seurat's drawing imperceptibly fuse, veiling the entire work in a vaporous atmosphere.

4

Metalpoint, Graphite, and Colored Pencils

METALPOINT

During the Middle Ages, scribes and merchants used thin, pointed rods of metal as writing and marking instruments. Gradually, artists began to use these tools, and by the beginning of the Renaissance they were a popular drawing instrument. Metalpoint instruments were made most commonly of silver, gold, copper, and lead, or from the alloys brass and bronze. Of these, silver was the most preferred and the most frequently used. Sometimes the metalpoint tool was simply a thin, metal rod sharpened to a point. At other times the rod was shaped into a decorated stylus or inserted in a shaft made of metal, wood, or paper (Fig. 4–1).

Metalpoint drawings must be executed upon a specially prepared surface called a ground. In early times, the ground was made by mixing white lead and bone dust with glue and water. The ground generally was applied to paper or parchment, although vellum, wood, and cloth were also used as supporting surfaces. Today, artists can prepare their grounds by mixing titanium white or zinc white pigments with glue and water, or they can make a simple ground by applying gesso, a white liquid used to prime artists' canvases, to heavy Bristol board, or masonite. The ground should be applied in several thin coats and then burnished to a smooth surface. The ground provides a smooth working surface

FIGURE 4-1
Metalpoint tools.

that is receptive to the tip of the metalpoint tool. More importantly, it causes the metalpoint mark to become more visible and distinct. In fact, if a ground were not used, certain metalpoints such as gold, silver, and brass would not leave a distinctly visible mark upon the supporting surface.

Although the marks produced by each metalpoint instrument are individually unique, they are generally similar. When initially drawn upon the ground, all metalpoint marks appear gray or dark gray regardless of the metal used. However, upon exposure to the atmosphere and after aging for several months, some metalpoints change in color and in value. For example, silver develops a brownish color, lightens in value, and becomes slightly transparent. Copper develops a yellowish color, lightens in value, and also becomes slightly transparent. Gold and lead show little if any change in coloration or value from their initial application.

Metalpoint is expressly a linear medium. Only the tip of the tool is used, and its point produces delicate, thin lines that vary little in their thickness or darkness no matter how much pressure is exerted upon the instrument while drawing. When compared to other drawing media such as charcoal and graphite pencil, metalpoint produces a mark that is quite light and within a limited value range that excludes extreme darks. Because the metalpoint instrument produces such a delicate, light line, it almost always is used to make small, intimate drawings.

The linear marks produced by the metalpoint instrument cannot be blended or smeared. Therefore, dark masses or modeled areas must be formed by building layers of line with a hatching or crosshatching technique. Once a metalpoint mark has been drawn upon the ground, it is difficult to remove. Minor corrections can be made by carefully removing the mark with a scraper. Or the ground can be slightly moistened with warm water until the mark disperses.

The use of metalpoint reached its peak during the Renaissance and then gradually declined until it experienced a short-lived revival during the nineteenth century. Although the medium is not widely used today, a few contemporary artists still draw in metalpoint.

Jan van Eyck

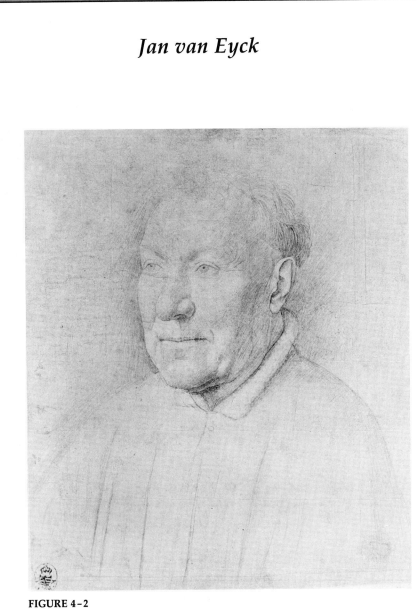

FIGURE 4-2
Jan van Eyck, *Cardinal Niccolò Albergati,* ca. 1431. Silverpoint on grayish-white prepared paper, 8³/₁₆″ × 7.″ Staatliche Kunstsammlungen, Dresden.

FIGURE 4–3
(Left) Jan van Eyck, *Cardinal Niccolò Albergati*, ca. 1432. Panel, 13⅞" × 10¾".
Kunsthistorisches Museum, Vienna.

FIGURE 4–4
(Right) Detail of Fig. 4–2.

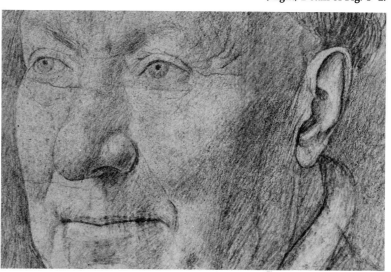

Jan van Eyck (ca. 1390–1441) was a Flemish artist who was influential in establishing a style of representational art called naturalism. Based on the principle of scientific objectivity, naturalism dictates that artists faithfully reproduce nature without idealizing or imposing value judgments. Recently, interest in naturalism has been revived by contemporary representational artists involved in the modern art movements of Photo Realism and New Realism.

Late in his career (ca. 1431), Van Eyck executed a drawing in silverpoint on a grayish white prepared paper entitled *Portrait of Cardinal Albergati* (Fig. 4–2). He later painted a portrait of the cardinal in oil paint that is nearly identical to this drawing (Fig. 4–3). Although Van Eyck's drawing is naturalistic, it is also psychologically penetrating.

Van Eyck used a chiaroscuro modeling technique to create the lifelike appearance of his subject. He created an illusion of volume by skillfully controlling the placement of the delicately hatched lines formed by the silverpoint stylus (Fig. 4–4). When he placed them closer together they formed the darker, recessed areas of the drawing. Conversely, when he placed them further apart they formed the lighter, advancing areas. He utilized the subtle tonalities created by the silverpoint medium to capture a soft light that radiates over the cardinal's benevolent face, establishing the reverent mood of this drawing.

GRAPHITE

History

The graphite pencil is the best known and most often used of all artists' materials. Most of us have drawn with it since childhood. Yet, familiar as we are with this instrument, we actually know surprisingly little about it.

The history of the graphite pencil began in 1564 near Borrowdale, England, when a deposit of graphite was discovered beneath a large tree uprooted during a storm. Farmers in the area quickly found a practical use for the material and began using lumps of graphite to brand their sheep. Shortly thereafter, merchants also began using pieces of graphite to mark packages and before long, a commercial graphite mine was established near Borrowdale. Graphite from the Borrowdale mine was so pure that initially it was sold in rough chunks for writing and marking purposes. Later, as it became more commonly used, pieces of graphite were wrapped in paper or string or inserted into various holding devices to facilitate handling (Fig. 4–5).

As the demand for graphite increased, the supply of pure graphite from the Borrowdale mine dwindled. Other deposits were located but they were not of the same high quality. Nonetheless, manufacturers discovered that if they ground the graphite into a powder they could then separate and remove impurities. However, once they had processed the graphite, they had to develop a method to "reassemble" the powder into solid, usable shapes. They experimented with various partially successful methods. Finally, late in the eighteenth century, the French artist/chemist Nicholas Jacques Conté discovered a practical and permanent solution when he used clay and water to bind the graphite particles together. Conté then pressed this mixture into a grooved wooden mold and formed it into thin sticks. Later, after the sticks had dried, he fired them in a kiln to make them

FIGURE 4–5
Early forms of graphite pencils.

solid. Finally, he sandwiched the sticks between two pieces of wood to form writing/drawing instruments. Although the process has been modernized, contemporary manufacturers still use this same basic procedure.

Graphite pencils are commonly called "lead" pencils even though they contain no lead in their marking core. When first discovered, graphite was assumed to be a type of lead and was called "black lead." Later, it was identified as a form of carbon and was subsequently renamed graphite. But the misnomer has endured, and graphite pencils are still called lead pencils.

Manufacturing Process

The modern graphite pencil is manufactured in a variety of shapes and sizes (Fig. 4–6). Whether round, hexagonal, or flat, most graphite pencils are made following the same basic procedure.

The leads are formed by mixing graphite, clay, and water into a stiff dough. The ratio of graphite to clay determines the pencil's firmness and the darkness of its mark. The more graphite the mixture contains the softer the lead and the darker its mark. Once mixed, the dough is pushed through a machine that forms it into thin, spaghetti-like strands. Later, these strands are cut into pencil lengths, stacked in a kiln, and fired. Finally, they are saturated with wax, cleaned, and are ready to be encased in wood.

FIGURE 4–6
Modern graphite pencils.

The wood encasement usually is made from the incense cedar tree. This wood produces a soft, straight grain that is easy to cut when the pencil is sharpened. The leads are encased in wood by sandwiching them between two identical grooved wooden blocks, which subsequently are cut and shaped into individual pencils (Fig. 4–7). The most common pencil shape is a hexagonal rod; this shape is easy to hold and prevents the pencil from rolling on flat surfaces. After shaping, the pencils are painted with several coats of nontoxic lacquer and then labeled on their side. Many pencils have a small, metal cylinder, called a ferrule, attached to their top. Some ferrules hold an eraser, while others are blunt metal caps that simply serve as decoration.

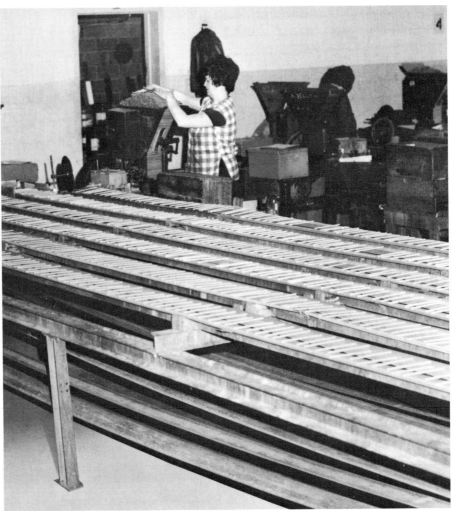

FIGURE 4–7
(Above, from the top down) a pre-stained slat of western incense cedar is cut one-half the thickness of a pencil; the slat is then mechanically grooved, forming a half of nine pencils; the "lead" (actually, graphite, clay, and gums) is laid in the grooves; a second grooved slat is compressed to the top of the leaded slat; the two slats are cut and shaped by high-speed cutters into nine pencils; after pencils are sanded, varnished, and labeled, the ferrule and eraser tip are added; finally, the pencils are boxed.

(Right) pencil factory.

Grading Systems

Most manufacturers of artists' graphite pencils use a standard grading system to indicate the firmness of the lead and the darkness of its mark. This grading system moves in progressive sequence from the softest pencil that makes the darkest mark to the hardest pencil that makes the lightest mark (Fig. 4–8). The softer and darker range of pencils extends from 8B to B, with 8B being the softest and darkest. HB and F are in the middle of the scale and are of medium hardness and darkness, while the harder and lighter range of pencils extends from H to 10H, with 10H being the hardest and the lightest.

A few manufacturers of graphite pencils do not use a standard grading system to identify the hardness or darkness of their pencils. Instead, they use a variety of trade names. For example, a pencil may be labeled Ebony or Black Magic. The firmness and darkness of these pencils will vary according to each manufacturer's standards.

FIGURE 4–8
Graphite pencil gradation scale, from the softest (left) to the hardest pencil (right).

Drawing Techniques

The graphite pencil can be used on many different types of paper. However, the harder pencils do tend to gouge the surface of softer and clay-coated papers. Excellent results can be obtained on medium or heavy-weight cotton drawing paper with a medium or medium-fine textured surface.

Because the graphite pencil is such a familiar instrument, we often overlook its vast potential for artistic expression. Out of habit, many artists sharpen and use the pencil for drawing as they would for writing. Although a standard writing point can be useful for drawing, other possibilities should be explored. For example, the pencil can be whittled and shaped into angular, blunt, or chiseled tips, each of which can produce its own unique mark. Or, for extremely delicate work, its tip can be pointed to needlelike fineness with a sandpaper block or mechanical lead pointer (Fig. 4–9).

FIGURE 4–9
Various shapes of pencil tips.

In addition to experimenting with various methods of sharpening the pencil, it is also helpful to experiment with various methods of holding the pencil while drawing. Again, out of habit, many artists prefer to hold the pencil in the familiar writing position while drawing. While this grip is adequate for many drawing purposes, other possibilities exist. For example, the pencil can be held under the hand, grasped between the thumb and four fingers. With this grip, both the tip and the side of the lead can be used to make long, sweeping marks. Or the pencil can be clenched in the fist to make bolder, more aggressive marks (Fig. 4–10).

Because it is such a convenient instrument, artists frequently use the graphite pencil to draw studies and make sketches in preparation for more developed artworks. Pablo Picasso's studies for his painting *Guernica* are excellent examples of this use (see box on pages 60–62).

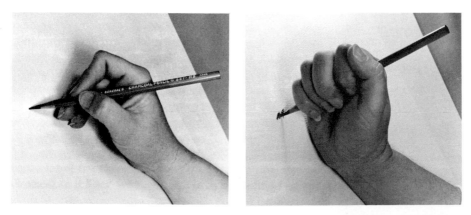

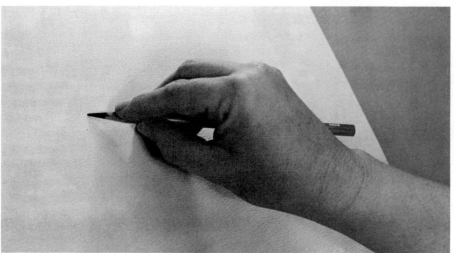

FIGURE 4–10
Various ways to hold a pencil; each one resulting in different marks.

Pablo Picasso

The Spanish artist Pablo Picasso (1881–1973) is undoubtedly one of the most important figures in the history of art. Picasso was the son of an art teacher, and as a youth he exhibited a remarkable artistic aptitude— especially in drawing. He was only 16 when he held his first one-man exhibition. Throughout his life, Picasso was incredibly prolific. Although he was known primarily as a painter and as the founder of cubism, he created masterpieces in all major artforms including drawing, painting, printmaking, sculpture, and ceramics.

In January, 1937, Picasso received a commission to paint a mural for the Spanish Pavilion at the Paris World's Fair. Three months later, during a revolt against the Spanish Republic, troops operating under the orders of the Spanish fascist general Francisco Franco bombed and destroyed the small Basque town of Guernica. Picasso, a loyalist outraged by the aerial bombardment, was so moved by the carnage that he made it the theme for his painting *Guernica* (Fig. 4–11).

A large painting, Guernica measures 11' 5 1/2" × 25' 5 3/4". Devoid of color, it is executed primarily in flat areas of black, white, and gray. Before he began painting, Picasso spent ten days developing an extensive series of compositional studies. In addition, he continued to draw studies as he painted until the work was finished nearly a month later. In total, he made 45 recorded preparatory studies, ranging from quick sketches to elaborately developed drawings. All but one of these studies were executed either in graphite pencil or in graphite pencil embellished with another medium.

Surely Picasso could not have selected a more suitable instrument for these drawings. Its immediacy and intimacy are readily apparent in his very first sketch (Fig. 4–12). Here, in a few swift strokes the artist records the genesis of his masterpiece at an almost subliminal level. Although they appear as random scribbles, the marks have already established the elements that dominate the final painting: the

FIGURE 4–11
Pablo Picasso, *Guernica,*1937.
Mural approx. 11'6" × 25'8".
Museo del Prado, Madrid.

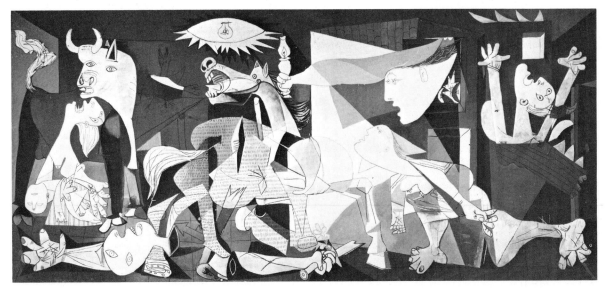

woman holding a lamp aloft, the fallen warrior, the impassive bull, and the contorted, shrieking horse.

Picasso completed his fourth compositional study (Fig. 4–13) on the same day as his first. Although the same instrument was used to draw both studies, the difference between the two could not be more striking. In this study, the four dominant figures are easily recognizable. Gone are the spontaneous approach and sketchy lines of the first study. The artist's initial passion has been tempered. Now, he draws with conscious intent as the pencil's lines are slowed and brought under control. In comparison to the tentative lines of the first study, the sharp, crisp lines of this drawing appear almost as if they were engraved into the paper's surface. Yet, finite as this composition appears, it also will undergo extensive changes.

(continued)

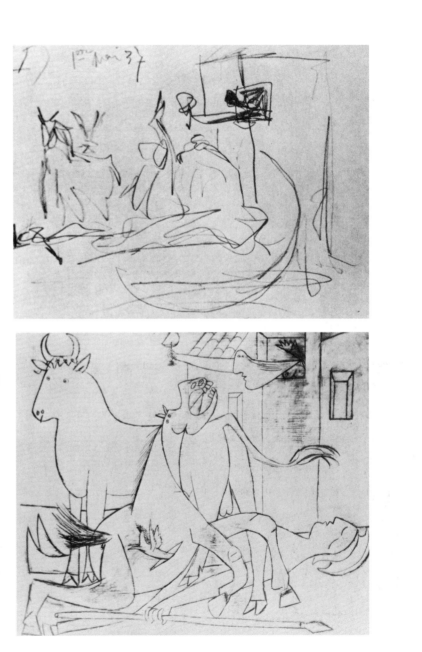

FIGURE 4–12
(Top) Pablo Picasso, *Estudio de Composicion para Guernica (1),* **May 1, 1937. Graphite pencil on blue paper, 8¼″ × 10⅝″. Museo del Prado, Madrid.**

FIGURE 4–13
(Bottom) Pablo Picasso, *Estudio de Composicion para Guernica (4),* **May 1, 1937. Pencil on gesso on wood, 21⅛″ × 25½″. Museo del Prado, Madrid.**

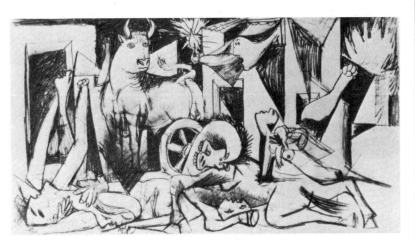

(continued)

Eight days after drawing his initial sketch, Picasso completed his final compositional study (Fig. 4–14). Shortly thereafter, he transferred this composition to the oversized canvas with only minor changes. This final study is considerably more complicated than the previous ones. Several new figures and images have been added. In addition, the horse, a symbol of Franco's Nationalist Spanish Party, has been moved to the center of the composition, the focal point around which the entire painting is structured.

In this study, Picasso once again uses the pencil to draw the figures and images in an expressive, spontaneous fashion. But, more importantly, he uses it to establish the interlocking dark and light shapes that now form the underlying structure of the composition. It is surely no accident that these same tonalities first established by the graphite pencil later appear as a dominant feature in the final painting.

The common graphite pencil is a seemingly simple instrument that often is taken for granted. Yet, we cannot underestimate the influential role it played from start to finish in the development of one of the most important artworks of the twentieth century. In fact, even after he completed the painting, Picasso continued to develop yet another series of eight graphite pencil drawings based on the wailing figure depicted in the painting (Fig. 4–15).

**FIGURE 4–14
(Above) Pablo Picasso,** *Estudio de Composician para Guernica (Final Study),* **May 9, 1937. Pencil on white paper, 17⁷/₈″ × 9¹/₂″. Museo del Prado, Madrid.**

**FIGURE 4–15
(Right) Pablo Picasso,** *Study for Guernica — Wailing Figure,* **June 22, 1937. Pencil and gouache on cardboard, 4⁵/₈″ × 3¹/₂″. Museo del Prado, Madrid.**

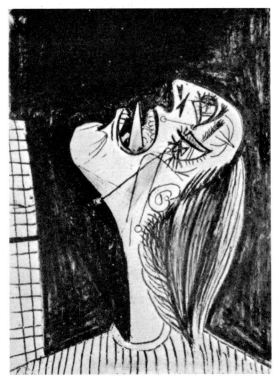

Many artists use graphite pencil to create more developed artworks that are intended as finished statements from their inception. The graphite pencil works of Jean-August-Dominique Ingres are excellent examples of drawings in this medium. In the portrait on page 65, Ingres used a series of delicate contour lines to depict his subject. These lines trace both the external and internal edges of the figure and create an illusion of volume that gives the drawing its lifelike quality. Although the lines are firm and precise, they are not sterile. Their freshness results from variations of thickness and tone achieved by the artist's sensitive manipulation of the chiseled tip of the soft graphite pencil.

To make his drawing appear even more realistic, Ingres fortified his delicate contour lines with equally delicate areas of tonal modeling. Because both share the same limited tonal range, the modeled areas enhance and visually integrate with the firmly established contour lines from which they often emanate. Yet, true to the doctrine he preached, the modeled areas remain subordinate to the artist's emphatic use of line.

Other Forms of Graphite

Mechanical Pencils

In addition to being available in pencil form, graphite is also available in thin leads that can be inserted into mechanical holders (Fig. 4–16). Like graphite pencil leads, these leads are available in a range of hardness and darkness (ranging from 7B to 9H). The mechanical holders are usually made of metal or plastic or a combination of the two. The leads are pointed in mechanical lead pointers. Generally, mechanical pencils are used by draftsmen, although some artists use them for detailed or delicate work.

FIGURE 4–16
Mechanical pencils.

Jean-Auguste-Dominique Ingres

Jean-Auguste-Dominique Ingres (1780–1867) received his initial artistic training at the age of nine while serving as his father's apprentice. When he was 11 he was sent to the Academy at Toulouse to study painting and sculpture. However, the most important phase of his education occurred when, at the age of 17, he entered the Paris studio of the renowned Neoclassical painter, Jacques Louis David.

Even as a student Ingres reacted against David's cold, academic style and quickly developed his own personal identity. During midlife, Ingres opened his own atelier and later became the Director of the Academy of France in Rome (1835–45). Nonetheless, his interest in classical themes and history which was established during his formative years in David's studio was to remain with him throughout his long and productive career. It is fitting that just as he had been influenced by the master artists who preceded him such as Giotto, Raphael, and Titian, Ingres himself became an inspiration to a younger generation of artists that included Degas, Renoir, Matisse, and Picasso.

Most authorities consider Ingres to be the definitive master of graphite pencil drawing. During his long career he produced an extensive collection of drawing in this medium. Of these, many were portraits drawn from life. They were executed either as studies for formal oil paintings or were intended as finished artistic statements in their own right.

One of Ingres's most engaging portraits is his drawing of Lucien Bonaparte, a younger brother of Napoleon (Fig. 4–17). Like Ingres, Lucien had developed a keen interest in classical antiquity and was, in fact, living in Rome when he posed for this portrait in about 1808. This common interest is reflected in the drawing that depicts the elegantly dressed Lucien proudly sitting on an ancient Roman sepulcher overlooking the Quirinal, a historic architectural site.

Ingres executed this small drawing on white wove paper apparently using a rather soft graphite pencil.

Toward the beginning of his career, Ingres favored a sharp, soft pencil. . . . Later his point tended to be duller and greyer. . . . It is impossible to establish a rigid sequence, however, as both graphite and touch vary greatly from drawing to drawing. At all times he seems to have kept his pencil, sharp or dull, in a chisel-shaped point, so that he could vary the width of his stroke at will without the delay of changing points. This raises the question: Did Ingres ever use more than one pencil in his portrait drawings for a greater variety of line and tone? A few affirmative examples stand out. . . . Yet with most of the drawings it is a moot point, requiring a more comprehensive examination. Until it is undertaken one must assume the general use of only one pencil.[1]

[1] Marjorie Benedict Cohn. Ingres Centennial Exhibition 1867–1967, Drawings, Watercolors and Oil Sketches from American Collections. Fogg Art Museum, Harvard University, February 12–April 9, 1967. Distributed by the New York Graphic Society, Greenwich, Connecticut.

FIGURE 4–17
Jean Auguste
Dominique Ingres,
Lucien Bonaparte,
1807–1808. Graphite,
9³⁄₈″ × 7¹⁄₈″.
Collection of John
Goelet, New York.

Stick Graphite

Graphite also can be purchased in solid, unwrapped sticks that are manufactured with the same basic process used to make the leads of the graphite pencil (Fig. 4–18). However, their size and shape are different. Graphite sticks are about half as long as a standard pencil and are made in two shapes: an elongated square and an elongated rectangle. Like graphite pencils, stick graphite is available in various gradations of hardness and darkness, although in a more limited range (B to 6B).

Stick graphite can be used with many of the same drawing techniques that are used with the graphite pencil. While the pencil is well suited for smaller, more intricate drawings, stick graphite generally is used to make larger drawings.

The main advantage of stick graphite is its versatility. Broad areas of value can be created by using either the blunt end or the flat sides of the medium. In addition, the end of the stick can be shaped to a sharp, chiseled edge that can be used to "cut" crisp lines across the page. As with the graphite pencil, various amounts of pressure can be exerted while drawing to achieve variations of darkness.

Powdered Graphite

Powdered graphite can be made by grinding graphite pencil leads or graphite sticks against medium-grade sandpaper (Fig. 4–19). It can also be purchased commercially in small containers. The darkness of the powder will be determined by the grade of graphite used in its composition.

Powdered graphite is particularly effective when it is used in combination with the graphite pencil to create subtle modeling effects. It can be sprinkled on the paper and then lightly buffed or blended with the fingertips, cotton swabs, or a paper stomp.

FIGURE 4–18
Stick graphite.

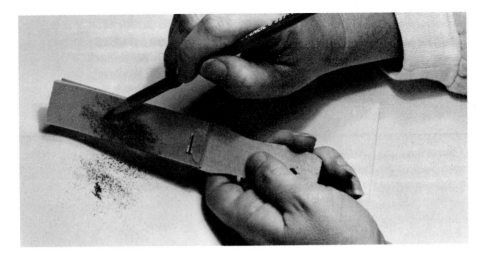

FIGURE 4–19
Graphite powder is created by rubbing graphite against medium-grade sandpaper.

Interesting textural effects can also be achieved by sprinkling powdered graphite on the page and then blotting, rather than rubbing, the surface with a sponge or rough textured fabric that has been lightly dampened with turpentine or another solvent (Fig. 4–20). Interesting value contrasts can be formed by applying Friskit (a liquid masking solution) to the paper's surface and working over it with dark, powdered graphite. When the Friskit is peeled off (like masking tape), a clean, light surface will appear below the dark surface.

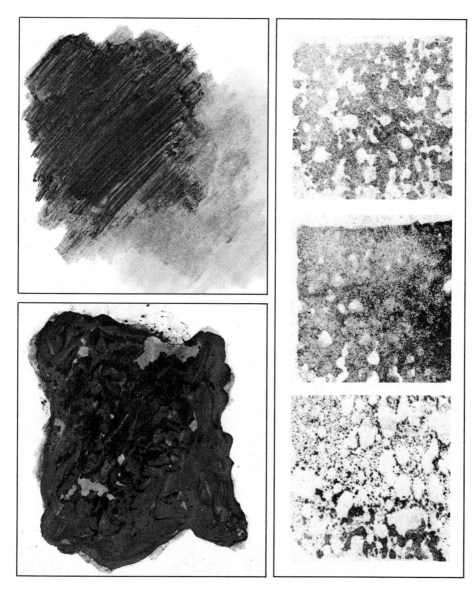

FIGURE 4–20
(Left, top) powdered graphite applied thickly (left) and thinly (right). (Left, bottom) polished graphite; (left, top-to-bottom) wet-to-dry applications of graphite.

If powdered graphite is mixed with a small amount of turpentine, it can be made into a fluid paste that can be applied to the paper with a soft sable brush (Fig. 4–21). After the initial application, the area can be buffed lightly with cotton swabs to produce a rich, dense black. Later, these areas can be drawn into and developed with hard or soft graphite pencils. They can also be blotted with a clean kneaded eraser to produce interesting textural effects and different values.

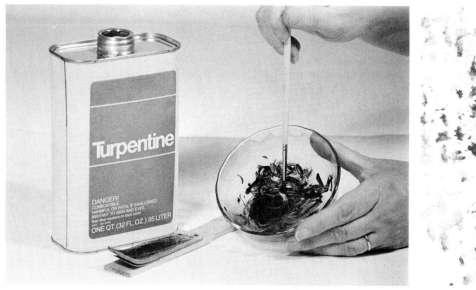

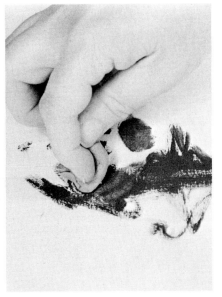

FIGURE 4–21
Making liquid, powdered graphite is a good way to make use of pencils that have become too short to use. To do this, first grind a 2B–5B pencil into a powder by rubbing the pencil against sandpaper. Then, using a small, soft-haired brush, apply rectified turpentine to the powdered graphite and mix it into a thin paste (top left). Apply the mixture directly onto the paper with a brush or burlap (top right). Create washes by thinning the mixture with the turpentine. Create impastos by mixing a thicker paste containing a higher porportion of graphite than of turpentine. Finally, buff with a cotton swab (bottom left) or blot with a clean, kneaded eraser (bottom right).

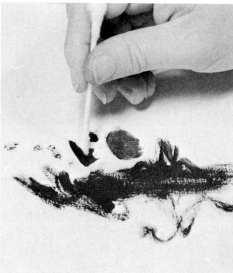

COLORED PENCILS

Professional-quality colored pencils became commercially available to artists about 50 years ago, although variants of the medium existed much earlier. In essence, colored pencils are manufactured by the same basic process that is used to make graphite pencils. However, the "leads" of colored pencils are composed of different ingredients and are hardened by drying under controlled conditions rather than by firing in a kiln. Although each colored lead is made with its own unique formula, the basic ingredients include permanent colored pigments, a synthetic wax base, and a clay binder. The pigment gives the lead its color, the wax causes it to flow, and the binder holds it together. As with most artist's materials, some brands of colored pencils are of higher quality than others. The better brands are made with light-fast permanent pigments. The best known manufacturer of professional-quality colored pencils currently produces a range of 72 different colors. Artists can purchase colored pencils either individually or in sets of several different sizes. Most manufacturers identify the color of individual pencils with a trade name and number, for example, crimson lake–925 (Fig. 4–22).

FIGURE 4–22
Colored pencils.

Colored pencils can be used on a variety of working surfaces. Excellent results can be obtained on medium-weight cotton drawing paper with a medium-rough surface. Interesting effects can also be achieved by drawing on either light or dark colored papers or on Bristol board coated with polymer gesso. Colored pencils produce less effective results when used on slick-surfaced, clay-coated papers.

Colored pencils are a clean and convenient way to work in color. They are inherently a semi-opaque medium. However, depending upon how they are used, they can produce effects ranging from brilliant impastos to transparent washes (achieved by mixing the medium with solvents).

Color quality is largely determined by the amount of pressure the artist applies to the pencil while drawing. If light pressure is applied, the pencil will produce lighter, transparent colors, often allowing the white of the paper to show through. In fact, some artists utilize the inherent white surface of their drawing paper to achieve lighter values similar to the way this same technique is used in watercolor. If the artist applies more pressure, the pencil will produce darker, opaque passages of color. Placing a sheet of smooth, durable padding under the drawing surface when working helps to create smoother solid areas of color.

Most artists prefer to mix their colors rather than use the "raw" color inherent to a single pencil. Subtle changes of a single color can be achieved by mixing it with another color to change its hue or with black, white, or gray to change its value. Colors can be mixed by applying from two to ten successive layers of color over one another. Colors can be most effectively mixed by applying darker colors over lighter colors. However, interesting effects can also be created by applying lighter colors over darker colors. In addition, colors can be rubbed and burnished with a white pencil or paper stomp to produce interesting value and textural effects.

Some artists do not mix colors by layering. Rather, they prefer to apply their colors as the impressionists did, by placing tiny flicks or dots of color adjacent to each other to achieve sparkling color effects. Colors also can be mixed by blending them with a colorless blender (unpigmented art marker) which chemically dissolves the binder. This method can be used to produce solid areas of even color or transparent modulated areas of color without buckling the paper. The tip of the blender should be cleaned each time it is used to prevent the intermixing of unwanted colors.

Transparent and wash effects can be achieved by mixing colored pencils with a solvent such as turpentine or water. (Almost all colored pencils can be dissolved with a turpentine solvent. However, there are certain colored pencils called watercolor pencils (Fig. 4–23) that can also be dissolved with water.) Solvents are normally applied to a predrawn area with a soft-haired or bristle brush. In addition, the pencil's lead can be made into a powder by abrading it against a sandpaper block and then mixing this powder with a solvent to form a thin, opaque paste or a transparent wash medium.

FIGURE 4–23
Watercolor pencils.

Corrections can be made in colored pencil by first blotting the unwanted area with a soft kneaded eraser to remove as much of the pigment as possible and then carefully erasing with a nonabrasive vinyl or rubber eraser. Corrections also can be made by working darker colors over unwanted lighter colors.

Occasionally, several weeks after completion, colored pencil drawings develop a condition known as "wax bloom." Wax bloom is caused by wax, contained in the pencil's lead, rising to the surface of the paper. This effect produces a foggy, out-of-focus appearance upon certain areas of the drawing's surface. It is no reason for concern since it can be corrected by simply wiping away the wax with a soft cloth. If the area is wiped gently, its color quality will not be altered. Wax bloom can also be prevented by spraying the finished artwork with a fixitive. However, because they contain acidic chemicals, fixitives should be used with caution.

Colored pencils are a versatile medium that can be combined with other colored media such as pastels, oil pastels, or watercolor. In addition, artists often use them to embellish drawing media such as graphite pencil and charcoal.

When completed, colored pencil drawings do not need to be sprayed with a fixitive since they contain sufficient binder to adhere the medium to the paper's surface. They should be mounted or matted and framed under glass.

Red Grooms

Is there a place for humor in the visual arts? Red Grooms seems to think so. Nicknamed after the color of his hair, Grooms was born in Nashville, Tennessee, in 1937. He studied at Peabody College; New School for Social Research, New York; School of the Art Institute of Chicago; and the Hans Hofmann School, Provincetown, Massachusetts. Grooms currently lives in New York City.

Red Grooms has been an innovative force in the contemporary art scene since the mid-1950s, when he was one of the originators of Happenings. A Happening is a type of improvised, spontaneous performance enacted by a group of people; there is no audience, only participants in the event. Grooms has worked in an extensive variety of artistic media and has designed costumes and sets for theater productions and motion pictures.

Many of his endeavors defy precise categorization. One such example is his famous installation, *Ruckus Manhattan.* An overwhelming, three-dimensional comic construction of New York City, the artwork was exhibited in the summer of 1976. Like his earlier Happenings, Ruckus Manhattan invites its audience to participate as both participants and subjects as they wander through the artist's "reconstruction" of their city.

The pervasive influence of city life reveals itself once again in Red Groom's colored pencil drawing *Nighthawks Revisited* (Fig. 4–24 and Plate 7), executed in 1980. This composition is a

FIGURE 4–24 Red Grooms, *Nighthawks Revisited*, 1980. Colored pencil on paper, 44¼" × 75¼'. Collection of the artist.

humorous parody of an earlier drawing, *Nighthawks* (Fig. 4–25), created by the renowned American artist Edward Hopper in 1942, as a study for his now famous painting of the same name.

Hopper's drawing depicts the patrons of a corner diner engulfed in the solitude of night. Hopper executed his work in conté crayon applying the medium in broad strokes to form the massive architectural framework of his drawing. He intentionally punctured this framework with a large rectangle of stark, "fluorescent" light that forms the interior of the diner and spills onto the outside street. This dramatic interplay of light and dark structures the drawing and establishes its mood of desolation. The lonely mood is amplified further in that there are no signs of life in the empty street and very little interaction between the patrons inside the diner.

Grooms's homage to Hopper borders on comic sacrilege. Ironically, both artists are present to witness the tribute. The good-natured red-haired waiter is Grooms himself, and the blocky figure smoking a cigarette and drinking coffee is none other than Edward Hopper. Next to Hopper, a well-dressed man sops gravy from his plate while his girlfriend in a polka-dotted dress attempts to eat spaghetti hanging from her fork. The curiously detailed interior of the diner includes dangling flypaper, today's menu with yesteryear's prices, and a "girly" magazine tucked under the luncheon counter.

Outside, the comedy continues. A nine-legged cat scurries across the street (are the nine legs symbolic?) while its colleague rummages in the trash. Empty liquor bottles litter the street, and a monstrous, finned Cadillac, with a woman in the back seat, waits expectantly at the curb.

The clutter makes its point and fills the lonely void. Yet, there sits a disgruntled Hopper hovered over his steaming coffee anxiously waiting to clean up the scene and restore a semblance of order and solitude.

FIGURE 4–25
Edward Hopper, *Drawing for the Painting NIGHTHAWKS,* **1942. Conté on paper, 7¾" × 14". Collection of Peter R. Blum.**

PART THREE

Drawing Materials and Techniques: Fluid Media

5

Inks, Pens/Oriental Brush and Ink

INKS

Chinese Ink

The first inks were made in Egypt and China during ancient times. These inks, called black carbon inks, were prepared by mixing carbon particles with a glue or gum binder and water to produce a dense black liquid that was used for writing and artistic purposes.

The ancient Chinese experimented wtih variations of the early carbon ink formula and added certain ingredients to improve its technical and visual qualities. Later, the preparation of ink was often accompanied by traditional ceremonies, and the secret formulas were passed from one generation to the next. Once the ingredients were mixed, chinese ink was customarily dried and shaped into small, solid sticks or cakes that were often elaborately ornamented. Solid sticks were preferred because they were more practical to transport and store than liquid ink. Artists rubbed the sticks against small, abrasive slabs made of decorated stone, clay, or bronze and mixed the fine-grained particles with water to produce a paste or liquid ink (Fig. 5–1).

Because they were high-quality, permanent, and convenient to ship, chinese inks were marketed in many parts of the Western world. Today, they are still sold in both the East and the West. Although the sticks are not as widely used as in ancient times, many artists still prefer them over other types of inks. Recently, manufacturers have started producing chinese ink in a liquid form.

76

FIGURE 5-1
Stone slab and Chinese ink sticks

India Ink

In seventeenth-century Europe, the carbon ink sticks that were imported from the Orient were known as either "Chinese ink" or "Indian ink." As European manufacturers began to produce their own carbon inks, these terms were interchangeably used to refer to black carbon inks in general.

Today, india ink is made with essentially the same ingredients that were used in ancient times. Contemporary india ink is made in a liquid form and is available in two basic formulas: nonwaterproof and waterproof (Fig. 5-2). Nonwaterproof inks are made by combining carbon, a gum binder, and water. Waterproof inks are also composed of carbon and a gum binder; however, shellac or rosin is added to make them waterproof when dry. Both inks are extremely permanent since their carbon base is virtually unaffected by deterioration.

Both nonwaterproof and waterproof india inks can be diluted with water to produce transparencies. Most artists prefer the waterproof ink for general drawing purposes, whereas they prefer the nonwaterproof ink for more delicate work and particularly for ink washes. India ink works best when it is used on smooth toothed papers that are slightly absorbent or on smooth Bristol board.

Bistre

Several centuries ago, artists prepared ink and watercolor from a brownish substance they called bistre. Artists made bistre by scraping wood soot from chimneys and then soaking or boiling the soot in water. As the solution soaked or boiled, bistre, a soluble tar, was extracted. Later the solution was strained and allowed to evaporate until a rich brown liquid remained. Sometimes the evaporation process continued until solid cakes of bistre were formed. Occasionally, a gum arabic binder was also added to improve the quality of the medium.

Bistre ink or watercolor produced rich, brown color that could be diluted to achieve a range of transparent values. However, since it was somewhat transparent, it could not produce extremely dark values. Although the term *bistre* is still used to identify certain artists' colors, artists' suppliers no longer produce true bistre. Figure 5–3 is an example of a drawing using bistre ink.

FIGURE 5–2
India ink

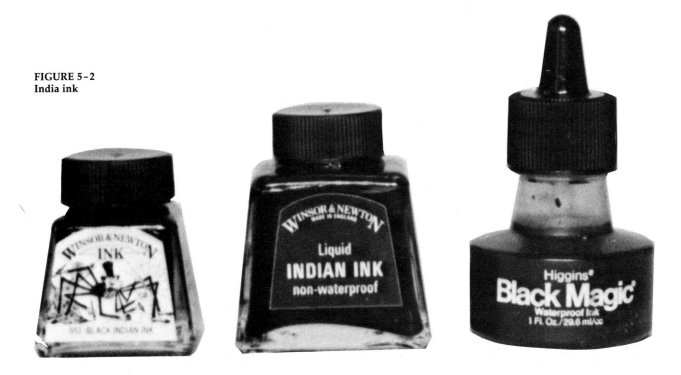

F. H. N⁰ 133

FIGURE 5–3
Nicholas Maes (?),
A Woman Hanging to the
Gallows, **17th c. Brown ink and**
brown wash on cream antique
laid paper, 160 × 93 mm. *Fogg*
Art Museum, Cambridge (Bequest of
Charles A. Loeser).

Sepia

Sepia is a type of ink that came into popular usage during the nineteenth century. Originally, sepia was prepared from the dark, brownish-black fluid contained in the sacs of cuttlefish and squid. When frightened, these marine animals discharge this inky fluid to cloud the water for self-protection.

Although artists used sepia for drawing purposes, more frequently they used it as a wash medium. They particularly prized the extensive range of dusky tonalities that could be produced when the medium was diluted with water.

Artists began to use the word *sepia* to describe not only the original ink but also other dark brown-colored artists' media. Today, *sepia* is a generic term that is used to describe a variety of dark brown inks, watercolors, oils, and other artists' media.

FIGURE 5-4
Giovanni Domenico Tiepolo,
The Spring Shower, c. 1790. **Pen and brown ink, brown wash over black chalk, 11¾" × 16¼".**
Cleveland Museum of Art, Cleveland (Purchase from the J.H. Wade Fund).

Manufacturers no longer make sepia inks with the original ingredients. Instead, they make them by mixing carbon particles with a synthetic dye. Now, as in the past, artists use modern sepia inks primarily as a wash medium. Figure 5–4 is a sepia ink drawing.

Colored Inks

Artists have traditionally preferred to create their ink drawings and washes in one or two colors, although there are many exceptions. In earlier times, artists extracted colorants for inks and washes from natural ingredients as unusual as blackberries or flower petals.

FIGURE 5–5 *(left to right)*
Reed, metal, and quill pens

Today, manufacturers have standardized the production of colored inks, which are currently produced in two basic types. The first is a waterproof ink made with synthetic dyes which fade rather quickly. This ink should not be used to create artworks if permanence is desired. The second type of colored ink was developed in the mid-1970s. Here permanent pigments are used as colorants, thus making the ink relatively permanent. These inks are available in nine basic colors that can be intermixed to form a range of color variations.

PENS

Ink can be applied to a drawing surface in various ways. Most frequently, it is applied with familiar instruments like pens and brushes. However, although they are not as commonly used, materials such as pointed sticks or twigs, fabrics, and sponges can also be used to apply ink.

When drawing with ink, artists traditionally have used three types of pens: reed pens, cut from the thin stalks of water reeds and bamboo; quill pens, made from bird feathers; and metal pens, fabricated from metals and alloys. In addition to these pens, contemporary artists can select from an assortment of pens and markers, like fountain pens, technical pens, and felt- or nylon-tipped markers.

Reed Pens

In ancient times, scribes and artists fashioned the first ink pens from the thin hollow stalks of water reeds and bamboo. Some contemporary artists still draw and write with reed pens. Their basic structure has remained unchanged since antiquity. Reed pens can be made from various types of reeds, cane, or bamboo. Although generally similar, each material has slightly different physical characteristics.

Once a proper reed has been selected, its stalk is cut into a shaft about the length of a common pencil, and a nib is shaped at one end. The nib can be fashioned into blunt, angled, chiseled, or medium-pointed tips (Fig. 5–5). However, because the reeds are so fibrous, it is difficult to cut and maintain a fine-pointed nib without weakening its tip.

Jackson Pollock

Today, many art critics and historians consider Jackson Pollock (1912–1956) to be the most important American artist of the modern era. Yet, more than 30 years after his death, his artwork still "raises eyebrows" and often engenders controversy and ridicule from the general public.

Pollock was born in Cody, Wyoming, but eventually settled in New York City where he studied art under the American regionalist, Thomas Hart Benton. In his formative years, Pollock was also influenced by the Mexican mural painters José Clemente Orozco and David Alfaro Siqueiros. Like them, he was at one time employed as a mural painter. Pollock was also intrigued by the techniques used by the American Indian sand painters of the West. Some historians feel this interest was a seminal influence upon the artist's mature style that developed from 1948 to 1952.

Pollock was one of the innovators of a style of art called Abstract Expressionism, which emerged as a dominant movement in American art during the late 1940s. The Abstract Expressionists, also called action painters, proposed that the act of painting, not the representation of subject matter, should be the primary consideration of the artist. The roots of this movement can be traced to the European Surrealists who developed the concept of automatic mark-making several decades earlier. Pollock seldom discussed or wrote about his art; however, in a rare instance he described his approach to painting in the following statement:

I hardly ever stretch my canvas before painting. I prefer to tack the unstretched canvas to the hard wall or the floor. I need the resistance of a hard surface. On the floor I am more at ease. I feel nearer, more part of the painting, since this way I can walk around it, work from the four sides and literally be in the painting. This is akin to the method of the Indian sand painters of the West . . . When I am in my painting, I'm not aware of what I'm doing. It is only after a sort of 'get acquainted' period that I see what I have been about. I have no fears about making changes, destroying the image, etc. because the painting has a life of its own. I try to let it come through.[1]

Pollock was obsessed with drawing. During his brief career (1930–1956) he is known to have created more than 533 drawings in a variety of media. He did not make drawings as preliminary studies for paintings but viewed drawing as a primary, direct means of artistic expression. Pollock often created his drawings using unconventional materials or he combined drawing media with painting and collage, thus sometimes making it impossible to categorize his work as either drawings or paintings. Pollock himself was aware of the similarities as evidenced by this explanation:

The source of my painting is the unconscious. I approach painting the same way I approach drawing, that is direct—with no preliminary studies. The drawings I do are relative to my painting but not for it. When I am painting I am not much aware of what is taking place—it is only after that I see what I have done.[2]

Pollock's untitled ink drawing (Fig. 5–6), although small in scale, is a visual counterpart to his larger paintings from this same period. Here, as in his paintings, the marks reveal the motions made by the artist's hand as he splashed, dripped, and flung his ink upon the drawing surface. Although he applied the ink spontaneously, the marks are largely contained within the page. They are, in fact, surrounded by a border. It is this combination of freedom and restraint that ultimately makes the work so appealing, clarifying it and keeping it from becoming simply a mass of interwoven lines.

[1] Francis Valentine O'Connor and Eugene Victor Thaw, eds. *Jackson Pollock: A Catalogue Raisonné of Paintings, Drawings and Other Works.* New Haven and London: Yale University Press, 1978, page xviii.

[2] O'Connor and Thaw, page xviii.

FIGURE 5–6
Jackson Pollack,
Untitled, **N.D. Ink on paper,**
17¼″ × 22¼″. *Private Collection,*
New York.

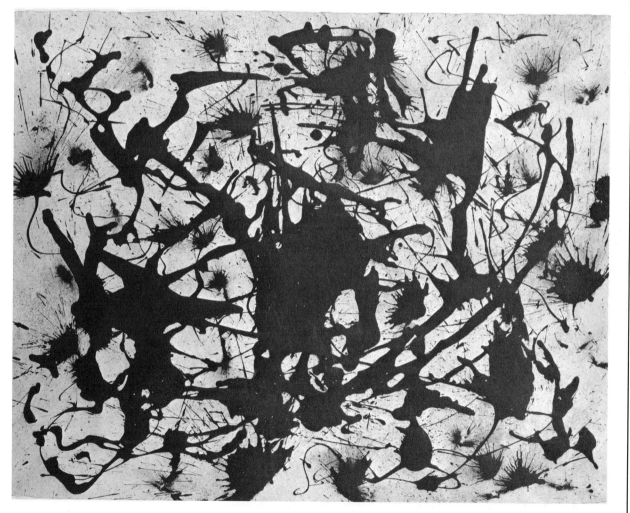

The fibrous nature of the reed pen contributes to the unique appearance of its mark. To prevent weakening, the reed pen must be cut with a rather wide, blunt nib instead of a fine, pointed one. A pen with a wide nib depletes the supply of ink in its reservoir faster than a pen with a narrow nib. Consequently, the reed pen produces a wide, short mark rather than a narrow, extended one. Also, when fully loaded with ink, the pen's nib produces a dense, bold mark. As the supply of ink dwindles, the pen's nib yields a drier almost "scratchy" line. When used for an extended period of time, the pen's nib becomes impregnated with ink. It tends to get spongy and limp. To alleviate this problem, artists often cut several pens and alternate their use when drawing. Another solution involves using pens that are cut with a nib at each end; the pen is simply flipped over when its nib becomes too weak to use. When a nib is no longer useful, a new one can be cut further up the shaft.

Although artists often make their own reed pens, they are also available commercially. They are usually sold as precut bamboo pens in various sizes. Some models have a nib cut at one end and a soft-haired, pointed brush attached to the other end.

Reed pens work best when they are used with a dense, yet fluid carbon ink (such as india or chinese ink) on a medium-textured drawing surface. Its thick, hollow-walled stalk makes the reed pen somewhat inflexible. Therefore, it does not glide over the paper with the effortless fluidity of a quill pen. Nevertheless, it moves without dragging and does not gouge the paper's surface. Also, because it is rather inflexible, the pen does not respond well to variations of pressure exerted by the artist's hand while drawing. Consequently, it produces lines that are similar in width.

Quill Pens

Although they existed earlier, quill pens came into common usage during the Middle Ages when monks used them for lettering and illustrating religious manuscripts. Unfortunately, they are not frequently used today even though they are still considered ideal instruments for writing and drawing in ink.

Quill pens were made from the wing feathers of birds, most commonly goose, swan, raven, and crow. Of these, goose quills were routinely used while raven and crow quills were reserved for finer, more intricate work.

The physical characteristics of the quill make it ideal for use as a drawing instrument. Structurally, it is a light, hollow-walled, feathered shaft composed of a substance that resembles a human fingernail. Like a fingernail, it is durable, yet also soft and pliable. These features make it easy to cut and fashion into a drawing nib. Unlike its predecessor the reed pen, the quill can be shaped into a variety of drawing nibs that include blunt, medium, and fine tips, as well as angular chiseled ones (Fig. 5–7). In addition, once cut, a fine tip can be made even finer by abrading it against sandpaper. Since it is durable, the tip of the quill does not wear down too quickly; however when it does, a new nib can be cut further up its shaft.

FIGURE 5-7 *(left to right)*
Bamboo, quill, and reed pens and the
marks they make

Because it can be fashioned with so many different tips, the quill pen can
produce an array of marks that vary considerably in their appearance. If cut at an
oblique angle, the nib can create wide, flowing, arabesque lines. When sharpened
to a delicate point, it can create thin, hairlike lines.

As noted, the quill pen is light and flexible. These features enable it to
gracefully glide across the page without dragging or abrading. Also, because it is
light and flexible, the quill is responsive to the slightest variations of pressure
from the artist's hand. If a slight downward pressure is exerted, the quill will
produce a thicker, wider line; more subtle manipulations will create the distinctly
personal, autographic marks that are so characteristic of this instrument.

Quill pens work best when used with a rather fluid ink on soft, medium-
textured paper. They are also especially adaptable for use on soft, handmade
papers with a slight grain.

Vincent Van Gogh

Vincent Van Gogh was a prolific artist who experimented with a wide variety of drawing media throughout his artistic career. In the winter of 1888, when he was 35, Van Gogh left Paris, where he had been working, to seek a warmer climate in Arles, in the south of France. He was enamored by this new environment, and the landscape surrounding Arles soon became a dominant subject of his drawings and paintings.

Interestingly, not only did the landscape inspire Van Gogh's subject matter but it also provided him with a new drawing instrument, which he fashioned from the hollow reeds that grew in the countryside. Earlier, when in Holland, Van Gogh had drawn with reed pens but found them lacking in quality. However, in Arles he found better reeds which he cut and shaped with tips like those of a quill pen. During the next several months, Van Gogh executed dozens of landscape drawings with reed pens, often using them in combination with other pens or with drawing media such as pencil, chalk, and wash.

Van Gogh used several approaches when creating his landscape drawings. Sometimes he drew on location and later used the drawing as the basis for composing a painting. In other instances, he reversed this procedure and used a painting as the basis for creating a drawing.

There is a direct relationship between many of Van Gogh's reed pen drawings (Fig. 5–8) and the landscapes he painted in Arles (Fig.

5–9 and Plate 7). In both, he established the major planes of the artwork by the strategic placement of different textural elements, such as staccato lines, arabesque swirls, and stippled dots. By varying the placement, direction, and value of these marks, he was able to create an illusion of depth through a distinct separation of planes.

Van Gogh found the reed pen well suited to his impulsive, energetic drawing technique. He used its blunt nib, loaded with ink, to form the short, dark lines of the foreground of *Field with Flowers.* Then, using a similar technique, he stippled the individual dots to form the middleground represented by fields of grain. Further, he took advantage of the dry, scratchy nature of the pen's nib, when depleted of ink, to capture the indistinct appearance of distant landscape forms.

FIGURE 5–8 *(far left)* **Vincent van Gogh,** *View of Arles,* **1888. Quill drawing in black ink which has turned brown,** **17⅙″ × 21⅝″.** *Museum of Fine Arts, Rhode Island School of Design, Providence (Gift of Mrs. Murray S. Danforth).*

FIGURE 5–9 *(below)* **Vincent van Gogh,** *View of Arles with Irises,* **1888. Oil on canvas, 21¼″ × 25⅝″.** *National Museum of Vincent van Gogh, Amsterdam (Vincent van Gogh Foundation).*

Leonardo da Vinci

During his lifetime, Leonardo da Vinci created over 2000 drawings, many of which, unfortunately, have been destroyed. Leonardo drew with a variety of traditional drawing media including natural chalk, silverpoint, wash, and the quill pen. His approach to subject matter was even more diverse than his media. His interests ranged from subjects as evasive as flowing water and the wind to those as concrete as anatomical dissections and war machines.

Grotesque Heads (Fig. 5–10) is an ink drawing Leonardo drew with a quill pen around 1490. At this point in his career Leonardo developed an interest in people with bizarre or eccentric facial characteristics. According to the sixteenth-century art historian Giorgio Vasari, when Leonardo happened upon such people he would follow and study them the entire day so that later in his studio he was able to draw them as though they were present.

Grotesque Heads is an interesting exercise in portraiture. At first glance, it seems to simply depict four heads symmetrically grouped around a central image. However, upon further examination, it becomes apparent that Leonardo has planned the placement of each head to depict the range of traditional portrait positions. For example, he placed a sharply defined, classical profile in the center of the page and then flanked it on either side with three-quarters profiles and above with frontal portraits.

In addition to depicting a range of portrait positions, Leonardo has exaggerated the features of each face to portray a gamut of expressions, ranging from the classical dignity and restraint of the central character to the shrieking screams of the madman shown in the upper left of the drawing.

The responsive nature of the quill pen is evident in Leonardo's drawing. In certain areas, like the hooded collar and shoulders of the central figure, he used the quill with a flourish of rapid strokes and varying pressures. He formed the thicker, darker lines by exerting heavier pressure on the pen when it was loaded with ink. In other areas, such as the foreground, he formed lighter, scratchy lines by applying less pressure on the pen when its ink supply was nearly depleted. When executing the more detailed facial features, he applied steady pressure on the pen and drew thin, hatched lines. He carefully controlled their placement to create an illusion of volume.

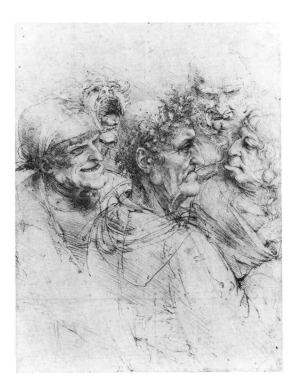

FIGURE 5–10
Leonardo da Vinci,
Five Grotesque Heads, **c. 1506–17.**
Pen and brown ink,
10¼″ × 8½″. *Windsor Castle, Royal Library.*
© *Her Majesty Queen Elizabeth II.*

Metal Pens

Attempts were made to produce metal pens as early as ancient times. Nevertheless, it was not until the early nineteenth century that they were commonly manufactured and used. Initially, metal pens were mass produced for writing purposes. However, artists began to use them, and they gradually replaced the reed and quill pen as a favorite drawing instrument.

The first mass-produced metal pens were standardized steel nibs that were inserted and held in a simple wooden holder. Steel pens became popular because they had a number of practical advantages over reed and quill pens. Steel pens were ready-made; it was not necessary to cut and prepare their nibs. They were durable and long lasting. Further, they could be purchased in an assortment of standardized nibs that would produce the same consistent mark each time they were used. Finally, steel pens could hold a larger supply of ink than their predecessors. Steel pens did have a major disadvantage—they tended to incise and sometimes gouge the paper. However, that problem was eliminated in modern times when special, hard-coated papers were developed for use with pen and ink.

The nibs of the first mass-produced steel pens were shaped to imitate quill pens. In fact, some contemporary manufacturers still label certain nibs with names derived from the quill, such as "crow quill" or "hawk quill." Today, most nibs are made of stainless steel or are coated with gold or brass to prevent corrosion. They are manufactured in a multitude of sizes and shapes ranging from extra-fine points that can produce delicate, barely visible lines to broad steel brushes nearly an inch wide. In addition to drawing points, there are special nibs for calligraphy, lettering, mechanical drawing, mapping, and a host of other purposes. Now as in the past, contemporary steel nibs are held in a simple wooden (or plastic) penholder that accommodates a range of interchangeable nibs (Fig. 5–11). Steel pens function best when used on hard-coated papers that are specifically designed for this purpose. Often these papers are bleached to provide a more brilliant contrast when used with carbon black ink.

FIGURE 5–11
Various metal nibs and the marks they produce

Alexander Calder

Alexander Calder is an American artist who received his initial training as a mechanical engineer before deciding to study art at the age of 25. He is best known as the innovator of the mobile, a type of kinetic sculpture that clearly reflects his background in engineering.

Calder's wit and playful personality are readily apparent in many of his artworks. Early in his career, while working in Paris in 1927, he designed and built a miniature mechanical circus, complete with animated performers and animals. Calder created many of his figures from thin wire that he twisted and manipulated into semiflat, sculptural forms. Indeed, many of these whimsical figures appear as though they are drawn in wire suspended in space.

While he was creating his circus, and for some time thereafter, Calder made a number of ink drawings that echo the concept of his wire sculpture.

Calder's drawing *Rodeo Style* (Fig. 5–12), executed with a metal tipped pen, is humorous in its conception. An oversized horse and rider has lassoed and subdued a small milk cow. The witty shapes of these spirited figures are animated by playful, energetic lines that effortlessly flow from Calder's pen. These lines visually retrace the movements of the artist's hand and have a life of their own, beginning as dark, forceful marks made with a loaded pen and gradually fading into a delicate tracery as the ink supply dwindles. The arabesque lines of the figures are counterbalanced by a straight, diagonal line that connects and establishes a tension between the large horse and rider and the small, startled cow. Still, the drawing apears as a comic standoff rather than a perilous confrontation between man and beast.

FIGURE 5–12
Alexander Calder,
Rodeo Style, **1932. Ink**
drawing, 9¹⁄₈″ × 18⁵⁄₈″.
Philadelphia Museum of Art,
Philadelphia (Purchase of The
Harrison Fund).

Fountain Pens

The fountain pen holds a self-contained supply of ink that automatically flows into the pen's nib as it is used. In some models, the ink reservoir is an integral part of the pen, while in others it is simply a replaceable ink cartridge. Fountain pens can be purchased with a standard, permanent nib or with a variety of threaded, interchangeable nibs. The main advantage of the fountain pen is that it is clean and convenient to use. The hazards of repeatedly dipping the pen in a bottle of ink are eliminated.

Technical Pens

The technical pen is a modern innovation that is used by draftsmen and artists alike. Like the fountain pen, these sophisticated instruments hold a self-contained ink supply, but in the form of a refillable cartridge. The pen's nib is made of stainless steel and is shaped like a hollow needle with a flat end. The nib is positioned centrally rather than on the side of the pen's shaft (Fig. 5–13). The centering of the tip enables the artist to manipulate the pen in any direction while drawing. The points are available in at least 13 different metric or standard nibs. The technical pen is unexcelled for predictable and consistent results. It dispenses an even flow of ink and produces clean, crisp lines of unvarying width.

Technical pens are designed to be used with specially formulated water-soluble inks. These inks are available in permanent carbon black or in an assortment of dye-based nonpermanent colors. Technical pens should be cleaned frequently for preventive maintenance, preferably with a commercial cleaner specifically formulated for this purpose. When not in use, the pens should be completely cleaned, or if filled with ink, stored in humidified receptacles to prevent clogging.

FIGURE 5–13
Technical pen with nibs

Herbert Fink

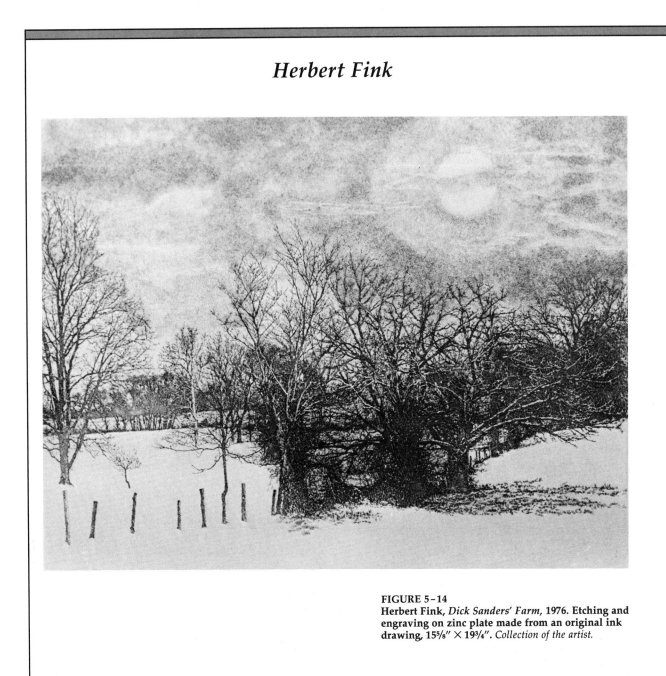

FIGURE 5–14
Herbert Fink, *Dick Sanders' Farm,* **1976. Etching and engraving on zinc plate made from an original ink drawing, 15⅝″ × 19¾″.** *Collection of the artist.*

Herbert Fink is a contemporary American artist who often draws with a technical pen. His landscape drawing *Dick Sanders' Farm* (Fig. 5–14) was executed with this instrument.

Before be begins a landscape drawing, Fink contemplates his subject for a considerable time, often months and sometimes years. In this instance, he had made numerous visits to a friend's farm and had observed this landscape under different conditions throughout the seasons. Fink has always been fascinated by trees, and in his landscape he was particularly intrigued by three large oaks growing along a fence line, flanked by a hedge row.

Fink considers the composition of his drawings to be as important as their imagery. When visually composing his landscapes, he looks for an inherent, hidden geometry that he later uses to create the underlying structure and rhythm of his drawings.

Fink composed *Dick Sanders' Farm* by first establishing the dominant group of three trees that divides the work slightly to the right of its vertical center. Next, he established the dark band of trees that roughly divides the page into horizontal halves. Once he had created these major divisions, Fink divided the horizontal ground plane into three diagonal shapes, separated by distinct value changes, which echo the separation seen in the three trees.

Fink created *Dick Sanders' Farm* in the following manner. He began by contemplating the landscape and making mental compositions over an extended period of time. He then made a group of small thumbnail sketches to plan the general composition of the drawing. When he felt that "conditions were correct," he used several rolls of film and photographed the scene on location. (Although he prefers to draw on site, Fink considers the camera a sketching tool that enables him to quickly capture the "specifics" and details of a particular scene. He uses his photographs as a reference and, while drawing, relies heavily upon his imagination rather than striving for an accurate photographic reproduction.)

Fink executed his drawing on two-ply illustration board using a technical pen with a series of three different, interchangeable points (000–0–1) to achieve a variety of linear widths. He used a jewel-tipped pen with a sapphire point rather than a common steel-tipped pen, since this pen point is long wearing and produces a constant flow of ink without clogging.

Due to his extensive training and previous preparation, Fink was able to begin his drawing directly in ink, without using pencil guidelines. He first established the basic structure of the three large trees and then proceeded to lay in the tree line in the center of the drawing before finally developing the ground plane.

Fink worked from general areas to more specific details and added what he calls the "ornamentation" last. Like a watercolorist, he planned the white areas of his drawing in advance and gradually filled in the darks until he had achieved the desired effect. He built his black areas with myriad thin lines and purposefully left traces of the white paper in these "solid" areas so they would not appear flat and "dead."

When drawing, Fink holds his pen like a pencil and pulls the instrument toward himself, so it does not gouge the paper or break the point. Fink often uses a stippling technique to form dotted areas in his drawings. When using this technique, he holds the pen diagonally, rather than vertically, to prevent gouging the paper.

Felt- and Nylon-Tipped Pens

Felt- and nylon-tipped pens were developed during the 1950s. They are currently available in an assortment of styles including those with broad and medium chisel-shaped nibs, as well as thick-, medium-, and fine-pointed tips. The pen's ink reservoir is encased in its shaft and contains a simple, fast-drying, dye-based ink. The inks produce brilliant colors when first used, but since the dyes are not permanent, the colors soon fade. Originally, felt- and nylon-tipped pens were produced for industrial and commercial uses, such as marking or addressing packages. While some artists find them suitable for sketches and layouts, these pens are not recommended when the permanence of the artwork is a consideration.

ORIENTAL BRUSH AND INK

Artists in the Orient have used brush and ink for calligraphic and artistic purposes since at least 300 B.C. Over the centuries, they established traditional techniques for using the medium which were subsequently passed from one generation to the next. These traditional techniques are exacting and highly disciplined. An artist learns the skills by diligently practicing conventional brush strokes and by copying classical masters' painting techniques and compositions. Today in the Orient, many artists still follow the established techniques for using brush and ink. However, in both the East and West other artists have freely adapted the medium to meet a more personal and expressive use.

The traditional Oriental brush-and-ink technique employs an animal hair brush that is used with a carbon-based ink stick called chinese or sumi ink (see chinese ink Page 76).

FIGURE 5-15
Felt-tipped pens

Oriental brushes are made from the hair of certain animals, such as rabbits, wolves, and goats. The brushes' flexibility is determined by the type of hair used in its construction. Rabbit and goat hair are more flexible than wolf hair. The brushes are formed by setting the hair in a small cylinder that is then attached to a bamboo or wooden handle. Some of the bamboo instruments are made with a brush attached at one end of the shaft and a pen nib cut from the opposite end; others have a brush that can be detached and stored inside of the hollow bamboo handle to protect its bristles from damage (Fig. 5–15). By nature, Oriental brushes are soft, flexible, and springy. When dry, the brushes are fluffy and full, but when wetted they quickly assume a compact, pointed shape. Although they are available in gradations of size, only a single brush is needed to produce a remarkable range of effects.

Traditional brush-and-ink artworks are usually created in one of four forms: the hand scroll, the hanging scroll, the album leaf, and the wall painting. The first three forms are executed using the following technique. The artist lays a piece of silk or paper on a flat surface and then loads the brush with ink. While working, the artist holds the brush vertically and manipulates it by raising and lowering the hand which is held suspended in midair above the paper (Fig. 5–16). By controlling the density and flow of the ink and by using both the tip and the body of the brush, the artist can create a multitude of lines that vary both in width and value. The method of execution is direct and swift; there is no possibility for correction. The ultimate success of a brush-and-ink artwork is judged by the freshness, strength, and directness of the artist's brushwork as well as by its aesthetic quality.

FIGURE 5–16
Various brush strokes in the brush-and-ink technique.

Zhou Zhijia

Zhou Zhijia was born in Shanghai, China, in 1950. He studied art at Hunan Normal University from 1973–1976 and at Southern Illinois University from 1985–1987.

When he was six years old, Zhijia began using the Oriental brush to learn Chinese calligraphy. In China, students learn calligraphy as a required course in primary and secondary school. They begin their studies by learning how to make a basic brush stroke. This stroke is executed in three consecutive movements using the tip and body of the brush. First, the direction of the stroke is determined. Next, the brush is "planted" and then moved slightly in the opposite direction of the intended direction of the stroke. Then the stroke is made. Finally, the stroke is terminated by once again moving slightly in the opposite direction of the main stroke. These movements are called the "three folds of a wave." Visually, this three-fold movement creates a strong line with a distinctly defined beginning and end. The beauty of the mark is further determined by the directness of its execution. There are eight basic marks used in Chinese calligraphy. Each can be seen in the eight calligraphic character "Yong" (forever) (Fig. 5–17).

Once he had mastered Chinese calligraphy, Zhijia proceeded to learn Chinese brush painting in which more complex strokes are created by using either the tip or the side of the brush.

Because of the similar way of moving the brush and of creating the strokes, the Chinese believe their calligraphy and brush painting are of the same origin. After artists have mastered the traditional strokes used in calligraphy and painting, they develop individualized strokes that identify the artists' own style.

Zhijia created his ink painting *Lotus* (Fig. 5–18) using traditional Chinese painting techniques. He executed his work on thin, single-layer unsized rice paper in Chinese ink and Chinese watercolor using several different types and sizes of brushes.

The artist mentally conceived his subject and predetermined its placement on the page. Although preconceived, the composition was not rigid or inflexible. Thus the artist was able to capitalize on "happy accidents" that occurred as he developed his painting.

Using the side of a large, flexible goat-hair brush, Zhijia first established the dominant motif of the open lotus. When applied to the unsized paper, the ink flowed freely; Zhijia utilized the liquid quality of his ink to establish the value range of this area. Next, using the same pointed brush, he formed the blooming flower by mixing red

watercolor with delicate traces of ink. The artist then used a smaller, less flexible, wolf-hair brush to paint the stem of the flower and stalk of the lily pad. He then mixed blue watercolor with a light amount of ink for the bladed elements of the drawing, again using a large brush. Finally, he painted the darker descriptive lines and dots of the painting with a small brush.

When completed, the painting was mounted on Chinese rice paper and inscribed and sealed by the artist with Chinese characters. Zhijia carved the seals that he used to imprint the drawing from soft stone. Oriental artists consider inscriptions and seals as integral parts of an artwork's composition. They provide identifying information, such as the topic of the artwork, the name of the artist, and the date of execution. Sometimes they even include poetry.

FIGURE 5–17 *(left)*
Each of the eight calligraphic characters used in Chinese calligraphy can be seen in the character "Yong" (forever).

FIGURE 5–18 *(right)*
Zhou Zhijia,
Lotus, **1987. Brush, ink, and watercolor, 13" × 17".**
Collection of the artist.

6

Brushes and Wash Drawings

BRUSHES

Artists' brushes are currently manufactured in a multitude of styles, shapes, and sizes. Although an individual brush can be adapted and used in many different ways, most brushes are designed for rather specific purposes. To simplify discussion, we will separate brushes into two basic groups: soft-haired and bristle.

Soft-Haired Brushes

Soft-haired brushes are made from the hair of certain animals, such as weasels, squirrels, and oxen, as well as from special synthetic fibers. By nature, these brushes are absorbent, springy, and flexible. Generally, artists use soft-haired brushes to apply fluid media like watercolor or ink wash. In addition, they also use them to apply thin washes of oil, alkyd, and acrylic paints.

 The finest and most expensive soft-haired brush is made from hair taken from the tail of a small, Russian weasel called the kolinsky. Manufacturers commonly, but incorrectly, call these and similar brushes "sable" or "red sable" brushes — names that are intended to associate the brush with the luxurious hair of the Russian sable. (Actually, sable hair is too soft and limp to use for brushes.) High-quality but more moderately priced soft-haired brushes are made from hair taken from the tails of certain species of Russian squirrels and from the ears of various oxen and cattle.

FIGURE 6–1
Soft-haired brushes

In the early 1970s, manufacturers began using a synthetic fiber, developed in Japan, in the production of artists' brushes. These brushes have the same basic characteristics as natural soft-haired brushes. However, they have added advantages in that they are more durable, easier to clean, and less expensive. Currently, these brushes are marketed under the trade names White Sable® or Taklon®.

Soft-haired brushes are manufactured in assorted shapes and sizes. *Rounds*, the most common and versatile shape, have a full, rounded body that swells slightly in the center and then tapers to a naturally pointed tip. *Ovals* have a full, oval-shaped body that falls to a blunt, rounded end. *Flats* are thin flat-bodied brushes that terminate in a straight, squared end (Fig. 6–1).

In addition to these styles, manufacturers also produce brushes that are specifically designed for use with ink and watercolor wash. *Wash brushes* are full bodied and are available in round, oval, and flat styles.

Soft-haired brushes are commonly available in sizes ranging from 000, the smallest, to 12, the largest. Larger sizes can be specially ordered.

Bristle Brushes

As their name implies, bristle brushes are coarse and rather stiff. The best bristle brushes are made from hairs taken from the backs of wild boars from China. Excellent bristle brushes are also made from certain types of common hog bristle. In addition, some manufacturers make bristle brushes from nylon and other synthetic fibers.

Natural bristles are different from hair. They are stiffer and do not terminate in a fine point. Rather, they split into frayed ends. The stiffness and fraying of the bristles make them ideal for applying thick impastos of oil, alkyd, and acrylic paints. Occasionally, artists also use these brushes with ink or watercolor to create dry-brush effects.

Manufacturers produce bristle brushes in several standardized shapes. *Flats* are flat shaped with long bristles that terminate in a straight, squared end. *Brights* essentially are the same shape as flats, except that they have shorter bristles. *Filberts* have a semiflat shape but with a fuller body and a rounded end. *Rounds* are rather long, with a full, rounded body that tapers to a point (Fig. 6–2). Bristle brushes are commonly available in sizes ranging from 1, the smallest, to 12, the largest. Certain brushes can also be ordered in larger sizes.

FIGURE 6–2
Bristle brushes

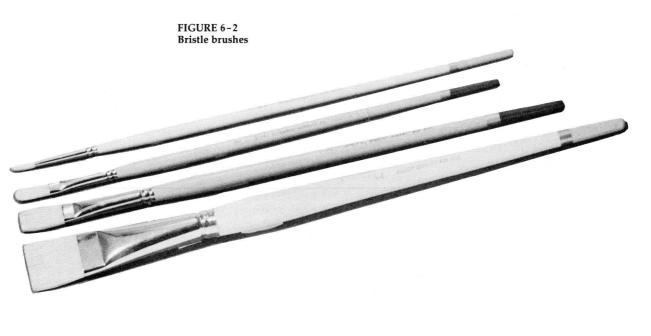

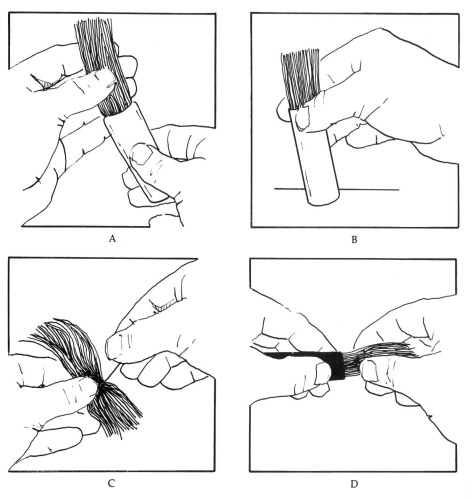

A

B

C

D

FIGURE 6–3
A, B, and C show how bristles are gathered and shaped, and then tied into a bundle. In D, the bundle is inserted into the ferrule, which is later attached to a wooden handle.

How Brushes Are Made

Brushes are made of three basic parts and are assembled in stages. First, the hair or bristles are gathered, shaped, and tied into a bundle. Next, they are inserted and glued into a small, metal cylinder called a ferrule. Finally, the ferrule is attached and crimped onto a wooden handle (Fig. 6–3). Traditionally, and for practical reasons, brushes that are used for watercolor and wash have short handles, while those that are used for easel painting with oil and acrylic have long handles.

Care of Brushes

Brushes should be cleaned immediately after use to ensure their future performance and longevity. Brushes that have been used with a waterbased medium,

FIGURE 6–4
Paint thinner, turpentine, and brushes

such as ink, watercolor, or acrylic, should be rinsed in lukewarm water until clean. Those that have been used with oils or alkyds should be cleaned with a solvent such as turpentine or paint thinner (Fig. 6–4).

After the initial cleaning, the hairs or bristles should be washed in lukewarm water with a mild soap or shampoo. It is important to thoroughly clean the hairs located at the base of the ferrule. Otherwise, dried pigment particles accumulate there and eventually cause the brush to loose its natural shape. After shampooing, the hairs should be completely rinsed in cold water. Then the brush should be shaken and its hairs should be squeezed — not pulled — to remove any remaining water.

Finally, the body of the brush should be restored to its natural shape by pointing, or flattening, the hairs with the fingers. When cleaned, the brush should be stored in a flat position, or with its bristles pointing upright. Brushes should never be left standing upright on their hairs, even for short periods of time, while soaking in a container of water or turpentine. Such positioning can permanently damage the natural shape and texture of the hairs.

WASH DRAWINGS

A wash drawing is a type of artwork that is made by combining techniques of both drawing and watercolor painting (Fig. 6–5). Wash drawings became a popular artform during the fifteenth century when artists began to use transparent ink and watercolor washes to fill in certain areas of their line drawings. Specifically, they used wash to depict the effect of light and shadow, to create an illusion of volume through modeling, and to form spatial and atmospheric effects. Later, as

FIGURE 6–5
Rembrandt van Rijn, *Two Mummers on Horseback*, c. 1640. Pen and ink with wash, 8⅜″ × 6¹/₁₆″. *Pierpont Morgan Library, New York.*

styles changed and drawings became less linear, artists applied washes in a more spontaneous, painterly fashion that often suggested rather than delineated form. In some instances, they applied the wash before the drawing was developed. In other cases, they applied it as a purely independent medium, without reference to a drawing.

Leonard Baskin

Leonard Baskin (b. 1922) is a contemporary American artist who works in a variety of areas including calligraphy, design, drawing, printmaking, and sculpture. Many of Baskin's woodblock prints and ink drawings have been used as book illustrations.

Baskin is a master draftsman who has long been interested in humanist and social issues. He generally depicts representational subject matter and sometimes combines animal and human imagery to create anthropomorphic creatures that defy precise description. Baskin created a group of such works in ink, ink wash, and watercolors entitled *The Raptors and Other Birds* (1964–1984).

Baskin's drawing *Egyptian (Rooster's Head)* (Fig. 6–6) was created using ink and ink wash. It is typical of many of the 65 drawings included in the raptors group.

Raptors are predatory birds with strong notched beaks and sharp claws adapted for hunting and killing. Baskin's rooster is no ordinary raptor. It is a frightening contemporary image—half bird, half human—possessing the most brutal characteristics of each. Baskin's raptor stands poised in a pugnacious military stance, eager for confrontation.

Baskin created his feathered warrior with a masterful unification of image and technique. He created the cock's comb with a dark, jagged-edged wash, making it the most dominant feature of the drawing. The comb established the rooster's identity and sits on its head like a spiked military helmet. The glaring eye is minute, yet hypnotic, as our attention is drawn to it again and again.

Curiously, Baskin did not emphasize the most important characteristic of a bird—its wings. Rightly so, since chickens do not fly. But the artist has created vestiges of wings represented by a thin tracery of lines embellished with an indistinct wash. The impotent wings dissolve before our very eyes as the raptor is transformed from a bird into a human predator.

FIGURE 6–6
Leonard Baskin, *Egyptian (Rooster's Head),* **1971. Ink on paper, 40″ × 27⅛″.**
Photograph courtesy of Kennedy Galleries, New York.

A wash drawing is usually made with a soft-haired brush and a liquid medium that can be diluted to achieve variations of value. In the past, artists made their wash drawings primarily with carbon black, bistre, and sepia inks, as well as with a limited range of transparent watercolors. Today, artists commonly use the contemporary counterparts of these traditional media — india ink and sepia. In addition, they also use water-soluble gouache and acrylic paints and occasionally even oil paints. Often, artists apply a wash with the same medium that was used to create the initial drawing. For example, they make an ink drawing and then develop it with an ink wash. At other times they create the initial drawing with a medium that is different from but compatible to the wash, such as pencil, charcoal, or pastel.

Artists usually use soft-haired brushes to create wash drawings. Generally, they use one of two popular styles. The first, usually made of weasel or squirrel hair, is a round pointed style that is thick in the middle and tapers to a fine point. The second, usually made of ox hair, is a broad, flat shape with a blunt end (Fig. 6–1). Both styles are produced in a range of sizes. Depending upon the brush and how it is manipulated, artists can achieve effects ranging from delicate, thin lines to broad areas of value.

Apply a wash on a thick, good-quality paper with an even grain. Many handmade papers are well suited for use with wash medium because they have a consistent fiber formation. If a wash is to be applied to large areas of the paper, first soak the paper and then, after blotting away excess moisture, tape the paper to a flat surface with paper tape.

To build areas of dark value, apply the wash in several successive layers that gradually move from light to dark. Each layer must dry completely before applying the next. Many washes tend to dry lighter than they appear in their initial application. In such cases, the artist can apply a slightly darker wash to produce the intended result.

APPENDIX
TO PART THREE
Drawing Aids

ERASERS

Natives of Central and South America discovered and used natural rubber long before it was introduced to Europe. During the late sixteenth century, Europeans discovered that rubber could remove pencil marks from paper, and by the late 1800s erasers were commonly used.

Today, erasers are manufactured in assorted shapes and sizes to serve a variety of purposes ranging from removing barely visible pencil marks and smudges to completely eradicating dark ink stains. In addition, artists often use erasers as "drawing" tools.

Erasers are manufactured by combining raw ingredients into a formula that is specific to the type of eraser being made. Although individual formulas vary, the following basic ingredients are used to make erasers: natural rubber, synthetic rubber, Factice, sulfur, preservatives, pumice (a volcanic abrasive material used primarily for ink erasers), colorants, and fillers. In order to work properly, an eraser must wear down or crumble as it is used, otherwise it would simply smear. Factice, a vulcanized oil, causes the eraser to crumble into fragments. When these fragments are rolled across the paper, debris adheres to them and is thus lifted from the page.

Common erasers are manufactured according to the following general process. The raw ingredients are measured and combined into a mixture. The mixture then is made into a uniform dough by repeatedly compressing it between two large, heated rollers. Next, the dough is pushed through a machine that shapes it into long, thin cylinders for pencil erasers (plugs) or wide strips for block erasers.

The cylinders are put in an oven and placed under steam pressure, which cures the material and transforms it from a dough into a solid. Finally, the solid cylinders are cut to length, smoothed, and attached to the end of the pencil by encasing them in cylindrical metal ferrules.

The wide strips of dough that are used to make block erasers are put into molds and placed under steam pressure to make them solid. The slabs then are removed from the molds, cooled in water, and cut to size. Finally, the erasers are placed in heavy, rotating barrels and tumbled against one another to remove their sharp edges.

Types of Erasers

Plug This handy and most commonly used of all erasers is a thin cylindrical plug secured to the end of the pencil by the ferrule. The pink-colored plug is used to erase pencil marks. However, an abrasive, gray plug is also made to erase ink. Generally, the plug is used for making minor corrections.

Pink Pearl Named for its color, the Pink Pearl eraser is made in the shape of a small rectangular block with angled ends. It is durable yet pliable. It is perhaps the most serviceable of all erasers in that it can be used with a variety of techniques to erase a diversity of drawing media. The Pink Pearl is especially recommended for erasing graphite, particularly pencil marks that have been embedded rather heavily in the paper. Because of its size, it is effective for making major corrections and for cleaning heavy deposits of soil and grime from border areas.

For general purposes, the Pink Pearl erases best if carefully rubbed in several different directions, gradually increasing the pressure until the correction is made. However, to make more precise erasures, one end of the eraser can be

Plug erasers

Pink Pearl eraser

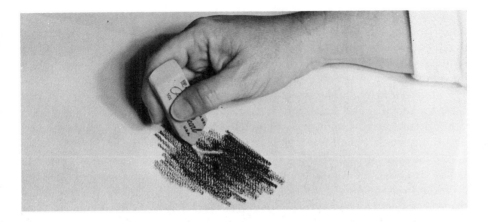

Pink Pearl eraser used as drawing tool

shaped into a thin, sharp edge by slicing it with a single-edged razor blade or by shaping it on a sandpaper block. When the eraser becomes dirty, it can be cleaned by rubbing it against sandpaper or a coarse fabric such as denim.

Unusual visual effects can be created when the Pink Pearl is used as a drawing tool. For example, if one end of the eraser is sliced to form a sharp, chiseled edge, it can be used to "cut" light lines and accents through existing dark areas. Also, if the edge of the eraser is coated with a solvent, such as turpentine or oil, it can be used to create smearing and blending effects.

Kneadable The kneadable eraser was developed in the 1940s. It is manufactured in the shape of a small rectangular block that is light blue or light gray. It is made with a large amount of nonvulcanized synthetic rubber, which makes it soft, somewhat sticky, and nonabrasive. The kneaded eraser certainly is the most versatile of all erasers as it can be used to erase and work a wide variety of drawing media such as charcoal, graphite, conté crayon, and pastel.

Kneadable eraser

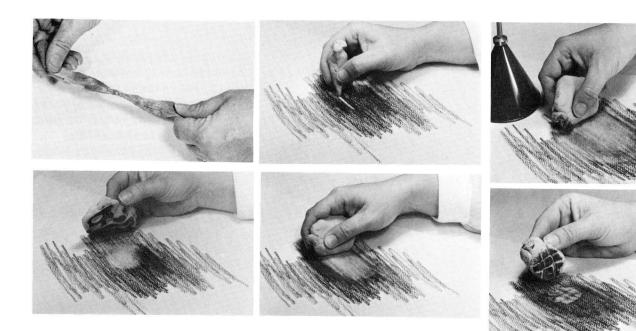

As the name implies, this eraser should be kneaded before it is used. Kneading, or pulling the eraser apart and sticking it back together again, makes it pliable, soft, and warm, which in turn makes it more absorbent. The eraser works best when it is warm. It can be kept warm while in use by resting it on a warm—but not hot—surface, such as a metal lampshade. Also, the eraser works best when it is clean. It can be cleaned by kneading; however, when it becomes too filled with dirt and grime, it should be discarded since it will no longer be absorbent.

The kneaded eraser is extremely useful for making delicate, nonabrasive erasures and for cleaning smudges, soil, and dirt from background and border areas. When using it for these purposes, first knead and warm the eraser and then blot, rather than rub, the area to lift out loose surface grime. Clean the eraser and gently rub it across the area in several different directions.

Since it is so pliable, the kneaded eraser can be molded into different shapes and used as a drawing tool. When flattened into a "pancake" it can be used as a blotter to form lighter areas and develop a wide range of values in a drawing. If it is rolled into a small ball or shaped to a point, it can be used to pull delicate highlights from darkened areas. Also, the kneaded eraser can be molded into assorted shapes and "swept" across existing dark areas to form broad, light areas.

If the eraser is coated with a small amount of solvent, it can be used to make smearing and blending effects. Also, interesting textural effects can be created by incising or carving textures directly into the eraser with a knife or nail and then blotting with the eraser. This method is similar to relief printing in that the incised or carved lower areas will remain dark in value while the protruding surfaces will lift light values from the paper.

Various uses for a kneadable eraser (clockwise from upper left): stretched to increase pliability; flattened to blot areas; in a point to highlight specific areas; in a sweeping motion to create lighter areas; to smear or blend; and to create textural effects.

Art Gum eraser

Art Gum The Art Gum was developed in the 1920s and was marketed as the first nonabrasive eraser. It is manufactured in the shape of a square or rectangular block and is yellowish brown. The Art Gum is medium hard and is made with a large amount of Factice, which makes it extremely crumbly. Originally, because it was nonabrasive, this eraser was used primarily by draftsmen to correct graphite pencil renderings. The main disadvantages of the Art Gum are that it crumbles too easily and that it often does not completely erase more heavily embedded marks. However, the Art Gum recently has been replaced by the vinyl eraser that is less abrasive and much more effective.

Vinyl The vinyl eraser, developed in Japan in the 1950s, is less abrasive and much more effective than the Art Gum. It is manufactured from vinyl, plastic, and chalk and is made in the shape of a small, white, rectangular block. This extremely nonabrasive eraser is used primarily by draftsmen to erase on plastic drafting film and Mylar. However, it also is very effective for erasing graphite and some other drawing media from paper.

Ink Ink erasers are manufactured in a variety of shapes and sizes including the standard rectangular block, a flat, wheel-shaped disk, and a pencil-shaped stick. They are usually light gray or blue-gray in color. They are made with a large amount of pumice, which makes them the most abrasive of all erasers. This eraser removes ink and other drawing media by actually wearing away the surface fibers of the paper rather than by lifting debris from the paper. Although they are used primarily to erase ink, they also can be used to erase heavily incised pencil marks as well as some other media (see Making Clean Erasures, page 113).

![Faber-Castell Non-Abrasive Non-Smudging Vinyl for Erasing Peel-Off Magic Rub 1960]

Stick The stick eraser is shaped like a pencil but its central core contains an eraser instead of a lead. The cores are manufactured in a variety of hardnesses and colors that differ according to their abrasiveness. Usually, the cores are wrapped in paper or encased in wood. One particularly useful type contains an eraser core that is divided into two halves, one a standard eraser, the other an abrasive ink eraser.

Stick eraser

The main advantages of the stick eraser are its convenience and cleanliness. It is usually used to make minor corrections. For general use, the eraser's core is exposed or sharpened and then carefully rubbed against the paper in a circular motion. For more delicate or precise erasures, the eraser's tip can be sharpened to a fine point on a sandpaper block. Similarly, when dirty, the eraser can be cleaned with sandpaper. As with other erasers, the stick eraser can be used to "draw" highlights and light lines through existing dark areas.

Electric The electric eraser is similar in size and shape to a small drill, and in fact, it operates on the same principle. Just as a drill holds a bit, the electric eraser holds a cylindrical-shaped eraser stick that erases by rotating at a high speed. The sticks are available in different hardnesses. Like the stick eraser, this eraser is used primarily for making minor or delicate corrections. These erasers must be used with caution since their fast, rotating speed can damage or even wear holes in the paper's surface.

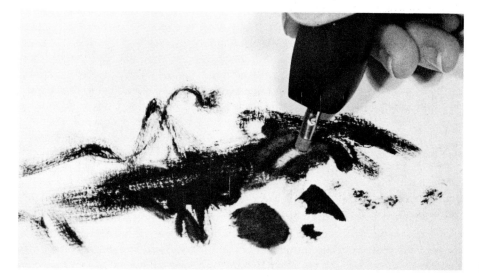

Electric eraser

Eraser bag

Eraser Bag The eraser bag resembles a cloth pillow and fits in the palm of your hand. It is made by stuffing pulverized eraser bits into a small, porous, cloth bag. This eraser is specifically designed to clean large areas of soil and surface debris from artworks and renderings. It also can be used to clean mats. As the bag is rubbed across the page, eraser granules are fed through the pores of the bag onto the paper. The pulverized eraser bits then are rolled between the bag and the paper and absorb dirt and grime from its surface.

Chamois A chamois is a small, soft, leather cloth made from the skins of sheep, goats, and other small animals. Originally, this leather cloth was made from the skin of the chamois, a small goatlike animal.

Pieces of chamois cloth are often used to erase charcoal from paper. They are used by simply wiping them gently across the paper's surface. Clean chamois cloths by shaking them or by slapping them against a solid object to remove the dust. When they become too dirty, wash them with soap and warm water.

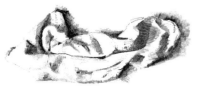

Chamois

Finally, white bread, with its crust removed, can be kneaded into a ball and also used to erase charcoal.

Protecting Drawings

It is important to keep drawings clean during the working process. Smudges, accidental marks, and grime all detract from the drawing's final appearance. This is especially true of background and border areas. Needless smearing of quick sketches can be avoided if you learn to hold your hand above the page rather than resting it on the paper's surface while drawing.

More developed or detailed drawings can be protected during the working process by covering them and isolating a small working area, much as a surgeon isolates an area of the body during an operation. This can be done by covering the drawing with paper or thick acetate with a hole cut to expose the working area. The cover prevents moisture and oil from the heel of the hand from being absorbed into the paper. It also keeps the drawing from being smeared.

Drawings "in process" should be completely covered and stored flat when not in use. Completed drawings should be stored on a firm, flat surface between two clean sheets of acid-free paper. Needless exposure to light should be avoided, since light causes paper to deteriorate.

Making Clean Erasures

Generally speaking, the better the quality of the paper the easier it will be to erase, since better quality papers usually have a more workable surface. The following method is suggested for making clean erasures of graphite, charcoal, and other abrasive materials.

First use a clean, warm, kneaded eraser to lift the particles from the paper's surface by blotting—not rubbing—with the eraser. Then clean the kneaded eraser and rub it across the area in several different directions.

Next, use a nonabrasive, vinyl eraser and again rub across the paper in several different directions. Finally, use a Pink Pearl eraser and gradually increase the pressure as you rub in a circular motion. Dust the eraser particles from the surface with a wide, soft sable brush. Do not brush the particles from the drawing with your hand, as it rubs sweat and oil into the paper.

Trouble Spots

If the previously mentioned method does not produce a clean erasure, try one or more of the following techniques on the trouble spot.

1. Use a clean, abrasive ink eraser and carefully move in a circular motion as you gradually increase the pressure until the spot is removed. Be careful not to rub a hole in the paper.
2. On very heavy paper, trouble spots can sometimes be removed by scraping the area with a new, single-edged razor blade or by actually slicing away the trouble spot. This method is sometimes used on heavy, handmade paper.
3. As a last resort, typewriter correction fluid or a water-base, nonglossy white paint may be applied to the area. Sometimes rubbing a small amount of talcum powder over the dried fluid or paint will enhance the surface finish. Correction fluid can also be used to paint over and block out errors in ink drawings. This type of correction is especially effective on drawings that are to be reproduced photographically, since the fluid will photograph like paper.

All of the above methods should first be tested on a sheet of paper of the same type as that which you are correcting to prevent irreparable errors. They also should be used only on high quality, thick paper.

Eraser Aids

Templates Specific or extremely small areas can be erased while protecting adjacent areas by using a template or eraser shield (a thin metal or plastic sheet with assorted openings cut in it) to isolate the area being erased.

Template

Friskit

Friskit Friskit is a masking liquid that can be painted, dribbled, or flung onto the paper's surface to form a protective membrane. It dries like rubber cement and may be worked with a variety of media. Later, it can be peeled off like masking tape to expose a clean surface below. It is also available in adhesive-backed sheets that can be cut into a variety of shapes before they are adhered to the paper.

DRAWING ACCESSORIES

Paper Stomps Paper stomps, also called paper stumps, are small, light-gray cylinders made of compressed paper. In appearance, they are similar to a short pencil that has been sharpened at both ends. They are available in different sizes numbered from 1–6, each having a slight variation in thickness and length, with 1 being the shortest and thinnest. Paper stomps are hard, yet slightly flexible, and are used to blend and model a variety of media, including charcoal, pencil, pastel, and conté crayon. When they become dirty or shiny and worn from use, they can be cleaned and sharpened with sandpaper.

Tortillions Paper tortillions are small cylindrical sticks of rolled paper that are pointed at one end. In appearance they are similar to a pencil stub. They are available in different sizes: small, large, and extra large. Since they are rolled

Paper stomps

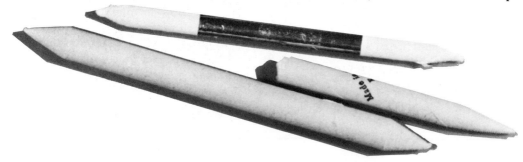

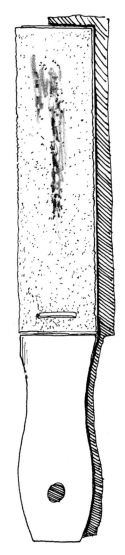

Sandpaper block

rather than compressed paper, they have a hollow center and are slightly more flexible than the paper stomp. They are used and cleaned like the paper stomp.

Cotton Swabs Cotton swabs or Q-tips, commonly used for hygenic purposes, are small, compressed paper sticks with cotton swabs rolled on each end. Like the paper stomp and tortillion, they can be used to blend or model a variety of drawing media. They may be used with the cotton swab on the end, or, if the cotton is removed, leaving only the bare paper stick, the end of the stick can be pointed with sandpaper to make a minature paper stomp that is especially useful for modeling small delicate areas.

Sandpaper Block The sandpaper block is a thin, flat wooden block covered with layered sheets of fine-grade sandpaper. It is a valuable tool that is used to sharpen and point a variety of graphic media. It can also be used to grind charcoal, graphite, and other media, into a powder or to clean erasers and paper stomps.

X-acto Knives X-acto knives are small hand-held tools that are available in a variety of styles. They can be purchased with several different handles and with an assortment of razor-sharp blades and are available either individually or in sets. Artists use this versatile tool to sharpen drawing media, and to cut paper and collage materials, as well as for other purposes.

Sponges Small natural and synthetic sponges can be used for a variety of "drawing" purposes. When dry, they can be used to model or blend large areas of charcoal or pastel. When wet, they can be used in a variety of techniques with ink or watercolor wash (for example, blotting, or adding water to control the flow of the media).

Sponges also can be used with almost any drawing medium in an interesting technique called imprinting in which the medium is placed directly on the sponge, and a blotting motion is used to transfer an impression from the sponge onto the paper. The method works well with liquid media but it may also be used with dry,

Sponges

powdered media. When imprinting with dry media, it is best to slightly dampen the sponge with a solvent before making the impression. Avoid using an excessive amount of solvent, since many solvents will cause deterioration when used on unprimed paper.

Turkey Wing Duster Chinese artists have used the turkey wing duster for centuries. It is a small fan-like brush that is made from the wing feathers of a domestic turkey. The feathers are held in a handle wrapped with a bamboo leaf. This tool is especially useful for brushing debris from loose surface drawings such as charcoal and pastel.

Solvents A solvent is a substance that will dissolve or disperse a material. There are a number of substances that can be combined with drawing media to make a material liquid and increase its fluidity. Some of the more common solvents include: turpentine, mineral spirits, benzine, and alcohol. When mixed with solvents to form a liquid, drawing media can be used to form washes similar in effect to watercolor washes. If only a small amount of solvent is used, certain media can be made into a paste and used to create blending and modeling effects. (For example, a liquid paste made with powdered graphite or charcoal and turpentine can be applied with a soft brush and then lightly buffed with cotton swabs to produce a dense, velvety black.)

Some solvents are acidic and may eventually cause paper deterioration if used on uncoated paper. Extreme caution should be exercised when using solvents since many of these chemicals are toxic and/or can cause skin irritations.

Fixatives

Fixatives When a mark is made on paper with an abrasive media such as pencil, charcoal, or pastel, the particles of the media are ground away and held by the paper's fibers. Fixatives are used to lightly bind these particles to the paper's surface and to keep them from smearing. Fixatives are made of diluted resin solutions (shellac, Manila copal, mastic, and so forth, mixed in alcohol). They are available commercially in aerosol spray cans or in bottles that are used with an atomizer. When fixing pictures, the artwork should be laid on a flat, level surface and sprayed with a light, uniform mist. It is best not to apply fixatives in heavy layers as overuse will cause tonal and color distortions. Some fixatives can also cause eventual paper deterioration because of their acidic content. Workable fixatives are a type of fixative whose surface can be worked upon after fixing.

Since most fixatives contain toxic chemicals, always use them in a well-ventilated area, preferably out of doors.

Drawing Boards Artists often use a drawing board to support their papers or boards while working. Some artists prefer to make their own drawing boards while others prefer to purchase them. In either case, drawing boards should be made of a durable, lightweight material, such as wood, plexiglass, or masonite. They should have a medium-smooth textured surface, just rough enough to keep the paper from sliding. Artists often equip their drawing boards with large clips to secure their paper to its surface.

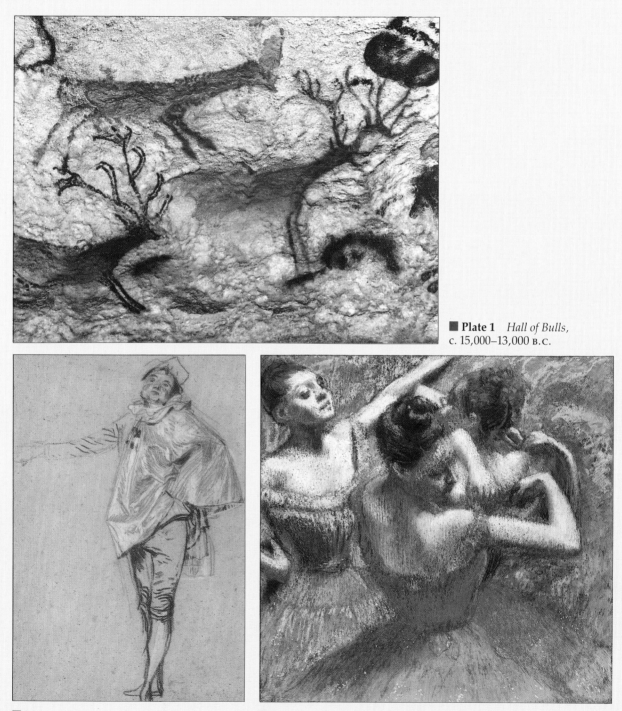

■ **Plate 1** *Hall of Bulls,* c. 15,000–13,000 B.C.

■ **Plate 2** Jean Antoine Watteau, *Man Standing.*

■ **Plate 3** Edgar Degas, *The Dancers,* c. 1899.

Plate 4 Michael Gould, *Willow and Loosestrife*.

Plate 5 Matthew Daub, *Christmas Day: Peoria*, 1985.

Plate 6 Red Grooms, *Nighthawks Revisited*, 1980.

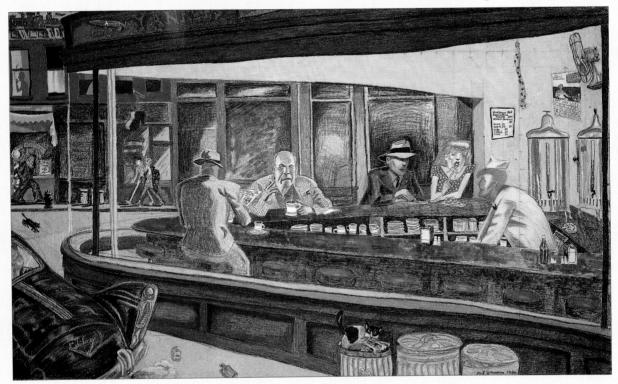

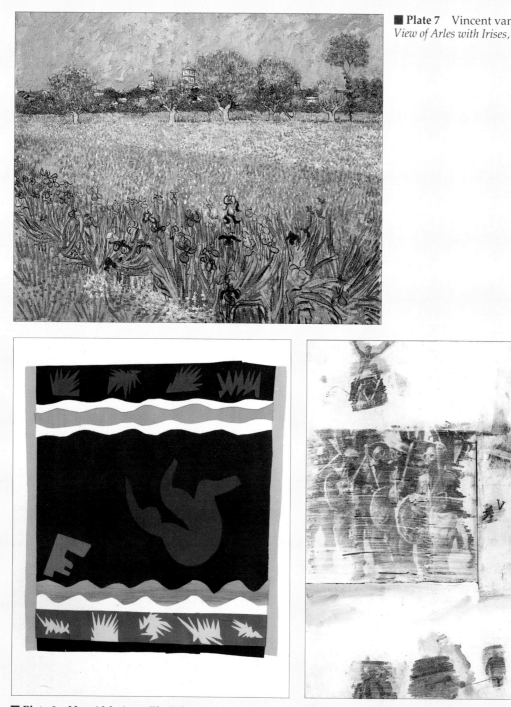

■ **Plate 7** Vincent van Gogh, *View of Arles with Irises*, 1888.

■ **Plate 8** Henri Matisse, *The Toboggan*, plate 20 from *Jazz*, 1947.

■ **Plate 9** Robert Rauschenberg, *Canto XXI*, *"Combined drawing" for Dante's Inferno*, 1959–60.

■ **Plate 10** Chuck Close, *Working Photographs for Linda*, 1975–76, include the various stages of process color separation and the original photograph used to create the painting *Linda*, 1975–76.

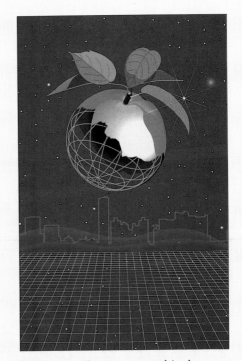

■ **Plate 11** Computer graphics by Genigraphics.

Innovative Drawing Processes

7
Established Innovations

MIXED MEDIA

When an artist uses several different media to create an artwork, the technique is called mixed media. Sometimes an artist consciously plans and develops an artwork in more than one medium to achieve special effects. At other times, the decision is spontaneous, often resulting from the limitations of using a single medium.

Hans Holbein's portrait of an unknown man (Fig. 7–1) is an excellent example of a mixed media drawing. Here, the artist has sequentially applied the media following an established tradition. He made the initial drawing in black chalk on a pale pink ground. Then, he added colored chalks to give the drawing a more life-like appearance. The artist later strengthened certain areas of the drawing with pen and india ink. Finally, he applied delicate, transparent ink washes to unify specific parts of the drawing.

Virtually any materials can be combined or used together in a mixed media technique as long as they are chemically and technically compatible. It is important to remember that certain media are inherently impermanent and that others can cause physical damage or deterioration to the artwork if used incorrectly. Some artists' materials, such as charcoal, graphite pencil, and ink, have been used

FIGURE 7-1
Hans Holbein, *Unknown*
Gentleman, **c. 1530. Black and**
colored chalks on pink ground,
India ink with pen and brush,
heightened with white body
color, 27.4 cm × 19.1 cm.
Windsor Castle, Royal Library,
England.

together for centuries. More recently developed materials such as watercolor pencil and markers have expanded the artist's repertoire of possibilities even further.

Sometimes, seemingly incompatible media can be used together in a single work to produce unique and unexpected effects. Such is the case in a group of drawings executed during the 1940s by the English artist Henry Moore.

During the Battle of Britain in World War II, London was attacked almost daily in air raids conducted by Nazi Germany. As the turmoil raged above the city, its occupants huddled underground in the tunnels and terminals of the subway for protection.

One evening, while visiting London, Moore was forced to remain underground for some time. He was so moved by the haunting scene that he decided to make it the subject of the series, *The Shelter Drawings.*

Moore began to make regular visits to London to observe the underground stations that interested him most. Out of respect for his subject's condition, he did

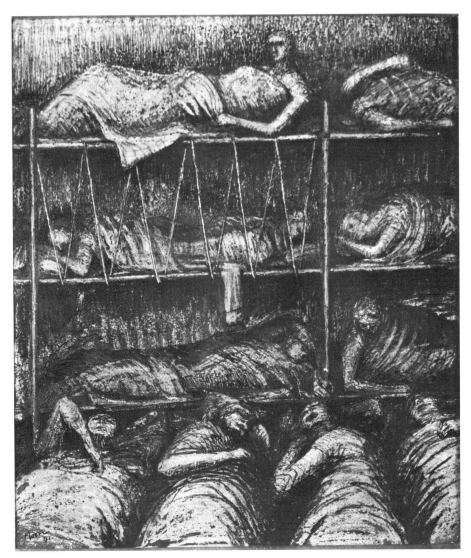

FIGURE 7-2
Henry Moore, *Shelter Scene: Bunks and Sleepers (Dans un Abri),* 1941. Chalk, India ink and wash, 48.2 cm × 43.2 cm. The Trustees, The Cecil Higgins Art Gallery, Bedford, England.

not actually draw on site. Rather, he quietly wandered about the shelters observing and occasionally taking notes on the back of an envelope. Moore visited the shelters several nights each week and then returned to the privacy of his studio, outside of London, to create his drawings from his notes and memory.

Many of Moore's shelter drawings share an ominous quality. In one example (Fig. 7–2), similarities can be drawn between the crowded underground caverns, filled with their restless sleepers, and the eerie atmosphere of the ancient Roman catacombs. Moore's agonized figures are huddled in cramped spaces, stacked on top of one another in a hastely built sleeping scaffold or laid out in orderly, compact rows along the ground. The figures are wrapped in their troubled sleep with swirling lines and covered in a weblike cocoon reminiscent of ancient Egyptian mummies.

Henry Moore is known primarily as a sculptor, although he also works in other media. Like many of his other drawings, his shelter drawings exhibit a sculptural quality in the way he uses multiple, wrapped contour lines to establish the volume and mass of his figures. In addition, this quality is further reinforced by spaces "punched" in the drawing through the use of dense, dark values. Moore has personally described the working techniques he used to create *The Shelter Drawings* in the following statement. "I sketched with pen and ink, wax crayons and watercolour, using the wax-resist technique which I had discovered by accident before the war. I had been doing a drawing for my three-year-old niece using two or three wax crayons. Wishing to add some more colour, I found a box of watercolour paints and was delighted to see the watercolour run off the parts of the drawing that had a surface of wax. It was like magic and I found it very useful when doing my sketch books."[1]

COLLAGE AND PAPIER COLLÉS

A collage is an artwork constructed of commonplace materials, such as paper scraps, fabrics, and wood veneer, that are cut and pasted into a composition. Artists usually select such materials because they have pronounced textures or surface patterns. Sometimes, artists combine collage materials with elements of drawing or painting to create a play between real objects and drawn or painted illusion.

The French artist Georges Braque is credited with creating the first collage in 1911. During the next several years, he and his contemporary Pablo Picasso developed the new medium and incorporated it into many of their early cubist works. Their collages were an important development in the beginning phases of modern art. Both artists used real objects, rather than purely drawn or painted

[1] Henry Moore, *Henry Moore.* New York: Simon and Schuster. 1968, p.140.

FIGURE 7-3
Kurt Schwitters, *The Hitler Gang*, 1944. Collage, 13⅝" × 9⅝". Marlborough Fine Art, London, England.

elements, glued onto the canvas or paper to form the surface planes of the artwork—an idea that helped establish the concept that art is not merely a reproduction of reality but that the art object has its own physical existence.

Papier collé is a type of collage in which primarily cut pieces of paper are used to make the art object. The German artist Kurt Schwitters created his first papier collé in 1919 and subsequently became well known for his small paper collages (Fig. 7–3). Schwitters's collages are created from commonplace, discarded bits of "trash," such as newspaper clippings, theater tickets, advertisements, and labels. When removed from their everyday context and composed as a collage, these cast-off materials have a poetic appeal in their subtle relationship of shape, color, and texture.

Late in his artistic career, when in his eighties and confined to a wheelchair, the renowned French artist Henri Matisse turned to cut-paper collage (paper cutouts) as a way of continuing his exploration into the relationship between line and color. Instead of drawing an outline and then "filling in" the shape with painted color, Matisse cut his exuberant shapes directly from solid pieces of gouache-colored paper. He compared his method of drawing/cutting in color to that of a sculptor who cuts directly into stone. Matisse viewed his collages as a synthesis of line, shape, and color (Fig. 7–4, Plate 9).

FIGURE 7–4
Henri Matisse, *The Toboggan,* **plate XX from** *Jazz,* **1947. Pochoir, printed in color, 13″ × 11⁷⁄₈″. The Museum of Modern Art, New York (The Louis E. Stern Collection).**

FROTTAGE/RUBBING

The surrealist artist Max Ernst frequently used collage and other graphic techniques as a means of exploring the subconscious. One of these techniques, called frottage, or rubbing, was invented by Ernst when he placed a sheet of paper on top of the grained boards of a wooden floor and rubbed over its surface with a soft pencil to produce relief transfer images. Ernst was so fascinated by the hallucinatory effect of the resulting images that he used frottage in a number of his later drawings and collages (Fig. 7–5). Frottage can be used to transfer images from almost any durable surface that has a high/low relief registration (a combination of high and low areas).

Later, Ernst used a variation of the frottage technique to form the surface textures in some of his oil paintings. He formed the transferred textures by placing the canvas over a rough-textured surface and then scraping paint across the canvas with a palette knife.

The contemporary artist Roy Lichtenstein frequently uses a frottage drawing technique to achieve a mechanical, anonymous appearance in his drawings. *Jet Pilot* (Fig. 7–6) is a pencil drawing Lichtenstein rendered in 1962 using

FIGURE 7–5
Max Ernst, *The Wheel of Light*, plate XXIX from *Histoire Naturelle*, 1925. Frottage, 9⁷⁄₈″ × 16¹⁄₂″. Kunstmuseum, Hanover, West Germany.

frottage. Lichtenstein placed his paper on top of a common window screen and rubbed the paper with a pencil; the raised elements of the screen appeared as a pattern of tiny dots.

In later drawings, Lichtenstein experimented with another type of screen with round perforations which resulted in the screen itself forming the dominant pattern. In yet another example, the artist placed a perforated screen on top of his paper and rubbed a lithographic crayon through the perforations onto the paper's surface producing a uniform machine-made look.

FIGURE 7–6
Roy Lichtenstein, *Jet Pilot*, 1962. Pencil and frottage, 15″ × 17″. Collection Richard Brown Baker, New York. Photograph courtesy of Leo Castelli.

IMPRINTING

In addition to frottage, Max Ernst also developed a technique called imprinting that he used to imprint textures onto the surface of his paintings. When painting in oil, he pushed a sponge or piece of fabric into wet paint already applied to the canvas. As the object was pulled away, it left an imprinted texture. This technique can be adapted to create varied textures on drawing surfaces. For imprinting, a drawing medium, such as charcoal, conté crayon, or graphite, is ground into a powder and mixed with rectified turpentine to form a semi-liquid paste. Liquid ink or watercolor can also be used. Next, certain textured materials, such as a porous sponge, rough burlap, ribbed corduroy, or patterned lace are gathered and cut into smaller pieces. The materials are then dampened with water or rectified turpentine and dipped into the liquid drawing medium. Finally, using firm, steady pressure, the texture is imprinted from the material onto the drawing surface. Imprinting can be used to embellish drawings, to form decorative motifs and patterns, or to form individual pieces for a collage.

TRANSFER

The contemporary artist Robert Rauschenberg used an innovative collage-like transfer technique to form the images in his series entitled *Thirty-Four Illustrations for Dante's Inferno* (Fig. 7–7 and Plate 10). Rauschenberg's images were first cut from popular magazines. Then, they were transferred directly to the working surface by saturating the front side of the magazine page with a solvent, such as lighter fluid or rectified turpentine, and placing the image face down on the working surface. The back side of the magazine page was rubbed with the lead of a hard pencil. The streaks and marks created by the back-and-forth motion of the pencil's lead are considered an aesthetic part of the transfer process.

This transfer process works best when used on relatively smooth paper. Also, it is important to use high-quality, recently published magazines in order to achieve effective color images. The transferred image will be a reverse of the original. Frequently, artists combine transferred images with collage and drawn images to form artworks that defy exact categorization.

CARTOON

The word *cartoon* is derived from the Italian *cartone*, which means "large piece of paper." Although the term is commonly used when referring to humorous or satirical drawings, such as comic strips, it also has another meaning.

In the fine arts, a cartoon is the final drawing that is made in preparation for a more developed artwork, such as a fresco, egg tempera, or oil painting. A

FIGURE 7-7
Robert Rauschenberg,
Illustration for Dante's *Inferno*,
***Canto XXI*, 1959-60. Gouache,**
collage, wash, red pencil, pencil,
14¼″ × 11½″. The Museum of
Modern Art, New York (Given
anonymously).

cartoon is not a sketch but rather an elaborately developed study that is drawn exactly the same size as the intended artwork. A cartoon is drawn in charcoal, ink, chalk, or pencil. The cartoon is transferred directly onto the wall, panel, or canvas in much the same way that carbon paper is used to transfer an image. The reverse side of the cartoon is covered with charcoal or chalk, then the original lines on the

FIGURE 7–8
Raphael, *Group of Warriors,*
c. 1510. Pen and brown ink over
under drawing with the stylus,
pricked for transfer. Ashmolean
Museum, Oxford, England.

face of the cartoon are retraced with a stylus and thus transferred to the surface
below. Also, cartoons can be transferred by pricking small holes along the lines of
the cartoon with a pin and then rubbing charcoal dust through the holes to form a
dot pattern. Afterwards, the cartoon is removed and the dots are connected to
reestablish the original drawing (Fig. 7–8).

8
Technological Innovations

Artists have always been interested in technological innovations. Historically, the introduction of new materials and working techniques has frequently resulted in the development of unique artforms. For example, in painting, artists experimented and mixed various binders with the basic pigments to create an array of painting media ranging from egg tempera to acrylic paints.

Today, artists live in the midst of a technological explosion. Never before have so many new resources been available for creative purposes. We will discuss three practical innovations—photographic images, copy machines, and computer graphics—in this chapter.

PHOTOGRAPHIC IMAGES

During the Renaissance, artists became increasingly concerned with creating artworks that were accurate reproductions of nature. To this end, they developed exacting systems of drawing and painting, such as linear perspective, chiaroscuro, and foreshortening. In addition, they also experimented with a variety of innovative drawing apparatuses. One such apparatus, called the camera obscura, was a projection device whose origin can be traced to ancient Greece.

Leonardo da Vinci described the camera obscura as a device that allowed light to enter a darkened room through a minute hole pierced in a wall, thereby projecting onto the opposite wall a mirror image of whatever appeared in front of

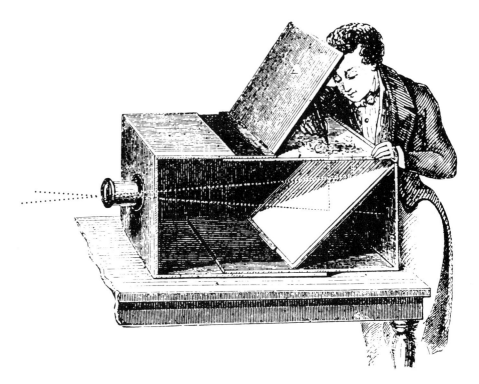

FIGURE 8-1
A camera obscura. An artist traces on ground glass the image formed by the lens and reflected by the mirror. From A. Ganot, *Traite elementaire de physique* **(Paris: 1855).**

the opening. According to Leonardo, the projected image looked as though it had been actually painted upon the wall. This device was modified in 1550, by the insertion of a biconvex lens into the hole, creating an even brighter, sharper image.

By the seventeenth century, the camera obscura had been equipped with an angled mirror that reversed the projected image to an upright position, thereby making it easier to copy. In addition, the device was made smaller and more portable, enabling artists to work out of doors and trace scenes directly from nature (Fig. 8-1).

Photography

The camera obscura was the precursor of photography. It was not until 1826 that J. Nicéphore Niepce took the world's first photograph on a pewter plate. Later, the artist/photographer Louis J. M. Daguerre further developed Niepce's discoveries, resulting in his remarkably precise daguerreotype portraits.

Artists of the nineteenth century had mixed reactions to photography. Some felt that photographers would eventually replace artists in their traditional role as representers of nature. Others, however, were quick to recognize the camera's potential as an aid to creativity. In fact, many famous nineteenth-century artists,

FIGURE 8–2
(Top) Eugene Durieu, *Studies*, 1854. Photographs. Musée Bonnat, Bayonne, France. (Bottom) Eugene Delacroix, *Studies*, 1855. Pen and ink, 9½″ × 13¾″. Musée Bonnat, Bayonne, France.

FIGURE 8–3
Eugene Delacroix, *Odalisque*, 1857. Oil on canvas. Musée de Beaux Arts, Lyon.

including Delacroix, Degas, and Toulouse-Lautrec, used photographs in composing and developing their artworks.

Eugène Delacroix was one of the first established artists to openly advocate the use of photography in drawing and painting. Under his supervision, models were posed and photographed by his friend Eugène Durieu. Delacroix would later use these photographs as a basis for figure studies (Fig. 8–2). Eventually, he even used photographs as the compositional basis for some of his major artworks, such as his *Odalisque* of 1857 (Fig. 8–3).

FIGURE 8-4
Eadweard Muybridge, *Equus Caballus Jumping*, **plate 637 from** *Animal Locomotion*, **1887. Albumen print. American Museum of Natural History, New York.**

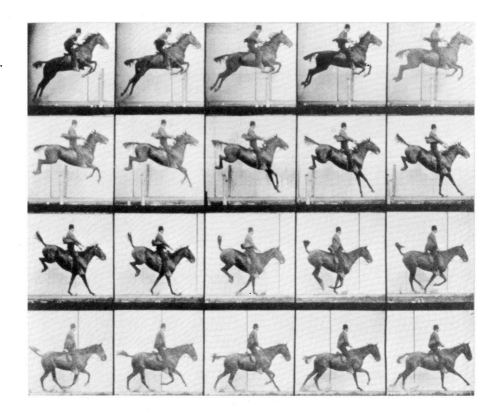

During the late 1850s, photographers developed special stereo cameras that enabled them to take pictures of animals and people in motion. However, since high-speed shutters had not yet been developed, these images were not sharply defined. Then, in 1872, an English photographer named Eadweard Muybridge took the first successful photograph to capture the movement of a galloping horse frozen in mid-stride (Fig. 8-4).

Muybridge continued experimenting with stop-action photography. Eventually, by positioning 24 cameras in a row, he was able to produce a series of sequential photographs showing the movements of a galloping racehorse. Unlike previous examples, these photographs clearly and accurately showed the correct position of the horse's legs, suspended in motion. Artists were astounded. Muybridge's photographs scientifically repudiated the convention they had used for centuries to depict horses in motion—a rocking horse stance with legs outstretched.

In 1887, Muybridge's action photographs were published in an 11-volume series entitled *Animal Locomotion*. Since horses were such popular subjects during the nineteenth century, many artists were keenly interested in Muybridge's photographs. Among them was the French artist, Edgar Degas. Degas had studied photographs of slow-moving horses, made by stereoscopic cameras, in his studio.

When he was introduced to Muybridge's action photographs of equine movement, he decided to use several of them as models for a group of charcoal and pastel studies.

Degas's drawing *Jockey* is clearly copied from a Muybridge photograph. A comparison of the two shows the similarities, particularly in the stance of the mounted jockey and the identical position of the horse's body and legs (Fig. 8–5). The artist also did several other drawings derived directly from Muybridge's photographs. In some instances, his drawings were literal copies of the photograph. In others, he freely altered the photographic image for aesthetic reasons. Interestingly, to further supplement his studies, Degas made several clay models of horses in motion based on Muybridge's photographs.

Other artworks by Degas were also influenced by photography, especially in their composition. Since the camera has a stationary and limited field of vision, it is common to see photographs in which prominent features, such as the torso, arms, or legs of a figure, are cut off or "cropped" in unconventional positions. Degas was intrigued by the unusual effects of photographic cropping. This

FIGURE 8–5
Edgar Degas, *The Jockey,* **1889. Pastel, 12½″ × 19¼″. Philadelphia Museum of Art, Philadelphia.**

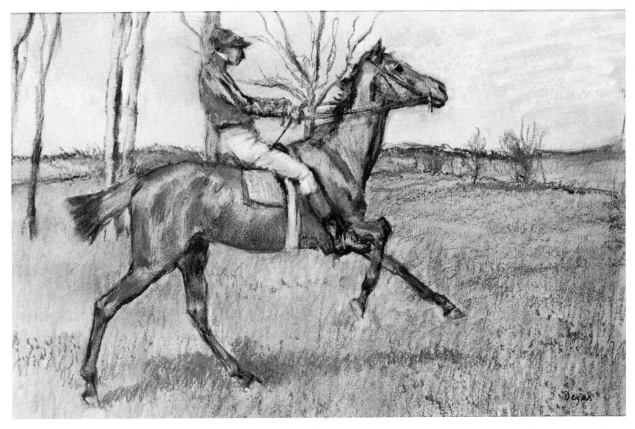

FIGURE 8-6
Edgar Degas, *Ballerina and Lady with Fan,* 1885. Pastel, 26″ × 30″. Philadelphia Museum of Art, Philadelphia.

influence can be clearly seen in the placement of the figures of the ballerinas in his pastel drawing *Ballerina and Lady with a Fan* (Fig. 8–6).

Artists continued to use photographs as an aid to creativity throughout the nineteenth and into the twentieth century. Although initially many artists interpreted photographic images quite literally, they gradually took greater liberties in adapting the images to aesthetic ends.

Photo-Realism

The relationship between art and photography reached its peak during the late 1960s in an art movement called Photo-Realism. By this time, the possibility of a rivalry between photography and art was nonexistent since both had evolved as separate, yet related artforms. Although photographic images were commonplace, contrary to earlier predictions, they had not replaced the traditional arts of drawing and painting.

The Photo-Realists, like nineteenth-century artists, used photographs as a source of information for their images. Unlike their predecessors who used photographs mainly as a reference, the Photo-Realists' primary concern was the photograph itself. In short, they were interested in the way the camera "sees" and records information, which is considerably different from visual perception.

A camera records whatever is in front of it, objectively and unemotionally. A single-lens camera with a fixed focal length has a stationary and limited field of vision. Also, it has a single focus that the photographer can adjust to achieve a specific depth of field, thus causing the photographic image to appear sharply defined in certain areas while out of focus in others.

By contrast, visual perception is subjective and directly tied to emotional association. When engaged in perceiving, the human eye is not stationary. It can roam at will and with amazing speed selectively focus on near or distant objects. Finally, human vision is binocular, thus enabling a wider field of vision and more accurate depth perception than a camera.

Chuck Close is a Photo-Realist artist who used 8″ x 10″ photographs as the basis for his monumental portraits (Fig. 8–7). His models are personal friends, but the manner in which they are photographed causes them to appear disturbingly detached. Usually, Close photographs his subjects in a frontal position using a tightly cropped photographic format reminiscent of a police mugshot. In addition, Close shoots his subjects from slightly below eye level, which gives them a confrontational, almost hypnotic appearance.

Close is especially interested in the topographical details and surface quality of the photographic image. More particularly, he is interested in how this information can be translated into a painted image. In his paintings, he strives to include minute details, such as enlarged pores, blemishes, and stubble, as well as sharply defined and blurred, unfocused areas. When transposed from the photograph and enlarged in scale, these topographical details become prominent features in a giant facial landscape.

In a magazine interview, Close discussed his approach to portraiture.

Portraiture is very important to my work, but not for what would seem like the most obvious reasons. Everyone knows something about the way people look — we have certain ideas about what's right and wrong. If the complexion is too green . . . it's not acceptable — whereas, if I were painting a tree, and it were a little too green or too red, no one but a botanist would know or care.

 . . . one thing I like about photographs is the snapshot or mugshot quality of a California driver's license. It's got such an immediacy and a strong reason to exist in terms of nailing down what a certain driver looks like. . . .

I never see someone and say, oh, you'd be great to paint. What I do is get together a whole bunch of people and shoot them, and some of them turn out to be interesting photographs. I don't really think about interesting people. I scan a contact sheet and try to imagine what it would be like to paint from that photograph. Some of them seem better than others, not in terms of the overall iconography but in terms of what kind of painting experience they would be — how sharp and how blurry.[1]

FIGURE 8-7
(Left) Chuck Close, *Linda*, State III from 5 Studies, 1975–76, Dye transfer photograph, 20" × 15⅞". Collection Akron Art Museum, Bottsford Memorial Exhibit: Museum purchase with funds from the Helen C. Bottsford Bequest. Photograph courtesy of The Pace Gallery, New York. (Right) Chuck Close, *Linda*, 1975–76, acrylic on gessoed linen, 108" × 84". Collection Akron Art Museum. Purchased with funds from an anonymous contribution in honor of Ruth C. Roush, and The Museum Acquisition Fund. Photograph courtesy of The Pace Gallery, New York.

[1] Elizabeth C. Baker, ed., "Ten Portraitists—Interviews/Statements," *Art in America* 63, no. 1 (January/February 1975): 41.

As we have seen, artists employ photographic images in various ways to assist creativity. Some artists conceive and photograph their own compositions, while others rely on ready-made images from books, magazines, or newspapers. When transposing photographic images for use in a drawing or painting, artists generally use one of two approaches.

The first approach is to draw directly from the photograph as they would draw from nature or from a live model. In this instance, the photograph is used as a primary reference that can be reproduced quite literally or interpreted as the artist sees fit.

In the second approach, the photograph is copied or transferred directly to a working surface, like paper or canvas. This can be accomplished by using one of several different methods.

One simple way is to reproduce the photographic image by using a copy machine. This reproduction method and its applications are discussed at length on pages 139–42.

Another method is to use a grid system to enlarge and transfer the photographic image to the working surface. A series of horizontal and vertical lines is superimposed upon the photograph to form a framework, or grid, of evenly sized units. Then, each unit is individually transferred from the photograph to the working surface. By transferring only one unit at a time, it is easier to keep points of reference and thereby maintain proportions. This is especially true when enlarging to a monumental scale, such as seen in Chuck Close's photographed and painted versions of *Linda* (Fig. 8–7).

A photograph can also be transferred to a working surface by using the same methods that are used to transfer a cartoon to a painting surface (see Cartoon, page 128). In the first method, the reverse side of the photograph is covered with charcoal or chalk. Then the photograph is placed on top of a sheet of paper and the major lines of the image are traced over with a stylus and thus transferred to the surface below. In the second method, the photograph is transferred by pricking small holes along the dominant lines of the image and then rubbing charcoal dust through the holes to form a dot pattern on the working surface. The photograph is then removed and the dots connected to reestablish the image.

Perhaps the most commonly used method for transferring or copying a photograph onto a working surface is direct projection. In this method, the photograph is placed in an opaque projector and projected onto a canvas or sheet of paper suspended vertically from a wall. Or, a photographic slide can be placed in a slide projector and used in the same manner. The size and focus of the projected image can be controlled by the distance the machine is placed from the wall and the position of the focus dial.

Still another means of transferring an image to a working surface is by using an artograph. The artograph is an apparatus that artists can use to draw enlargements of photographs, of opaque images, or of images on acetate. The image is inserted into the machine and attached to a vertical pallette which is positioned in front of a lighted mirror. The image reflected in the mirror is then projected

FIGURE 8–8
Artograph

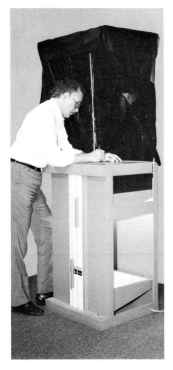

through a lens onto a sheet of paper resting on a flat surface directly beneath the machine. The artist then simply traces the projected image onto the paper. The size and focus of the projected image can be controlled by a dial setting located on the side of the machine (Fig. 8–8).

COPY MACHINES

Photocopiers, or copy machines, were originally developed to reproduce documents for business and professional purposes. Recently, however, artists have begun experimenting with innovative ways of using them to create artworks.

Currently, most copy machines reproduce images by a photoelectric, dry printing process. In fact, the trade name Xerox is a shortened form of the word *xerography,* from the Greek *xeros* meaning dry and *graphic* meaning writing.

Although making a copy is simple, the actual copying process is rather complicated (Fig. 8–9). Briefly, it can be described as follows.

1. The original copy is placed face down on a transparent glass plate.
2. An exposure lamp projects a latent image from the original copy, through a lens, onto the surface of an electromagnetically charged, photosensitive drum or belt.
3. The areas of the drum or belt that are exposed to light will lose their charge while the unexposed areas will retain a positive electromagnetic

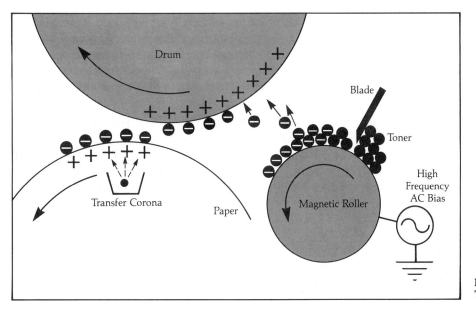

FIGURE 8–9
The photocopying process

charge, thus forming a latent image on the surface of the drum or belt.

4. As the drum or belt rotates, particles of negatively charged toner (a dry pigmented powder) electromagnetically attach themselves to the positively charged latent image on the drum or belt.
5. The image is transferred from the drum or belt onto a sheet of copy paper.
6. The copy paper carrying the final image passes over a fuser roller that heats the toner, causing it to adhere permanently to the paper.
7. The final copy is deposited onto a pick-up tray at the end of the machine.

Depending on the pigmentation of the toner, copy machines can produce black, red, green, blue, or brown images. In certain machines, these colors also can be mixed to produce other colors. Full-color copiers are currently available, but they are very expensive to purchase and operate. In addition, certain copy machines have been integrated with computers for more advanced functioning. Also, computer-controlled laser copiers, which have the advantage of speed and better quality reproduction with less maintenance, have recently been introduced to the public market.

The copy machine is a particularly appropriate apparatus for today's artist in that it can create instant, mass-produced images, as well as be adapted to myriad creative uses. The following are some examples of the ways in which artists can use copy machines to reproduce and alter images for artistic purposes.

Artists use copy machines to reproduce images from an extensive variety of sources, such as books, magazines, newspapers, photographs, original artworks, works on acetate, and even natural objects. Once selected, images can be reproduced on various substrates such as one-hundred-percent cotton paper, certain colored and textured papers, thin boards, acetate, and cloth. However, to avoid mechanical problems, it is important to ensure that the substrates conform to the dimensions required by the machine and that they are heat resistant. The images produced by copy machines are relatively permanent if used on the proper substrate, since the toner is made from carbon black and iron oxide powder.

In addition to reproducing images, copy machines can be adjusted to enlarge or reduce images. In fact, some copiers have "zoom" enlargement or reduction modes capable of one percent increments. Also, certain copy machines can be programmed to remove unwanted information such as typeface or images from the original copy. Some machines even have erasure modes that enable them to remove underlining or highlighting made on the original copy by felt-tipped markers.

Copy machines can produce back-to-back images in which an image is copied on both the front and back of a piece of paper. Also, an image can be copied and then a second, different image can be copied over the original.

Most copy machines produce high-contrast, black-and-white images rather than halftone images. The darkness of the image can be mechanically controlled

by a dial setting. However, if the toner box is "packed," the copier can produce denser blacks than normal. Although copy machines normally produce high-contrast images, if the original image is repeatedly enlarged and recopied, irregular dot patterns and grained textures can be created. In addition, actual halftone images can be created by making a halftone original, which is simply copied. Or, the original image can be covered with a halftone screen overlay, formed of a small dot pattern, and then copied.

Artists sometimes use copy machines to copy images either from acetate or onto an acetate substrate. (Note: When copying from an acetate image, the image should be covered with a white background sheet to avoid poor-quality reproduction.) Also an acetate overlay can be superimposed upon an original image and then both can be simultaneously copied. Acetate overlays are particularly effective when developing a reductive or additive series in which the original image is slightly altered in each sequence.

Occasionally, artists will incorporate letters and numbers into copied images (Fig. 8–10). This can be accomplished by cutting and gluing typeface from books, magazines, or newspapers onto the original copy. In addition, the original image can simply be inserted into a typewriter, typed upon, and then copied. Or, press

"Runner" Pen & Ink by Spyros Karayiannis 1985

"SUITABLE FOR FRAMING"
A Drawing Exhibition

FIGURE 8–10
Spyros Karayiannis, *Suitable for Framing* **exhibit announcement, 1985. Copy machine, 5″ × 4″. Courtesy of the artist.**

FIGURE 8-11
Mainframe computer graphics

type can be transferred from acetate sheets onto the original image and then copied.

Once an image has been reproduced by a copy machine, it can be further altered by the artist. For example, the image can be embellished with other media such as charcoal, pastel, conté crayon, or design markers. In addition, the tonalities of the image can be lightened, by erasing with a kneaded or Pink Pearl eraser. Also, copied images can be transferred to other surfaces by saturating the front of the image with a solvent and rubbing its back side with hard pencil lead (see Transfer, page 128).

Copied images can be cut into shapes and strips and used in a series, collage, or other innovative artform. For example, these shapes can be glued and then sealed onto a board or canvas with acrylic medium. Later, after the medium has dried, the image can be coated with thin glazes of acrylic or oil paint and thus integrated into a painting.

The copy machine can be a useful apparatus for experimenting with an artwork that is in progress. For example, several copies can be made of the work, and then the artist can explore alternative solutions by working upon the copies rather than the actual artwork. Or, an artist can explore alternatives by preparing acetate overlays which are placed upon the original artwork and copied. Later, once determined, the final solution can be executed upon the original artwork.

Most artists have easy access to copy machines since they are owned by many public and private institutions. However, the more sophisticated copy machines are quite expensive and therefore are often run by trained operators to avoid mechanical problems. Nonetheless, artists are free to experiment with procedures and techniques on the smaller, less expensive machines.

COMPUTER GRAPHICS*

Among the most exciting new technologies for artists and designers of the twentieth century are computers for image making. For many years, mainframe computers have been employed for creating specialized imagery and mechanical animation for such industrial applications as automobile design and automotive engineering drawings. The cost of mainframe computers and mainframe graphical software, however, is prohibitive for all but the largest industrial manufacturers (Fig. 8-11).

The invention of the silicon memory chip and the advent of microcomputers has brought microcomputer graphics to the commercial art industry, to university engineering and design programs, and to art schools and independent artists and designers who find advantages in using this technology for producing images.

* The author thanks Dr. Michael Youngblood for writing this section.

Typical microcomputers for graphical production range from expensive graphic systems to the more moderately priced home computers. Within this range of technological sophistication and cost, lies exciting new tools for artistic image making. Images on computers are made in two ways. The most basic method is to program computers to generate images. In the early days, programming computers to produce images was the only way one could obtain graphical results. The first computer images were simple geometric shapes resulting from mathematical algorithms programmed into the computer. As the power and sophistication of computers and computer software developed, the sophistication of computer-generated images increased (Figs. 8–12 and 8–13).

FIGURES 8-12 and 8-13
Microcomputer graphics

Today, it is unnecessary for computer users or artists to program images into computers. All of the programming has been done previously by software programmers who design the imaging software sold with or for computers. All that is required now is the willingness to sit down to a computer and learn the relatively simple commands that tell the computer what to draw. For instance, most computers used for creating images can be used almost like a regular drawing tablet or a piece of watercolor paper—you simply draw and watch the computer image develop on the computer screen. The artist learns to "boot the system" (turn on the computer), "save images or files to floppy disks" (store drawings in a portfolio), and use "pull-down menus" (select the proper sized paint brush). The small number of computer commands necessary to use graphical software today is no more difficult to learn than learning to mix oil paints, or sizing canvas, or building a stretcher frame.

A clear understanding of the power of microcomputers for graphic design and image creation can only be gained through actual demonstrations or through first-hand experience with microcomputers and software for image creation. It is clear, however, that microcomputers provide professional artists with powerful new tools for generating and recording their visual ideas. The major advantage of microcomputer graphics for artists is the capacity to swiftly create and store graphical information. In this way, artists increase ten-fold their ability to generate and record ideas. Merely using the computer as an idea sketch book significantly increases the number of ideas that may be stored for future reference. These ideas may be recalled effortlessly, thereby increasing the artist's productivity and efficiency.

For example, an artist using traditional methods might spend an entire day sketching ideas for a major art work or commercial design. These methods require the original image to be redrawn, traced, or photocopied time after time for each subsequent revision. With the computer, initial ideas may be stored on disk, subsequent changes in the original design can be made quickly, and again saved to disk. For each reiteration, the original image may be recalled from memory to be changed with ease.

Finally, while the microcomputer is a useful adjunctive tool to traditional disciplines such as commercial art, design, engineering and architectural drafting,

FIGURE 8-14
Experimental computer graphics

it may also be explored as a medium in its own right. Artists may explore the computer as a medium much as the still camera and movie camera were explored at the turn of the century. In fact, exploring the use of the computer as a medium may, in time, provide new artistic traditions much as exploring the use of canvas and pig-bristle brushes eventually led to many of our contemporary traditions in the fine arts (Fig. 8-14).

PART FIVE

Preservation and Presentation of Drawings

9
Preservation of Drawings

Artists frequently use paper for "temporary" artworks such as layouts, rough sketches, and preliminary studies. Since these artworks are created with the expectation that they will eventually be discarded or destroyed, the paper's quality and permanence are usually not important. However, when preservation of artworks is desired, artists should attempt to ensure the quality and longevity of their papers.*

Artworks created on paper are subject to various forms of deterioration, such as discoloration, embrittlement, and decay (Fig. 9–1). Deterioration can take place rapidly and be immediately apparent, or it can occur slowly and imperceptibly over the years. Often, deterioration is progressive. Once it begins, deterioration will continue to spread and worsen over time. While it is impossible to completely eliminate the causes of paper deterioration, proper conservation procedures can minimize its effects.

The agents of paper deterioration can be grouped into two categories: internal, which results from the raw ingredients and processes used to make the paper; and external, caused by environmental conditions. It is important to realize that these factors do not operate in isolation. Rather, they interact with and influence one another. For example, the amount of humidity in the atmosphere is directly

* Anne F. Clapp's *Curatorial Care of Works of Art on Paper* (obtainable from The Intermuseum Laboratory, Oberlin College, Oberlin, Ohio) was a helpful source of information for this chapter.

FIGURE 9–1
Deteriorated drawing

related to the temperature at any given moment. The major factors that contribute to paper deterioration are acid, light, relative humidity, temperature, and infestation.

ACID

Acidity is one of the main causes of paper deterioration. Acidic substances found in paper can trigger chemical reactions that damage the paper's fiber structure, making it become discolored, brittle, and weak.

Acid substances are found in paper either because they are contained in the ingredients used to make the paper or because they are introduced into the paper after the manufacturing process. In the first instance, acid substances can be found in impurities, like iron or copper particles, that are imbedded in the fiber pulp; in the lignin of wood fiber pulp; in acid residues from bleaches; or in ingredients used for sizing the paper. In the second instance, acid substances can be introduced by certain acidic media drawn or painted on the paper; transmitted through close association with secondary materials that contain acid, such as certain cardboard backings, mounting papers, matboard, and adhesives (acids tend to migrate from one surface to another); or introduced by environmental pollutants such as automobile exhausts and heating and industrial fuels.

When the preservation or longevity of an artwork on paper is important, paper is used that is made entirely of acid-free ingredients or one that has been buffered against any acidic ingredients that may have been added during manufacturing. Even though certain papers are made with acid ingredients, they can sometimes be buffered or neutralized against acidic effects by the addition of alkaline substances, such as calcium carbonate, a chalklike product.

Acidity or alkalinity in paper is expressed in pH units. The units are measured on a scale ranging from 1 (extreme acidity) to 14 (extreme alkalinity). When selecting a paper for its permanence, choose one that is neutral in both acidity and alkalinity (around pH 7). An excess of either will cause paper deterioration. Ph measurements are usually indicated on packaging labels, or they can be obtained by consulting retailers or manufacturers.

Before applying any medium to paper, check it for acid content. This is especially important for oil-based media, dyes, and certain colored inks. If water is used to soak the paper or is otherwise applied to its surface (for example, when mixed in glues or pastes or to wet gummed tapes), a distilled or de-ionized form should be used. If a glue, paste, or tape is applied to the paper, it should be of an acid-free composition. The following adhesives will not harm paper: wheat starch or rice starch paste, PVA adhesive glue, and Scotch 415 double-faced tape. Inferior adhesives include animal glue, rubber cement, paper tape, masking tape, and common adhesive tape.

FIGURE 9–2
Properly stored artwork

While a work is in progress, it should be executed in a clean, neutral environment. Store an unfinished piece flat, by sandwiching it between two sheets of acid-free paper. For more permanent storage, wrap artworks in acid-free paper and store them on flat shelves or in specially constructed acid-free storage cases. If possible, store artworks in a neutral environment, with a constant temperature and relative humidity. Artworks should not be stored in lighted areas because light agitates existing acidity (Fig. 9–2).

Drawings should be protected from acid migration during storage. This means they should not be stored in proximity to acidic materials. For example, drawings should not be wrapped in newsprint or butcher paper, nor should they be stored on bare wooden shelves. The correct method for protecting a drawing against acid migration would be to wrap the artwork in a sheet of 100 percent cotton rag or neutral Ph paper.

For further protection against acidity, artworks on paper should be properly mounted or matted and framed. Since acid migrates from one surface to another, only acid-free materials should be used when preparing artworks for exhibition. (Conservation procedures for mounting, matting, and framing artworks on paper are discussed in Chapter 10.)

LIGHT

Light is a form of luminous electromagnetic radiation that can be emitted from either natural or artificial sources. The sun gives off light that contains the wavelengths of the visible color spectrum (red, orange, yellow, green, blue, indigo, and violet). It also emits infrared and ultraviolet wavelengths which are invisible to human perception.

The most common artificial light sources, incandescent and fluorescent light, emit wavelengths of visible light. Incandescent light sources broadcast infrared wavelengths while fluorescent light emits ultraviolet wavelengths.

Light, whether natural or artificial, is potentially damaging to paper. Infrared light gives off low-frequency energy, which causes a radiant heating effect that makes paper become dry and brittle. (This process could be likened to heating a sheet of paper in an oven at a very low temperature for an extended period.) Ultraviolet light emits high-frequency energy which triggers photo-chemical reactions that damage paper's cellulose structure.

The damaging effect of light is determined by two factors: the strength or intensity of the light source and the amount of time the artwork is exposed to it. Exposing an artwork to an intense light source for a short period is just as damaging as exposing it to a less intense light source for a long time. Artworks not on exhibition should be kept in a dark storage space under neutral atmospheric conditions. During exhibition, strict procedures should be followed to ensure proper lighting conditions (Fig. 9–3).

FIGURE 9-3
Gallery exhibition with proper
lighting

Artworks on paper should not be displayed in either direct sunlight or intense artificial light. Light intensity is measured in units of footcandles. The preferred level of intensity for illuminating artworks on paper is five to ten footcandles.

Natural light contains high amounts of ultraviolet radiation. Since ultraviolet radiation is absorbed by its surroundings, direct natural light contains significantly higher amounts of radiation than indirect natural light.

Control the intensity of ultraviolet radiation given off by natural light through dimming, reflecting, or filtering the light source. Dim natural light by placing shades, curtains, or louvers over windows and skylights. Reflect it by controlling the direction of the light source through the use of screens or blinds. Also, paint an exhibition area with zinc white or Titanium white paint, which absorbs ultraviolet radiation and thus reflects light free of ultraviolet wavelengths. Natural light can be filtered by special ultraviolet filtering substances that are incorporated into windows and skylights during the manufacturing process, or through special filtering coatings that are applied after manufacturing. In addition, special ultraviolet filtering window shades, made from acrylic, can be fitted over windows. For added protection, artists should use special glazing materials that filter out ultraviolet light when framing artworks or building display cases.

The intensity of incandescent and fluorescent artificial light can be controlled by limiting the wattage of the light source, by using diffused or indirect

lighting, or by increasing the distance between the light source and the art object. Also, as with natural lights, special filters can be used to control the emission of ultraviolet and infrared radiation.

Fluorescent lights contain significant amounts of ultraviolet radiation. There are two basic types of fluorescent light sources: cool white and warm white. Warm white sources emit much less ultraviolet radiation than cool white sources and are therefore preferred for lighting exhibition areas. However, if used to illuminate artworks on paper, both types of fluorescent lights should be covered with filters. Filters can take the form of special sleeves that fit directly over the bulb, or permanent acrylic coverings that fit over the light fixture's encasement.

RELATIVE HUMIDITY

Humidity refers to the amount of moisture in the air. Relative humidity is the actual amount of moisture in the air as compared with the maximum amount that the air could contain at a given temperature. Relative humidity is expressed as a percentage.

Under normal conditions, paper has a moisture content of 6 to 7 percent. High relative humidity is detrimental to paper. It causes cellulose to absorb water and provides an environment that encourages the growth of mold and other organisms. In addition, high relative humidity makes paper more susceptible to deterioration from light. These combined factors can cause the paper to become discolored, soft, and crumbly.

Low relative humidity makes paper dry, brittle, and inflexible. Fluctuating relative humidity causes paper to swell as it absorbs water and contract as it dries. This continued expansion and contraction damages the paper's fiber structure.

For conservation purposes, it is important to maintain constant temperature and relative humidity levels in the environment where artworks are stored or exhibited. For artworks on paper, the optimum relative humidity falls between 45 percent and 55 percent with an absolute upper limit of 65 percent. It is also important to keep the air within the storage or exhibition environment circulating. Optimum environmental conditions can be maintained through the use of air conditioning and dehumidifying/humidifying systems.

TEMPERATURE

Temperature and relative humidity are interrelated: a fluctuation in temperature causes a corresponding change in relative humidity. A rise in temperature produces lower relative humidity, while a fall in temperature produces higher relative humidity.

High temperatures are detrimental to paper because they accelerate destructive chemical reactions. When combined with low relative humidity, they can also

cause paper to dry and lose its natural moisture content, which causes discoloration and brittleness that eventually leads to breakage of the paper's fibers. Conversely, low temperatures combined with high relative humidity can result in condensation which eventually causes paper to become soft and crumbly. Fluctuating temperatures cause paper to expand and contract. This in turn makes the cellulose fibers abrade against each other and eventually weaken and break.

For conservation purposes, maintain a constant temperature in the environment where artworks are exhibited or stored. The optimum temperature for artworks on paper is 65 to 70 degrees Fahrenheit. Constant temperatures can be maintained through the use of heating and air conditioning systems.

INFESTATION

Mold spores are the most common agents of paper infestation. Present in most environments, mold spores do not usually begin to grow unless the relative humidity is above 70 percent and the temperature is above 70 degress Fahrenheit. They proliferate in still, warm, moist air.

Mold is damaging to paper because it reacts with high relative humidity and temperatures to soften and weaken the paper's fiber structure. It also causes increased acidity and discoloration. When combined, these factors ultimately lead to deterioration and crumbling of the paper.

Infestation can also be due to certain types of insects. These pests, like mold, flourish in dark, musty, undisturbed environments.

Control infestation by maintaining a clean working, storage, or exhibition environment. Most important, maintain relative humidity and temperature at a proper and constant level. In addition, circulate air to avoid stagnant pockets that encourage the growth of mold. Infestation from insects can be controlled by following the same procedures and by using insecticides when necessary.

10
Presentation of Drawings

MOUNTING

There are many ways to prepare drawings for display and exhibition, but the most common methods fall into three general categories: mounting, matting, and framing.

Mounting is one of the simplest ways of preparing a drawing for presentation. In this method, the artwork is "mounted" or placed on top of a supporting surface. Generally, artists use one of three mounting methods: a dry mount, a suspended mount, or a floating mount system.

In the dry mounting procedure, the artwork is adhered to a supporting surface by placing a sheet of acid-free glued paper (called dry mount tissue) between it and the supporting surface (usually poster board or foam core board) (Fig. 10–1). The entire sandwich is then heat pressed and thus is permanently sealed together. Although the procedure is effective, it is irreversible. Once mounted, the artwork cannot be removed from its supporting surface. In addition, the materials that are used in this procedure often have a high acid content that eventually causes the artwork to deteriorate. Therefore, dry mounting should not be used when preservation of the artwork is important.

FIGURE 10-1
Dry mount procedure. (a)
drawing, dry mount tissue, and
supporting surface; (b) layers
heat-pressed with tacking iron;
(c) illustration placed into dry
mount press; (d) dry mount press.

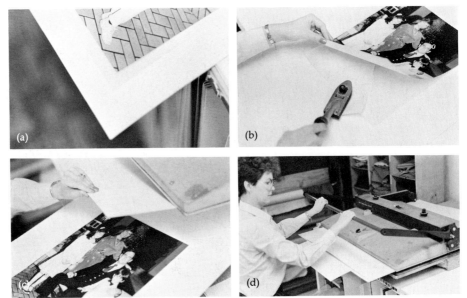

When preservation of the artwork is a consideration, artists use a suspended or floating rather than a permanent mounting system. These mounts are prepared as follows.

In the first method, the drawing is simply suspended from, rather than glued to, the supporting surface. First, a supporting surface of 100 percent cotton rag or neutral pH board is prepared. The board can be cut to the same dimensions as the artwork, or it can be cut larger so a border is left around the drawing. Next, a piece of acid-free, double-faced linen tape is moistened on its reverse side and glued horizontally across the top edge of the board. Finally, the front side of the tape is moistened and the top edge of the drawing is carefully glued to it. A suspended mounting system is particularly effective for displaying artworks on paper having four distinct edges when the feathered edges of the paper are set off by a surrounding border.

In the second mounting method, the drawing is held in place by inserting it into four small, triangular pockets that are attached to the corners of the supporting surface. Once again, a supporting surface of 100 percent cotton rag or neutral pH board is prepared and cut to the same dimensions as the artwork. Next, a short piece of single-faced, acid-free linen tape is cut and placed over each corner. Then the tape is folded and glued to the back side of the board so a small triangular pocket is formed. Finally, the corners of the drawing are carefully tucked into each pocket (Fig. 10-2). If a border is to be left around the drawing, a larger supporting surface is prepared and a similar mounting method is used. However, here the triangular pockets are formed from medium-weight acid-free drawing paper glued to the supporting surface with wheat starch paste (Fig. 10-3).

FIGURE 10-2
Drawing supported by double-faced linen tape.

FIGURE 10-3
Drawing supported by corner pockets.

Both the suspended and floating mounting methods protect the drawing from damage by allowing the paper to expand and contract with variations in temperature and humidity. Also, the artworks can later be removed from their mounts if desired.

FIGURE 10–4
Matted drawing

MATTING

Matting is another way of preparing drawings for presentation. In this method, the artwork is mounted on a supporting surface and displayed behind a "window" that is cut from a piece of mat board (Fig. 10–4).

Mats can be cut from many types of board, including those with colored and decorative surfaces such as fabric, cork, and foil. However, the more common types of mat board are made with highly acidic materials. Since acid migrates from one surface to another, if used, these boards will eventually cause the artwork to deteriorate. As always, when preservation is a consideration, mats should be made from 100 percent cotton rag board or a neutral pH board. Non-acid mat board is currently available in an assortment of light values and pastel colors.

The procedure for matting a drawing is as follows. First, the dimensions of the mat are determined. The dimensions of the window should be slightly smaller than those of the drawing so the artwork will be engaged by the mat board and not buckle through its edges. While there are no set standards for determining the width of the mat's border, generally the larger the mat, the wider its borders. The mat should visually enhance and physically protect the drawing. Therefore, it should neither be too narrow nor too wide. Also, it is common practice to make the bottom of the mat slightly wider than its sides. This visually compensates for the fact that if all sides are the same width, the bottom will appear narrower. Once the dimensions of the window and its border have been determined, the height and width of the entire mat can be established.

When transferring the dimensions of the window and its borders, marking should be done on the back, rather than the face of the board. This practice will ensure that the face of the mat remains clean during preparation and cutting.

(a)

(b)

The window can be cut with a mat knife, X-acto knife, or a single-edged razor blade. However, for a more professional appearance, most artists prefer to use a special mat cutting mechanism that creates a 45-degree beveled edge around the mat's window (Fig. 10–5).

The beveled edge serves two functions. It is visually attractive in that it provides a subtle transition that gradually leads the eye from the edge of the mat into the artwork. In addition, unlike a vertical edge, a beveled edge will not cast a shadow from the mat onto the artwork.

When cutting a mat it is important to use a *very* sharp blade. This is particularly true when cutting rag board, which is more difficult to cut than standard mat board. Also, when cutting a beveled mat, to ensure crisply cut corners, it is wise to cautiously extend both cuts, ever so slightly, beyond the dimensions marked at each corner on the reverse side of the mat. The outer edges of the mat should not be cut until after the window has been cut. If necessary after the mat has been cut, a piece of very fine grade sandpaper can be used to remove fuzz or splinters from the cut edges, or they can be lightly burnished with a tool called a bone folder. Later, the mat can be cleaned with a soft kneaded eraser or eraser bag and then brushed clean with a soft-haired brush.

Once the mat has been cut, the supporting surface that will hold the drawing is prepared. It should be cut to the same dimensions as the outer edges of the mat and, like the mat, it should be cut from a sheet of acid-free board. Next, the mat and supporting surface are hinged together along their top edge with linen tape. Then, the drawing is placed on top of the supporting surface and the mat is folded back over it. The drawing is carefully adjusted and positioned exactly as it will finally appear through the window of the mat. The drawing is then covered with a clean sheet of paper upon which a weight is placed so the mat can be lifted without moving the drawing.

FIGURE 10–5
Cutting a mat. (a) comparing dimensions of art and mat board; (b) inserting mat board in mat cutter; (c) mechanism on mat cutter creating a 45-degree beveled edge; (d) displaying finished mat.

(c)

(d)

After the mat has been lifted, the drawing is hinged to the supporting surface. The hinges, called T-hinges, are prepared by cutting four strips of acid-free linen tape several inches long. The ends and sides of the tape are frayed to eliminate sharp edges. Two of the strips are then glued to the back of the drawing so they extend several inches beyond its top edge. Then the two remaining strips are glued face down over these onto the supporting surface (Fig. 10 – 6). If preferred, hinges can also be prepared from non-acid Japanese Kozo paper and wheat starch paste rather than linen tape. When suspending larger drawings, it may be necessary to use more than two hinges. After hinging, the mat is folded back over the drawing and its supporting surface, and the drawing is ready to display or frame.

After a drawing has been matted, it is often framed under glass or plexiglass for protection. Here, the mat serves a practical purpose in that it keeps the artwork from resting directly against the glass while it is being displayed. It is especially important that loose-surface artworks, such as charcoal or pastel drawings, be protected by deep-ply mat since they are somewhat fragile and tend to flake or dust from the drawing's surface if pressed against glass.

In addition to serving a practical purpose, mats are also used for aesthetic and decorative reasons. For example, a lightly tinted mat can be used to compliment or bring out the colors of a pastel drawing. Or, a mat with thin decorative lines drawn around its window (called a French mat) can be used to subtly

FIGURE 10 – 6
T-hinges secure drawing to
supporting surface

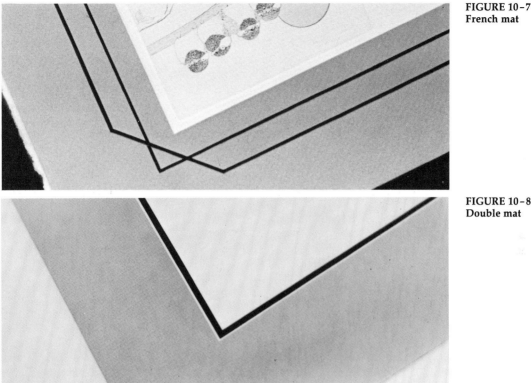

FIGURE 10-7
French mat

FIGURE 10-8
Double mat

enhance an ink drawing (Fig. 10-7). Another interesting effect that can be achieved when matting a graphite pencil drawing is to carefully darken the beveled edge of the mat with a medium-soft graphite pencil to repeat the tonalities of the drawing.

Occasionally, artists mat their drawings with a double mat. Double mats are prepared by mounting two mats of the same outer dimensions on top of one another. However, the window opening of the bottom mat is cut to slightly smaller dimensions and thus appears as a thin decorative border around the drawing. Often to set off the artwork, the bottom mat is a different value or color (Fig. 10-8). Since double mats create a deep space between the artwork and the glass, they are frequently used to give added protection to loose-surface artworks such as charcoal or pastel drawing.

In addition to standard rectangular and square mats, it is also possible to cut irregular, oval, and circular shapes. To display a group or series of small drawings, a large mat with several windows can be prepared.

Some artists prefer to do their own mounting and matting because it is less expensive. Others, in order to save time and ensure quality craftsmanship, use the services of professionals.

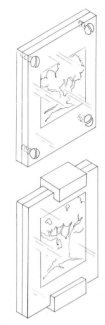

FRAMING

Framing a drawing serves a practical as well as an aesthetic purpose in that it protects the artwork from potential damage. Many different types of frames and framing devices are currently available. However, drawings are usually framed by placing the mounted or matted artwork under glass or plexiglass which is held in place by a wood, metal, or plastic molding.

Perhaps the simplest and most inexpensive method for framing an artwork is to merely sandwich the mounted or matted artwork between two pieces of plexiglass that are held together by screws fastened at each corner. Another simple framing device can be made by covering a mounted or matted drawing with glass or plexiglass that is held in place by two metal brackets, called museum clips. The clips are secured at the top and bottom of the "package" and tightened with a tension cord that is stretched between them on the reverse side of the artwork (Fig. 10–9).

Standard picture frames are constructed with a molding that holds the mounted or matted artwork and glass together. Today, artists can select from an astonishing variety of moldings. There are traditional wooden moldings available in assorted shapes and sizes that can be stained, painted, or decorated. Also, there are metal moldings in subtly burnished or highly polished anodized finishes. In addition, there are frames made of acrylic plastic in a range of colors that span the complete color spectrum.

FIGURE 10–9
(top) Sandwich frame; (bottom) Museum clip frame

Selecting a molding is largely a matter of personal preference. However, there are aesthetic as well as practical considerations. Most importantly, a frame should enhance, not detract from the appearance of the artwork. The size, shape, color, and surface quality of the molding should be carefully selected so it relates to rather than overpowers the artwork. For example, a delicate graphite pencil drawing could be framed using a thin, simple molding with a burnished pewter finish that echoes the tonalities of the graphite medium.

Picture frames are made by cutting a length of molding into four pieces with a 45-degree mitered corner on both ends. The pieces are cut with a miterbox and saw or a heavy-duty mitered blade, called a chopper. Once cut, they are placed in a special L-shaped vice and fastened together. Wooden frames are glued and then reinforced with nails at each corner. Then the nails are countersunk with a punch and the holes are filled with colored putty. [Note: Wood is highly acidic and acid can migrate from the wooden molding to the mounted or matted drawing. To prevent acid migration, it is wise to seal the inside edge of the molding with several coats of gesso before assembling the frame (Fig. 10–10).] Most metal and plastic frames are held together with L-shaped tension brackets that are inserted and tightened at each corner (Fig. 10–11).

FIGURE 10–10
Wooden frame made from moulding

After the molding has been assembled, a piece of glass or plexiglass is cleaned and inserted into the back of the frame. Two types of glass can be used, standard and nonglare. However, nonglare glass is not recommended for displaying fine artworks since it tends to distort the image, causing it to appear somewhat

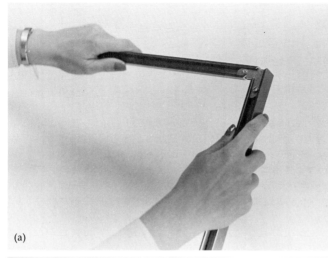

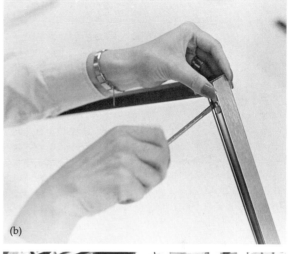

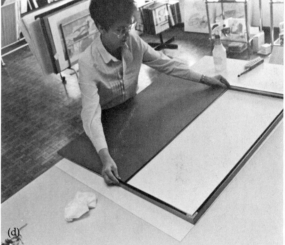

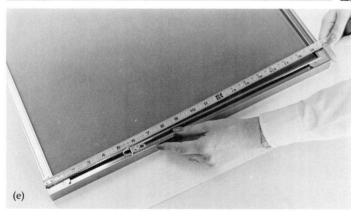

FIGURE 10–11
Putting together a metal frame: (a) placing L-shaped
tension brackets in two corners; (b) tightening
brackets; (c) cleaning glass or plexiglass with
newspaper and an alcohol-water mixture; (d) sliding
print, mat, and glass or plexiglass into frame,
face-down; (e) after placing remaining side of frame
and tightening brackets, measuring for placement of
metal brackets.

fuzzy and out of focus. For practical reasons, many artists prefer to display their drawings under plexiglass rather than glass. Plexiglass is difficult to break and is therefore safe for mailing, shipping, or transporting the artwork. In addition, a certain type of plexiglass (UF3) retards ultraviolet light, which causes deterioration. The main disadvantages of plexiglass are that it collects dust through static cling and that it scratches easily. Also, particles from loose-surface artworks such as charcoal and pastel drawings tend to adhere to plexiglass due to static cling. Plexiglass should be cleaned with a special plexiglass cleaner.

Once the glass or plexiglass has been positioned, the mounted or matted artwork is inserted face down on top of it. (When inserting the artwork, it is best to hold the frame in a perpendicular position so the drawing can be seen under glass and checked for imperfections before final assembling.) The frame is then backed with several sheets of acid-free board for additional support. When a wooden molding is used, the ''package'' is held in place with diamond-shaped points or small nails that are inserted into the sides of the molding. When a metal or plexiglass molding is used, the package is held in place with metal tension clips inserted between the molding and backing board. When a frame is made with a wooden molding, the back of the frame is usually sealed with a sheet of brown wrapping paper. However, since this paper has a very high acid content, it would be preferable to use an acid-free paper.

Once constructed, frames are hung by suspending them from a wire or a metal bracket attached to the back of the frame. If a wire is used, the height of the frame should be divided into thirds, and the wire should be stretched horizontally between the first divisions from the top. When a wooden molding is used, the wire is held by screw eyes inserted into the molding. Wires are attached to metal frames by a special clip that is inserted into the back of the molding before the frame is assembled.

In addition to standard rectangular frames, frames also are available in circular, oval, and irregular shapes. As with mounting and matting, some artists make their own frames while others prefer to use the services of professionals.

PORTFOLIOS

A portfolio is a representative selection of artworks that best exemplify the abilities of an artist. In the past, the term was used when referring to a collection of original artworks. Today, the term is also used to describe a collection of photographic examples of an artist's work, such as 2" x 2" color slides, 4" x 5" color transparencies, or 8" x 10" color photographs. In fact, for the sake of convenience, artists increasingly are asked to submit photographic examples rather than their original artworks. Photographic portfolios will be discussed in a separate section, immediately following a discussion of traditional fine arts portfolios.

Fine Arts Portfolios

Portfolios are used in both fine arts and commercial art. In the fine arts, there are two basic types of portfolios (Fig. 10–12). The first group includes those that are assembled to show the breadth or range of an individual's experience. In this instance, artworks are selected that best exemplify the artist's potential development and that exhibit a variety of experiences in media, technique, and subject matter. Portfolios of this type are submitted by candidates who apply to fine arts programs at the undergraduate level. Also, students in some fine arts programs are required to submit this type of portfolio as part of a qualifying review before entering their junior or senior year. In addition, candidates may be asked to submit a fine arts portfolio when applying or competing for academic scholarships.

The second group of fine arts portfolios includes those that are assembled to show a more specific or limited aspect of an individual's abilities. In this instance, artworks are selected that best exemplify an individual's personal style or thematic approach, or that exhibit the artist's abilities with a particular medium. Portfolios of this type are often submitted by candidates who apply to fine arts graduate programs. In addition, artists also submit this type of portfolio when presenting their artworks to prospective clients, art dealers, museum curators, or administrators of grant-funding foundations or agencies.

The appropriate number of artworks to include in a fine arts portfolio is relative to the situation. However, unless specific requirements are stated, 20 artworks are usually sufficient.

FIGURE 10–12
Sample portfolio

A fine arts portfolio can be organized in various ways. One common method is to simply arrange the work in chronological sequence, with the most recent works appearing first. Another method is to organize the work by grouping it according to medium. In this instance, it is best to have a balanced selection of artworks in each medium. Finally, portfolios can be categorically arranged according to subject matter or thematic concepts, such as figure studies, still lifes, or landscapes. Again, it would be wise to have a balanced selection of artwork in each category.

Next to the actual quality of the artwork itself, presentation is the single most important aspect to be considered when assembling a portfolio. The following procedure is suggested.

1. First, all artworks should be neatly presented. They should be trimmed or cropped to remove ragged or spiral edges. Also, artworks that are creased, wrinkled, or otherwise damaged or aged should not be included in the portfolio. Artworks should be carefully cleaned with a soft kneaded eraser to remove smudges, grime, and fingerprints. Then the artwork should be "dusted" with an eraser bag to remove any remaining soiled areas. (See Erasers page 106.)

2. When assembling a portfolio, artists should anticipate that their artworks will be handled by the viewer and prepare them accordingly. Certain artworks should be protected from smudging and smearing by spraying them with a fixative. This is especially true of loose-surface artworks such as pastel and charcoal drawings. However, fixatives should be used sparingly since they can cause paper deterioration.

 For formal presentations, all artworks should be professionally mounted or matted upon a durable supporting surface. (See Mounting and Matting pages 153 and 156.) When assembling a portfolio, artists sometimes make the exterior dimensions of all mounts, mats, and supporting surfaces the same, even though their interior dimensions may differ. This consistency creates a more professional appearance and facilitates handling. To protect them from damage, artworks should be covered with a thin sheet of acetate, which is placed behind the mat's window and taped to the supporting surface.

3. If the portfolio is divided into sections, it should be separated with neatly labeled dividers. Also, labels can be attached to the back of each artwork indicating additional information such as medium, size, title, and date of execution.

4. Professional portfolio cases are available in various styles and can be purchased through most art supply stores. Or, artists can construct their own portfolio cases. Whether purchased or handmade, the portfolio case should be sturdy, yet not bulky. It should both contain and protect the artworks, especially if the portfolio is to be shipped. Also, the portfolio should be easy to open to avoid aggravating the

viewer. Finally, the portfolio case should not detract from its contents. Since first impressions are important, the case should have an attractive, professional appearance. For security, the case should be neatly labeled on the inside with the artist's name, address, and telephone number.

Fine Arts Photographic Portfolios

Artists are frequently asked to submit photographic portfolios rather than original artworks because the former are more convenient to handle. This is particularly true in the field of fine arts.

Photographic portfolios are usually assembled from a selection of 2" x 2" color slides (Fig. 10–13). However, in certain instances, 8" x 10" color photographs are used instead. In addition, many artists have recently begun using 3" x 5" color transparencies which are easier to view because of their size. In either case, it is imperative that only high-quality, well-photographed examples are included in the portfolio.

Photographic portfolios, like their original counterparts, can be classified into two basic types: those that are assembled to show the breadth and range of an individual's experience and those that demonstrate a more specific aspect of an individual's abilities. In both cases, the information given for original portfolios will generally apply to photographic portfolios.

FIGURE 10–13
Example from a photographic portfolio

Like the standard portfolio, photographic portfolios should contain about 20 examples, several of which may be details of a particular artwork. Slides and transparencies should be mounted in standard cardboard mounts. They should not be encased in metal and glass protective mounts, since this type of mount frequently "jams" when placed in slide projectors. Also, the protective glass coverings sometimes break during handling and shipping. If necessary, slides can be cropped with a silver reflective tape to block out unwanted areas.

Slides should be neatly labeled on their cardboard mounts with the following information.

1. The artists name.
2. The title of the artwork.
3. The medium in which the work was executed.
4. The dimensions of the artwork.
5. The date of execution of the artwork.
6. The number of the slide as it appears in the group's sequence.
7. The correct position for viewing the slide should be indicated by placing a small red dot in the lower left-hand corner of the slide's front face.

Once prepared, the slides should be inserted in numerical sequence into the individual pockets of a clear plastic slip sheet. To protect the slides against deterioration, archival slip sheets should be used. Then, on a sheet of paper, a corresponding list of the slides should be prepared in numerical sequence indicating the title, medium, dimensions, and date of execution of each artwork.

If 3" x 5" color transparencies or 8" x 10" color photographs are used instead of, or in addition to, slides, artists should follow the same basic procedures that were used to prepare slides. However, the photographs should be labeled on their reverse side and sequentially arranged in individual protective plastic sheets.

Once prepared, the slip sheets containing slides, transparencies, or photographs should be placed in a simple, durable, protective folder. The corresponding list should be included in the front of the folder. Also, in some instances, artists may be asked to include a resumé and statement of intent along with photographic examples of their artworks. Finally, for added protection, the folder and its contents can be sandwiched in bubble wrap before it is inserted into a padded mailing envelope.

Commercial Art Portfolios

In commercial art, graphic designers prepare and submit portfolios primarily to show their abilities and potential to prospective employers. In addition, many commercial art schools require candidates to submit a portfolio when applying to their programs. Also, once employed, graphic designers are often asked to submit portfolios to clients (Fig. 10–14).

FIGURE 10-14
Commercial art portfolio

Individual commercial art schools have different requirements regarding portfolio presentations by candidates; therefore, we will limit our discussion of commercial art portfolios to those submitted by graphic designers to prospective employers.

Most employers prefer to see original artwork rather than photographic examples of an artist's work. Thus, it is imperative that the artwork be professionally executed and presented. The procedures that were previously discussed for preparing a fine arts portfolio can be generally applied when preparing a commercial art portfolio. Again, it is important to emphasize that next to the quality of the artwork, presentation is the single most important aspect to be considered when preparing a portfolio.

Although individual employers may have their own specific requirements, it is recommended that graphic designers include the following examples when submitting their portfolio to a prospective employer.

1. *Hand Lettering* One or two plates should be included to demonstrate the artist's ability to execute clean and accurate presentations.
2. *Spot Drawings* One or two plates of black-and-white line drawings executed in ink, zipatone, or scratchboard.
3. *Marker Renderings* Two plates should be included, containing examples in black and white and one containing examples in color. Each example should be drawn with a self-imposed time limit and should be labeled as follows:
 A. *Quicky* five to ten minutes.
 B. *Moderate* ten to 30 minutes.
 C. *Super* one hour.

4. *Ad Layout with Mechanicals* One plate should be included with the following examples.
 A. *Thumbnails* a group of small quick sketches that are executed to explore ideas. They should be drawn in proportion to the final layout.
 B. *Rough* a full-scale, quick drawing in which the placement of elements, such as shapes, lines, values, and colors, is established.
 C. *Layout or Comprehensive* a full-scale rendering that closely resembles the finished artwork.
 D. *Mechanical* an example that is prepared as an original for photo mechanical reproduction.
5. *Trademark/Logos* One or two plates with a collection of various designs. A logo is a business name or trademark that may be represented as a design or symbol.
6. *Letterheads* One or two plates containing examples with letterhead, envelope, business card, invoice statement, and matchbook.
7. *Photo-Retouch* One or two plates of photographic retouching.
8. *Airbrush* One or two plates of examples.
9. *Color Key* One plate should be included. This example is made by placing colored overlays on a black-and-white original. The overlays are made from pre-prepared sheets of colored polyester film.
10. *Figure Drawing* One or two plates of high-quality figure studies should be included.
11. *Fashion Illustration* This item is optional, but one or two plates may be included if the artist has an interest in this area.
12. *Cartooning* This item is optional, but one or two plates may be included if the artist has an interest in this area.
13. *Dimensional Designs* One or two plates containing photographic examples of three-dimensional designs such as packages, containers, or counter displays.
14. *Covers* One or two plates that include examples of original illustrations for the cover of a record jacket or magazine, such as TV Guide.
15. *TV Story Board* One or two plates that include a series of illustrations for a proposed television commercial or animation series.
16. *Illustrations* One or two plates containing examples that exhibit the artist's drawing ability. Illustrations can be executed in media such as pen and ink, watercolor, or gouache.

PHOTOGRAPHING ARTWORKS

There are numerous occasions when artists need photographic examples of their artwork. Any artist who has ever tried to describe his or her artwork will appreciate the wisdom of the cliché, "a picture is worth a thousand words."

Artists frequently are asked to submit photographic examples, rather than their original artwork, when applying for entrance into undergraduate or graduate programs, or with their applications for job interviews. In addition, artists often submit photographic examples when entering their work in competitive exhibitions or when submitting their work for consideration by art dealers, curators, or private collectors. Most artists also keep photographic examples as a personal record of their artistic development. Such examples are convenient to use when making personal presentations.

Artists generally prepare photographic examples of their artwork in one of the following ways: as standard 35 mm black-and-white or colored slides; as 4" x 5" black-and-white or colored transparencies; or as 8" x 10" black-and-white or colored glossy prints.

Because specialized knowledge and equipment are needed to obtain quality reproductions of artwork, many artists prefer to have their work photographed by professionals. Others, however, prefer to shoot their own photographs and then have the film commercially processed. Artists not familiar with the equipment and procedures used in photography should consult with a photographer before attempting to shoot their own photographs.

Due to the nature of this text we will confine our discussion of photographing artworks to two-dimensional works executed primarily in drawing media. Before beginning, the following equipment will need to be rented or purchased from a photographic supplier:

1. a 35 mm single-lens reflex camera;
2. colored slide film;
3. a cable release;
4. two photo floodlights;
5. a light exposure meter (some cameras have built in light meters);
6. a copy stand or tripod;
7. an easel (optional);
8. a black background curtain (optional);
9. a close-up lens (optional—a close-up lens would be used when photographing miniatures or very fine details).

Photographers employ two basic procedures when photographing two-dimensional artwork. In the first procedure, used for photographing smaller work, the artwork is supported on a flat copy stand. In the second, used for photographing both small and large work, the artwork is supported, vertically, by an easel.

Artworks can be photographed in natural light. However, it is preferable to photograph indoors under controlled lighting conditions as there are many variables to be considered when photographing out-of-doors.

The following procedure is suggested for taking standard 35 mm color slides of a two-dimensional artwork using a copy stand. The same basic procedure would be followed when taking 4" x 5" black-and-white or colored transparencies

or when taking 8″ x 10″ black-and-white or colored glossy prints. A different film, however, would be used for each purpose.

First, load the camera with film. Although other films can be used, Ectachrome Tungsten 50 Colored Slide Film, with a color temperature of 3,200 Kelvin (K), is recommended. This is a slow speed film that is ideal for photographing detail and for use under artificial light. For best results, use colored slide film when photographing either black-and-white or colored artworks. Keep your film refrigerated when not in use. Remove it from refrigeration (but do not open it) two hours before use to prevent condensation on the film.

Insert the clipped end of the film securely in the slot provided on the take-up spool of the camera. Be sure the film is engaged in the teeth of both the upper and lower sprockets. Use the camera's advance lever to take up any slack and to ensure that the film is advancing properly. Close the camera and continue advancing the film until number 1 appears on the exposure indicator.

Next, attach the cable release to the camera. This apparatus, which functions as an extension of the camera, is a long cable that is attached to the shutter release. It activates the release when you push the plunger, similar in shape to a hypodermic needle. The cable release prevents the camera from jiggling or moving when the shutter release is pushed.

Now, attach the camera to the copy stand. A copy stand is a small table with a flat top that is used to support the artwork while it is being photographed. One side of the stand is equipped with a central vertical post to which is attached a

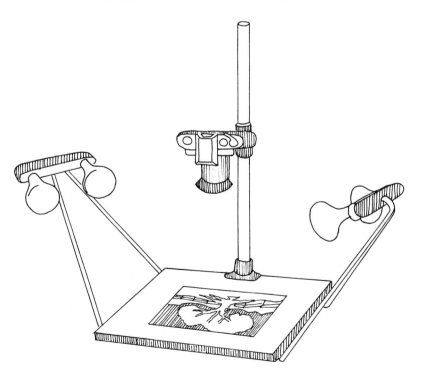

FIGURE 10–15
Copy stand

sliding platform that holds the camera. The camera is positioned on this platform and moved vertically up or down in order to properly frame the artwork (Fig. 10–15).

If needed, place a piece of clear, nonglare glass over the artwork to keep it flat and to prevent reflections. In some instances the copy stand is equipped with photo floodlights that are attached directly to it. Otherwise, position the photo floodlights, on stands, at a 90-degree-angle to the artwork so each floodlight casts an equal amount of evenly distributed light (Fig. 10–15). If you are using tungsten film, use two tungsten lights of equal wattage. Tungsten lights are usually rated between 3,200 and 3,400 (K).

Use a light meter to take a reading from the artwork to determine the camera's shutter speed and aperature (F stop, or opening of the lens). Also, use the light meter to ensure an even distribution of light across the entire artwork. Some cameras have a built-in light meter, otherwise use a hand-held meter.

If you are photographing artworks that contain extreme dark and light contrast, use an 18 percent gray card to determine the shutter speed and aperature of the camera. Position your gray card in the center of the artwork and take your light reading from it. When photographing artworks executed in color, a *slight* underexposure tends to make colors deeper and richer. Overexposure tends to wash-out colors unless the work is especially dark in nature.

There should be no movement in the room when you are photographing. In addition, the environment should be clean and free of dust. Push the cable release button and take the first exposure. Then manually advance the film to the next exposure.

For the most successful results, it is best to "bracket" when photographing artworks. Bracketing is a technique in which a series of three exposures, rather than a single exposure, is taken of each artwork. Take the first exposure using the shutter speed and aperature reading indicated by the light meter. Then take the second exposure shooting one stop below. This should ensure that one of the three shots is perfect.

After you have taken your last exposure, press the rewind button and turn the crank clockwise to rewind the film. When there is no longer any tension on the film, pull out the rewind knob, open the camera, and remove the film.

For best results, have your film processed by a professional photo lab. When your slides have been returned, place them in a projector and check the three slides to see which is the most accurate. If you are going to make duplicates, have them made from this slide.

It is wise to keep a record of each photo session. Such a record should include a list of the artworks that were photographed; the type of film that was used; the type and wattage of the lights that were used; and the readings of the camera's shutter speed and aperature settings from each bracket.

As an alternative to the previously discussed method, some photographers prefer to photograph artworks while they are held vertically by an easel or suspended from a wall. This method is particularly suitable for photographing

larger artworks. In this instance, the same basic procedures just discussed are used, with minor variations.

First, load your camera with film and connect the shutter release cable to the camera. Then attach your camera to the tripod panhead for stability. Position your artwork at the proper height vertically on an easel or suspended from a wall. Be sure the artwork is hanging parallel to the camera to prevent keystoning. (Keystoning creates an image with a trapezoid rather than with a rectangular shape.) If you desire, hang a black velvet curtain, or a similar dark fabric, behind the artwork to help prevent reflections. Position your photo floodlights, on stands, at a 90-degree-angle to the artwork. Take a light reading from the artwork and adjust your camera settings. Finally, push the cable release button to expose the film.

PACKING AND SHIPPING

Packing

When artworks are transported, special consideration must be given to packing and shipping to ensure their safe arrival. Generally, drawings are shipped in one of three ways: as individual sheets, as mounted or matted pieces, or as framed artworks.

Drawings on individual sheets can be conveniently packaged and shipped by carefully rolling them into a cylinder and inserting them into a heavy card-board mailing tube. Although this method is expedient, it is also rather precarious, since mailing tubes are sometimes crushed or damaged in transit. If a mailing tube is used, be certain to use a heavy, reinforced cardboard tube with firm metal or plastic ends. Before inserting the drawing into the tube, it is wise to wrap it in plastic or glassine (a smooth, thin, moisture-proof paper similar in appearance to rice paper) to protect it from moisture. Also, include a forwarding and return address label inside the tube in case the outer address label is damaged.

Flat artworks, such as individual sheets and mounted or matted drawings, can be prepared for shipping as follows. First, wrap and seal the artwork in a sheet of glassine to protect it from moisture. Next, for added protection, wrap the artwork in a thin sheet of bubble wrap. Then, cut two pieces of eighth-inch or quarter-inch Masonite or plywood slightly larger than the dimensions of the package. (As an added precaution against moisture, paint the boards on both sides with several thin coats of gesso or latex paint.) Finally, sandwich the wrapped artwork between the Masonite boards and bind the edges with a heavy-duty PVC packaging tape. Once again, it would be wise to include an address label inside the package.

Packing a framed artwork for shipping is a rather complicated procedure since both the frame and the artwork must be protected from damage. The most

practical method is to package the artwork in a reusable, cushioned wooden crate. This procedure can generally be described as follows. First, gather the following materials:

1. a sheet of glassine;
2. a sheet of bubble wrap (a cushioned, plastic packing material covered with tiny air bubbles);
3. two sheets of quarter-inch plywood or Masonite;
4. four pieces of 1 inch by 4 inch construction-grade board;
5. two thin sheets and four thick strips of ethafoam padding (a type of semi-hard cushioned foam that is pliable yet durable);
6. carpenter's glue;
7. several dozen brass wood-screws.

The dimensions of the crate will be determined by the dimensions of the drawing. To avoid mistakes, prepare a rough, dimensional sketch of the crate before buying your materials. Once the dimensions have been established, assemble the crate as follows (Fig. 10–16).

1. Cut two identical pieces of plywood or Masonite to size.
2. Cut four pieces of 1 inch by 4 inch construction-grade board to size.
3. Using carpenter's glue and wood screws, drill holes and attach the two longer boards to each side.
4. Cut and glue a thin sheet of ethafoam padding to the interior face of the enclosed plywood sheet.
5. Wrap and seal the framed artwork in glassine and then in a thin sheet of bubble wrap.
6. As a guide, set the packaged artwork on top of the padding. Then, cut three strips of ethafoam and insert and glue them between the frame and sideboards of the crate. The strips should be the same thickness as the depth of the wrapped frame and should fit snugly against the frame.
7. Cut and glue the second thin sheet of ethafoam padding to the remaining plywood sheet. Be sure to leave a border so the sheet can be inserted face down inside the crate.
8. Position the second plywood sheet and attach it with glue and wood screws to the three supporting boards.
9. Cut a fourth strip of ethafoam and snugly insert it, unglued, into the open end of the crate.
10. Position and screw, unglued, the remaining 1 inch by 4 inch board to the end of the crate. (When the drawing arrives at its final destination, it can be easily unpacked by simply unscrewing this board and removing the ethafoam strip behind it.)

FIGURE 10–16-a
Museum crate

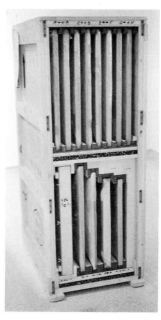

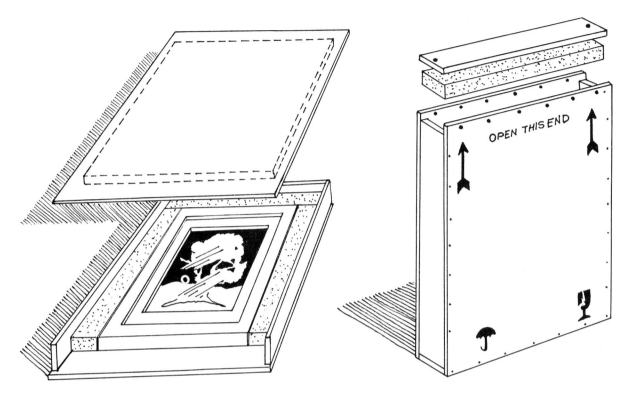

FIGURE 10–16-b
Assembling crate

11. If desired, for added protection against moisture, the entire crate can be painted with gesso or latex before it is assembled.
12. To facilitate handling, especially on larger crates, wooden or metal handles can be attached to the sides of the crate.
13. Carefully label the crate with the following information.

 A. Both forwarding and return addresses (Again, it would be wise to include an address label on the inside of the package in case the outer address label is damaged.)

 B. FRAGILE

 C. KEEP DRY

 D. OPEN THIS END

When drawings are transported only a short distance, a crate is not usually necessary. In this case, the following procedure is recommended to protect the drawing from damage.

1. Wrap and seal the drawing in glassine to protect it against moisture.
2. Wrap this package with a thin sheet of bubble wrap.
3. To protect the corners of the frame from damage, prepare and attach four corner pads from cardboard or foam.
4. Wrap the entire package in a packing blanket.

Shipping

There are four common methods of shipping or delivering artworks:

1. Hand delivery;
2. The United States Postal Service;
3. United Parcel Service (UPS);
4. Greyhound Package Express.

The simplest and most expedient way to transport an artwork is hand delivery. In this case, the artwork is packaged and hand carried by the artist or the agent to its final destination.

The United States Postal Service will mail artworks that are appropriately packaged or crated including those that are framed under glass, plexiglas, or acrylic. However, postal regulations limit the weight of the package to 70 pounds and its dimensions to 108 inches (this dimension is determined by adding the longest dimension of one side and the girth of the package). Packages delivered by common carrier can be insured up to $500. If more insurance is desired, the package can be sent by registered mail and can be insured up to $25,000. The artwork can be insured on consent of the postmaster, without proof of value. However, if damage occurs and a claim is filed, a validation of the artwork's value must be established before payment will be made. A return receipt can be requested when sending a package by registered mail. This receipt is signed by the recipient and returned to the sender, thus indicating that the package arrived safely.

The United States Postal Service offers three methods of shipping: Parcel Post, which is the least expensive and slowest; First Class, which is more expensive and faster; and Overnight Express, which is the most expensive and the quickest. A package shipped Overnight Express will arrive at its destination almost anywhere in the United States within twenty-four hours. Packages that are shipped Overnight Express can only be insured up to $500. The United States Postal Service normally does not pick up packages from residences. However, in some rural areas, carriers will pick up and deliver small packages and bill you the next day.

The United Parcel Service (UPS) will ship artworks that are properly packaged, including wooden crates. UPS will accept artworks framed under plexiglas

or acrylic but will not accept artworks framed under glass. Regulations limit the weight of the artwork to 70 pounds and its dimensions to 108 inches. Artworks can be insured for any amount up to $25,000 if the value of the artwork can be substantiated.

UPS will pick up packages from a residence for a $3.25 service charge. To make arrangements, call their toll-free number and provide the following information at least one day in advance: the contents of the package and how it is packaged, the weight and size of the package, its point of origin and destination, and the amount of insurance desired. The agent will calculate the charges which in turn are paid the next day when the driver picks up the package. In addition, for a small fee, a UPS acknowledgement of delivery card can be prepared and attached to the package. Once the package has been delivered, this receipt is returned to the sender. In addition to residential pick-ups, to save on service charges, packages also can be dropped off at local UPS terminals.

UPS offers four methods of delivery: Regular Ground, Blue Label, Red Label, and COD. Packages sent by Regular Ground service are handled as normal deliveries. Those sent by Blue Label are delivered in two days while those sent by Red Label are delivered within 24 hours. When packages are sent COD, the sender can specify that the recipient pay either by cash or check. Upon collection of the COD payment, UPS will issue the sender their personal check.

In addition to serving the United States, including Hawaii, UPS also has service to parts of Canada, Puerto Rico, and many European countries.

Greyhound Package Express will deliver artworks that are adequately packaged, including wooden crates. They will not accept artworks that are framed under glass but will accept those framed under plexiglas or acrylic. Greyhound regulations limit the weight of a package to 100 pounds and its dimensions to 141 inches, with a maximum length of 60 inches. Packages are automatically insured for up to $100 but can be insured for a maximum of $1000.

In larger metropolitan areas, Greyhound will make residential pick-ups for a small fee. Otherwise, packages are brought to the Greyhound terminal by the sender. When a package has arrived at its destination, a Greyhound agent will notify the recipient. If the recipient cannot be reached by telephone, he or she will be notified by mail. Unclaimed packages will be held for two weeks, after which the sender is notified and the package is sent to a central warehouse for storage. Packages sent by Greyhound are usually prepaid, but in certain instances they can be sent COD. In addition to regular service, Greyhound Express also offers Priority Service in which the package is guaranteed a place on the "next bus out" heading in the direction of the package's destination.

DISPLAYING

Compared to other artworks such as paintings and sculpture, drawings are often smaller in size and more intimate in nature. These qualities directly influence the way in which they are exhibited.

Drawings are best viewed in an environment in which they are not over-powered or dwarfed by their surroundings. When possible, it is preferable to exhibit them in smaller, more intimate spaces rather than in vast, open areas. For example, when exhibiting in a gallery, several small rooms or a space divided with vertical partitions is more desirable than a large open room.

When displaying drawings, it is important not to hang them too high or too low. The proper height can be determined by establishing an imaginary horizontal line on the wall at the height of an average person's eye level; when positioned, the center of the drawing should fall upon this line. If a row of drawings is to be displayed, a string can be temporarily stretched along the wall to assure that each artwork is correctly centered. If two smaller drawings are to be hung next to a large one, the works should be placed so the eye level line runs through the center of the larger work. Then, the two smaller works should be positioned so that one is above eye level and the other below (Fig. 10–17).

Drawings should be displayed with an adequate amount of space surrounding them. The amount of space is relative to the size of the artwork. Generally, the larger the piece, the greater the surrounding space. Also, when displaying a group of drawings there should be visual harmony between adjacent

FIGURE 10–17
Pleasing display of artwork

artworks. For example, a bold, high-contrast drawing should not be placed next to a more delicate, subdued drawing.

If possible, drawings should be displayed in natural, filtered light. They should not be displayed in direct sunlight, since sunlight causes deterioration. When drawings are displayed under artificial light, it is best to use a "warm" rather than fluorescent light since fluorescent light tends to drain values and colors from the artwork. Also, to further protect the drawings, the light level should be kept low. Track lighting is commonly used to light drawings when they are exhibited in a gallery. This type of lighting is particularly advantageous in that the lights can be adjusted to shine on individual works. If highlighting is used to show off a drawing, the light should be positioned so it illuminates the entire work rather than just its center.

Index